NEW ZELAND

THE LAND AT THE END OF THE EARTH

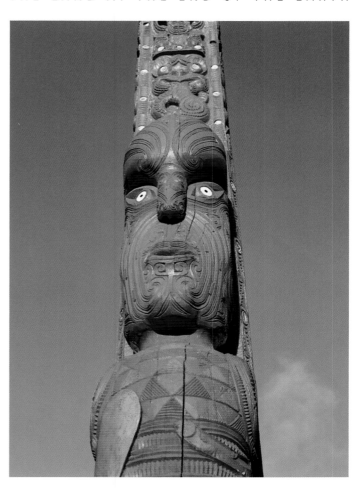

WHITE STAR PUBLISHERS

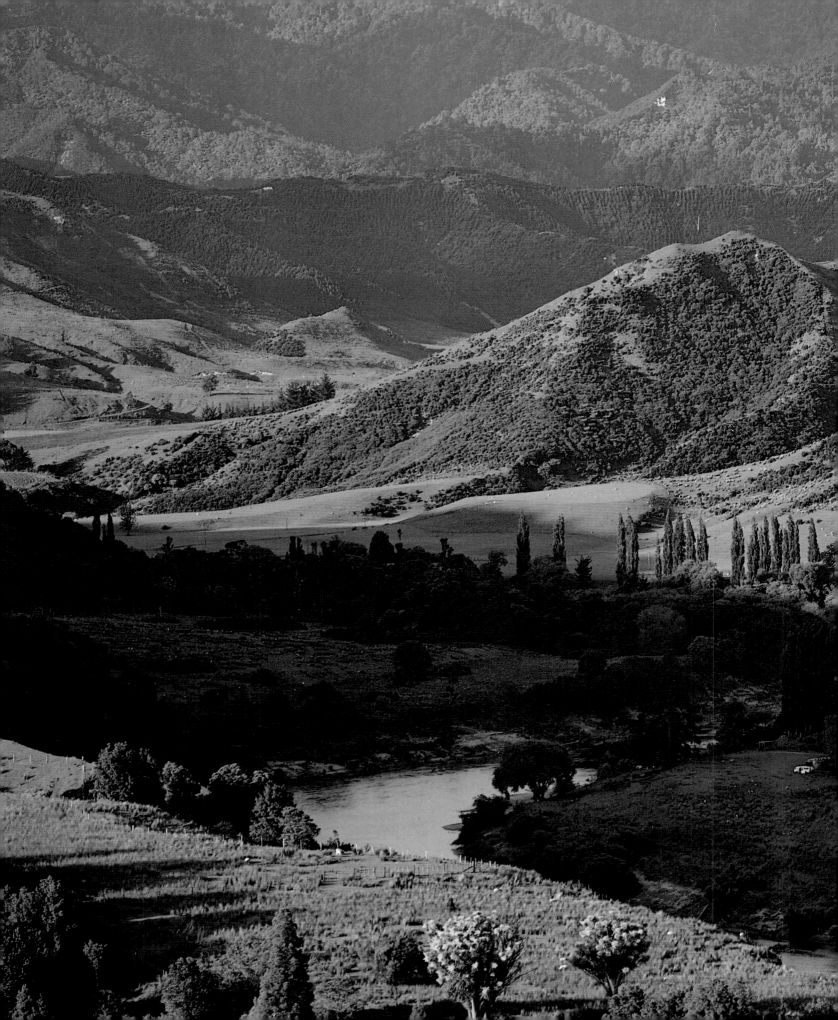

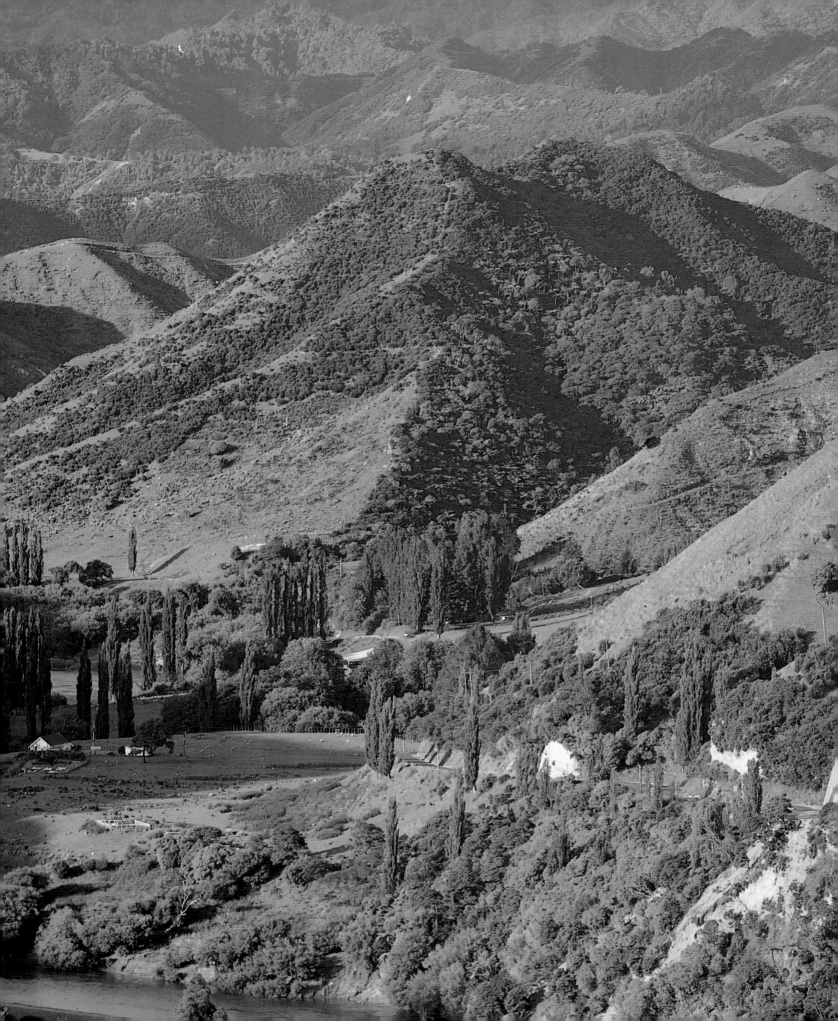

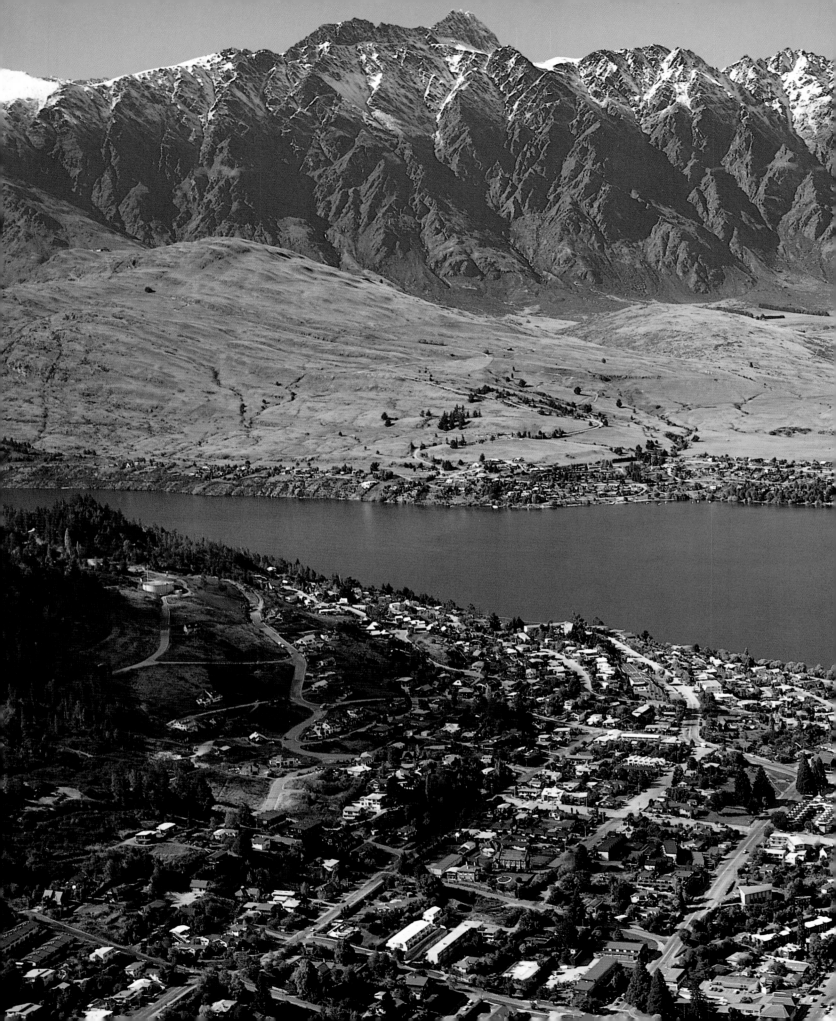

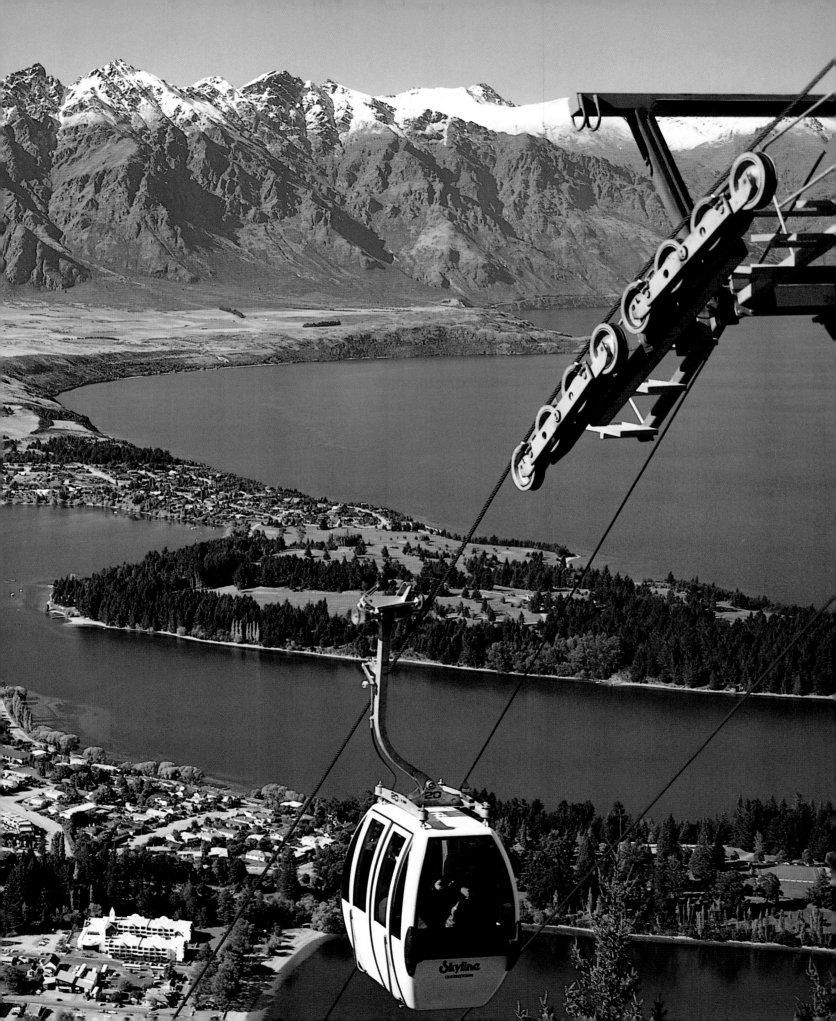

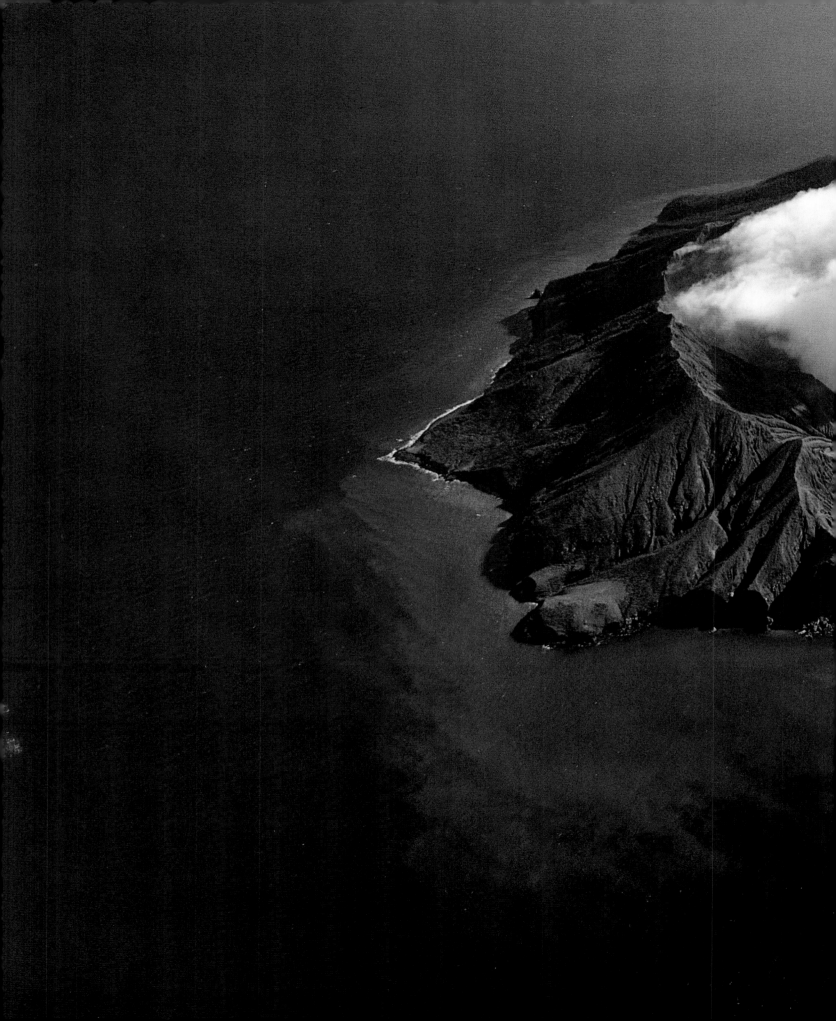

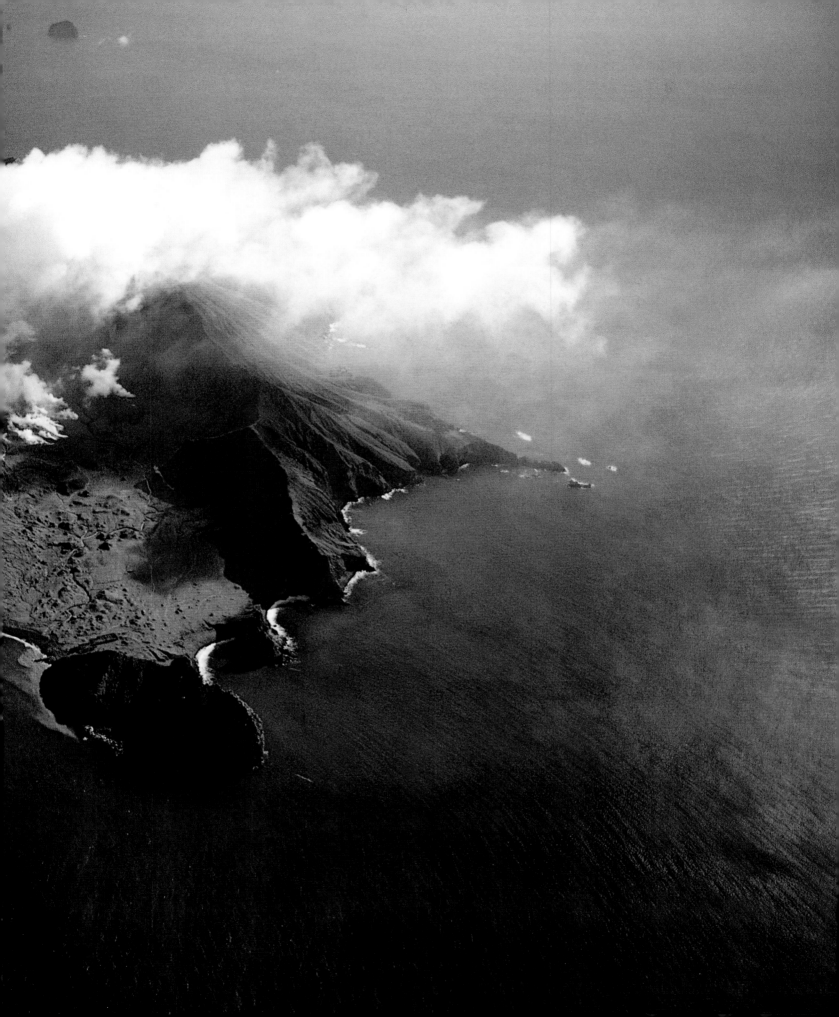

Text
Colin Monteath

Graphic Design
Anna Galliani

Map
Arabella Lazzarin

Contents

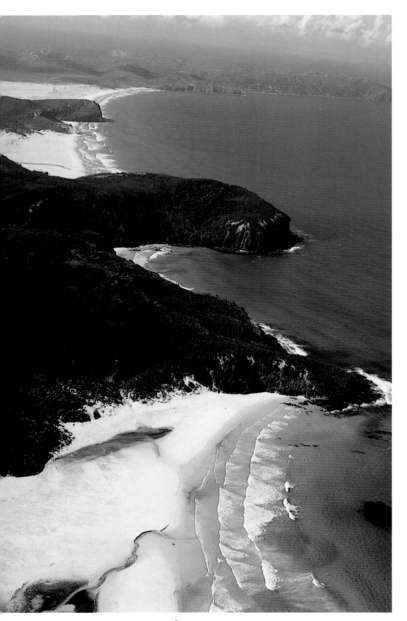

1 *Rotorua in central North Island is one of the focal points for Maori culture in New Zealand. Carved doorways, weapons and waka canoes are a vital part of Maori tradition.*

2-3 *The Wanganui river is the longest continuously navigable river in New Zealand. With its headwaters on the central volcanic plateau of the North Island the Wanganui flows some 125 miles to the Tasman Sea. Once an important river for the Maoris commuting by canoe, it is now popular with recreationists keen on rafting, jet boating and canoeing. Some lovely peaceful campsites can be found in the heart of rich farmland bordering the river.*

4-5 *The Skyline Gondola whisks Queenstown visitors several hundred feet above the city to a restaurant and observation platform with a stunning panorama over Lake Wakatipu and the Remarkable Mountains. Queenstown is recognized as the fun capital of the South Island's "Southern Lakes" district with superb trekking and boating in summer and skiing for all levels of ability in winter. This view of Queenstown is taken in early autumn with the trees just starting to change color and the first snowfall on the Remarkables.*

6-7 *New Zealand is known as the "Shaky Isles" and nowhere is the volcanic activity more spectacular or violent than on White Island , a small island some 30 miles north of the township of Whakatane in the Bay of Plenty. While the volcano is clearly visible from Whakatane, visitors can get a better feel for active vulcanism by taking a scenic flight in a small aircraft directly over the craters.*

8 *This aerial view of part of Northland's coastline, jutting into the Pacific Ocean gives a good impression of the remote and pristine beaches of clean white sand for which New Zealand has rightly become famous. Rugged headlands of dense bush come right down to the sea adding to the feel of isolation. Northland is easily accessible from the city of Auckland.*

9 *As the sun sinks into the Tasman Sea at the end of the day the western aspects of Mount Cook are transformed into a kaleidoscope of pinks and mauves. At 12,350 feet Mount Cook is New Zealand's highest peak. Although not high by world standards, its glaciated flanks descend into deep shadowy valleys not far above sea level. The Southern Alps stretch the length of South Island providing a mecca for mountaineers, skiers and trekkers.*

© 1995 White Star s.p.a.
Via C. Sassone, 22/24
13100 Vercelli, Italy
www.whitestar.it

New updated edition in 2007

ISBN-10: 88-544-0091-2
ISBN-13: 978-88-544-0091-7

Reprints:
1 2 3 4 5 6 11 10 09 08 07

Color separations by La Cromografica, Ghemme (Novara) Italy

Printed in Singapore

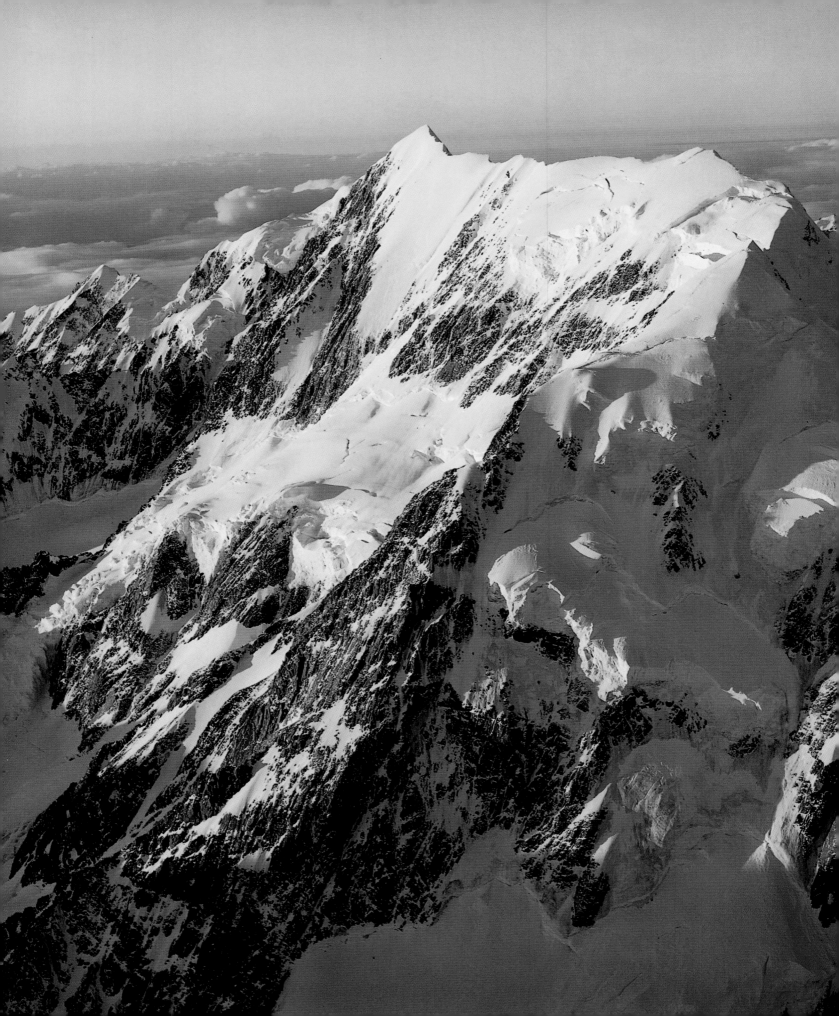

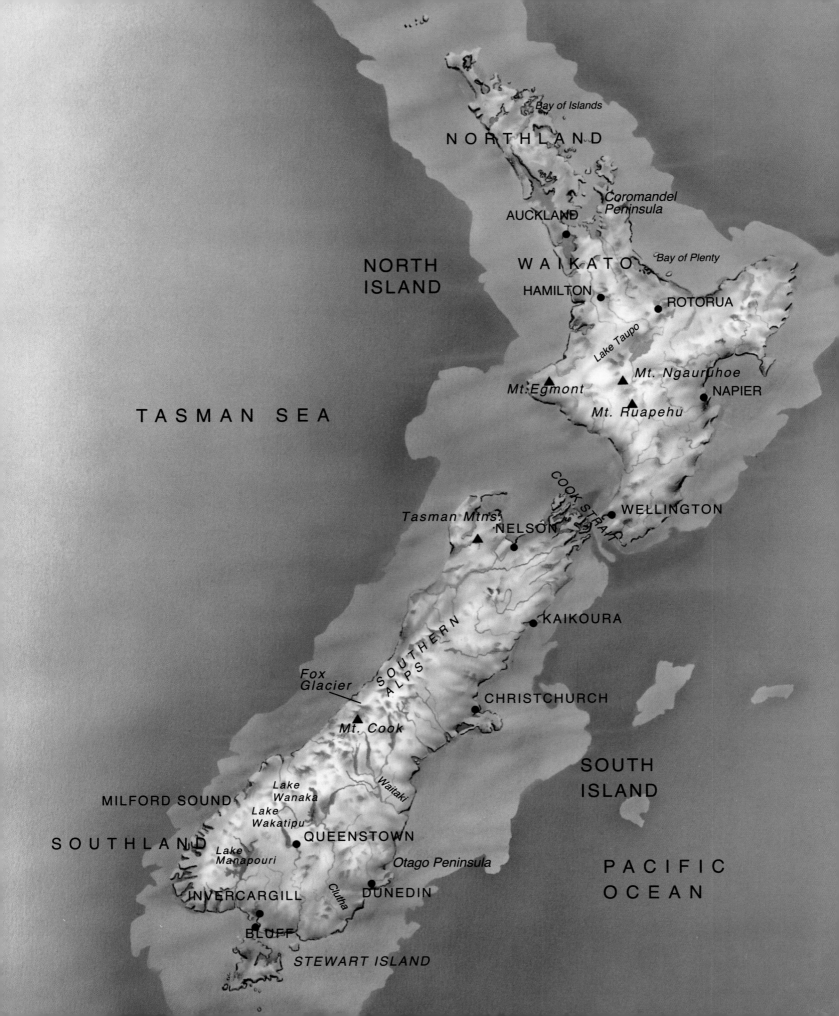

NORTHLAND

Bay of Islands

Coromandel Peninsula

AUCKLAND

NORTH
ISLAND

WAIKATO

Bay of Plenty

HAMILTON

ROTORUA

Lake Taupo

▲ *Mt. Ngauruhoe*

Mt. Egmont ▲

NAPIER

▲ *Mt. Ruapehu*

TASMAN SEA

Cook Strait

WELLINGTON

Tasman Mtns.

NELSON

▲

KAIKOURA

SOUTHERN
ALPS

*Fox
Glacier*

CHRISTCHURCH

▲ *Mt. Cook*

SOUTH
ISLAND

Waitaki

MILFORD SOUND

*Lake
Wanaka*

*Lake
Wakatipu*

SOUTHLAND

*Lake
Manapouri*

QUEENSTOWN

Otago Peninsula

PACIFIC
OCEAN

Clutha

INVERCARGILL

DUNEDIN

BLUFF

STEWART ISLAND

11 *Aoraki (Mount Cook), right, and Mount Tasman, New Zealand's second highest summit, are perfectly reflected in a West Coast lake. The backbone of the Southern Alps is only about 12.5 miles from the Tasman Sea so steep glaciers such as the Fox and Franz Josef flow down through heavily vegetated gorges to the narrow coastal plain.*

12-13 *The tiny township of Lake Tekapo sits at the crossroads of the Mackenzie Country and the Southern Alps. Lake Tekapo is a popular recreation spot in both summer and winter. Its glacial fed waters feed the Benmore-Waitaki hydro-electric scheme providing electricity to much of the South Island. Lake Tekapo can be quite eye-catching as the sun reflects across water impregnated with fine glacial sediment thereby creating a vivid turquoise landscape.*

14-15 *A fleet of small ferries transport passengers and vehicles between the North and South Islands from Wellington to Picton across Cook Strait. It is a three-hour voyage at present although faster, more modern vessels will be in operation shortly. The Cook Strait has a wicked reputation for stormy weather although by the time vessels get close to Picton they are generally sheltered in the peaceful waters of Marlborough Sounds.*

16-17 *Lovely historic homes set in parklike gardens are a feature of New Zealand. Mansion House on Northland's Kawau Island was built by Governor Sir George Grey in 1862. Kawau Island is also the refuge for the tiny Parma wallaby thought to be close to extinction in its Australian homeland.*

18-19 *Lake Mangamahoe with its foreshores draped with tree ferns lies at the foot of the dormant volcano Taranaki (Mount Egmont). The Taranaki district with its fertile volcanic soil is famous for highly productive dairy farms. Taranaki is only a few miles from the Tasman Sea so often catches violent weather.*

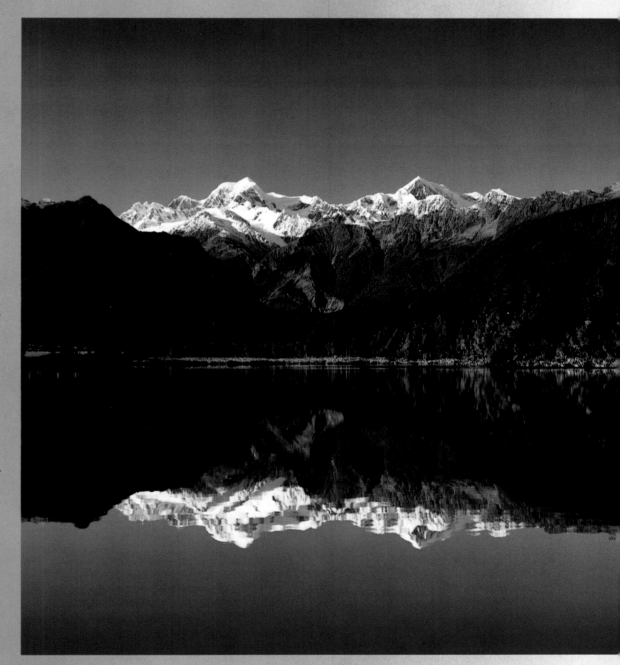

Introduction

In 1884, the European Andreas Reischek, wrote of New Zealand "...and like a carpet at your feet, in endless gradations of light and shade, the New Zealand bush spreads out in green waves downwards to the edge of the ocean."

Even today, despite much of the country being heavily modified by agriculture and the vigorous growth of modern sprawling cities, New Zealand is blessed with vast areas of wild bushland, a rugged backbone of alpine peaks, volcanoes, hot springs, clean water and remote unfrequented beaches. New Zealand is home to a relic of the reptile world, the Tuatara, and strange flightless birds, notably the Kiwi and the nocturnal Kakapo, the largest parrot in the world. Seen by many as a haven of peace, New Zealand continues to thrive in a world racked by tension and overcrowding. While some merely focus attention on New Zealand's achievements in various international sporting fields, the tiny country has rocketed into prominence in the 1980s as a result of its nuclear-free policy. In general, New Zealanders care for their environment and take great pride in the maintenance of an extensive national park system. The World Heritage designation of South Westland is seen as a major wilderness of international significance. New Zealand's environmental management skills have become a highly sought-after commodity especially throughout South-East Asia.

As a tourist destination New Zealand is firmly on the map as a place for a quiet relaxing holiday at a coastal village or perhaps for a "farm-stay" experience on a high country sheep station. For the more adventurous who relish clean air and outdoor activities, New Zealand is a paradise for skiing, yachting, mountaineering, scuba-diving, kayaking and fishing. Many consider New Zealand as "the walking capital of the world" - a place to leave the automobile behind.

Separated from the ancient supercontinent Gondwanaland for the last 100 million years, New Zealand lies in isolation on the southern rim of the Pacific Ocean - a glittering necklace of verdant, tranquil islands

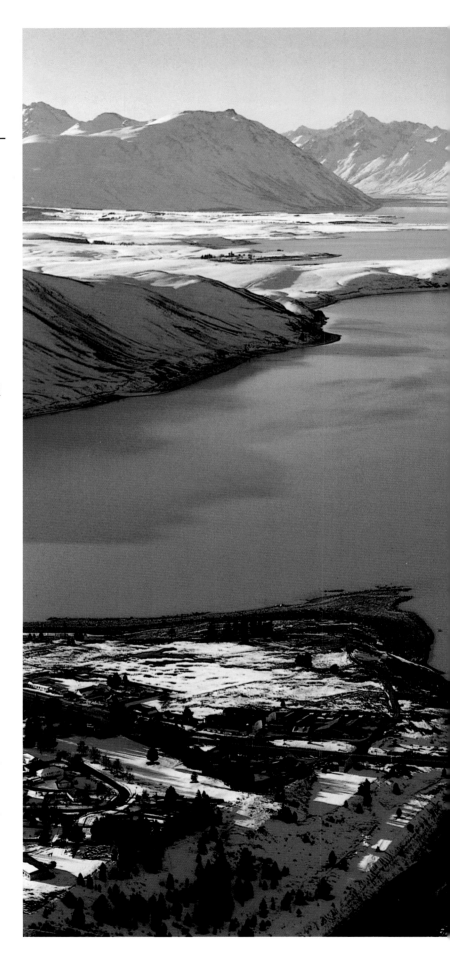

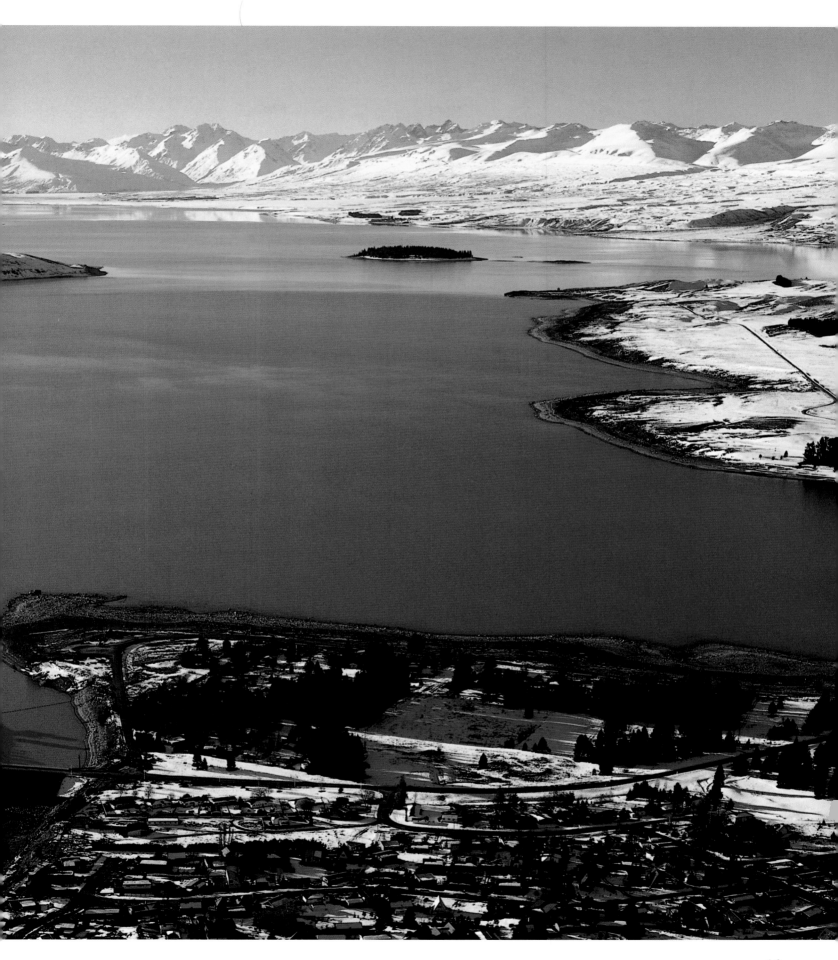

inhabited by people of Maori, Polynesian and European extraction.

New Zealand's nearest neighbor, Australia, lies to the west some 1,250 miles away across the storm-tossed Tasman Sea. New Zealand was originally connected to the eastern edge of the Australian mainland, Tasmania and Antarctica. With the gradual breaking up of Gondwanaland's land-links, New Zealand missed out on the introduction of the early marsupial mammals (Kangaroos, Koalas etc) which arrived in Australia via South America and on snakes which wriggled into Australia from New Guinea-Indonesia connections. Highly-specialized birds and unique plants are among New Zealand's most attractive legacy on land. Coastal waters abound in penguins, seals, whales and dolphins including the smallest dolphin in the world, the Hector's.

The Maoris have been called "Vikings of the Sunrise". These early Polynesian seafarers were skilful Pacific navigators who landed on the northern shores of New Zealand in ocean-going *wakas* (canoes) some 800 years before the arrival of the first European voyagers. Apart from Antarctica, New Zealand was the last major land mass to be reached and inhabited by man.

The Maori people gradually colonized the semi-tropical regions of the North Island, eking out an existence from hunting, fishing and harvesting the *kumara* (sweet potato). Tribal warfare and cannibalism were common. Weaker tribes were pushed southward to inhabit the much colder South Island. Many hunted the now-extinct Moa, a flightless ostrich-like creature, perhaps the tallest bird ever to have lived. While the precipitous Southern Alps proved a formidable barrier for the Maori, crossing routes were established to the rugged rainforest regions of the West Coast in search of *Pounamu*, the "stone of the gods" - a highly-prized nephritic jade.

Centered in Batavia (now Jakarta) in the 17th Century, the Dutch East India Company dominated the trading routes around the East Indies for 200 years. Voyages purely for exploration were rare. In 1642 Abel Tasman, in his wooden vessels *Zeehaen* and *Heemskerk*, sailed eastward at 55 S underneath mainland Australia searching for *Terra Australis Incognita* - the great south land - and a faster way to the lucrative trading markets in South America, then dominated by the Spanish.

Tasman discovered Van Dieman's Land (Tasmania) before crossing what is now known as

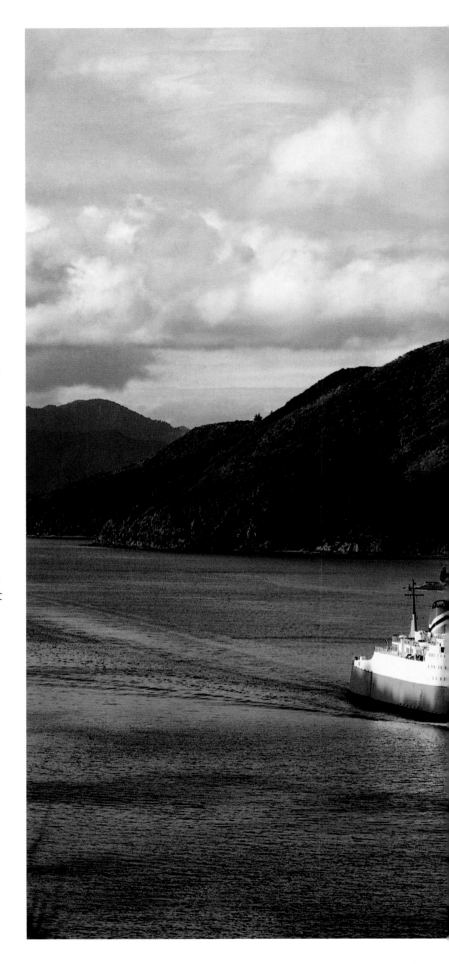

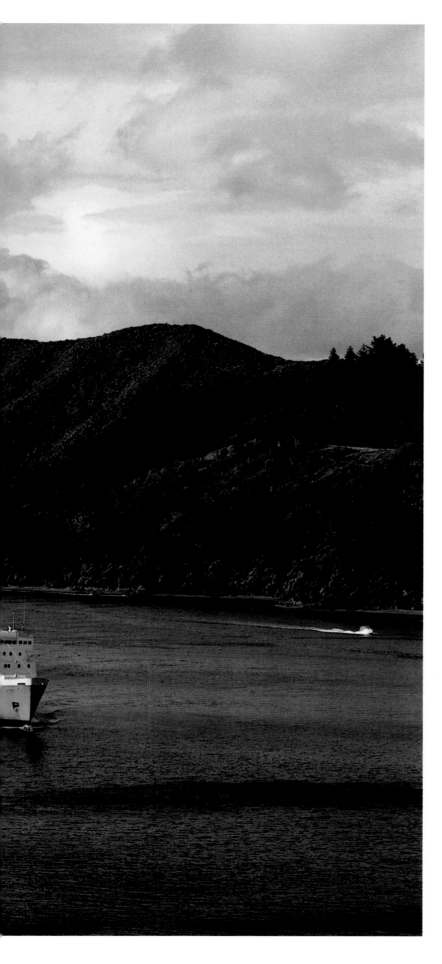

the Tasman Sea to reach the west coast of the South Island of New Zealand. On December 13th 1642 he recorded "a Land Uplifted High" in his log as he caught sight of the snowy summits of the Southern Alps which rise to 12,000 feet within about 15 miles of the bush-lined beaches. Thinking he had reached South America, Tasman named his landfall *Staten Landt* (the Dutch name for South America). Later, the name changed to *Niew Zeeland* after Tasman's native province.

Englishman James Cook opened up the Pacific to the European world with three remarkable voyages of scientific discovery in the 1700s. Captain Cook circumnavigated New Zealand in 1769 and formally took possession of the land for the British crown. Cook's excellent charts of the coastline were relied upon for the next 150 years despite his error of thinking Stewart Island was part of the South Island. Cook visited New Zealand twice more during the 1770s so he could resupply his ships after long arduous voyages to the edge of both polar regions. Although Tasman and Cook's first encounters with the Maoris were violent, Cook grew to respect Maori culture, making many friends during his ten year-association with the country.

Almost inevitably, Cook's journals sparked off the sealing and whaling industry in New Zealand waters. With Europe engulfed in the Napoleonic wars, demand for various byproducts of seals and whales grew steadily. Based out of eastern Australia, the renegade sealers used New Zealand harbors as a source of fresh water and timber to repair their ships. Initially seals were plentiful; however it wasn't long before numbers were sufficiently depleted to force the hunters further south to New Zealand's sub-antarctic islands.

Following the opening up of eastern Australia and Tasmania as penal colonies in the late 1700s large scale immigration to New Zealand from Britain got underway in 1842; formal annexation by Britain occurred in 1840 after the signing of the Treaty of Waitangi. The introduction of firearms, alcohol, prostitution and diseases by the new colonists had a profound effect on the Maori population, decimating their numbers. Despite some violent skirmishes (Maori Land Wars 1860-81) Maori and *Pakeha* (European) gradually learned to live peaceably enough together. The Maori had no concept of owning or selling their land and as a result many of the so-called

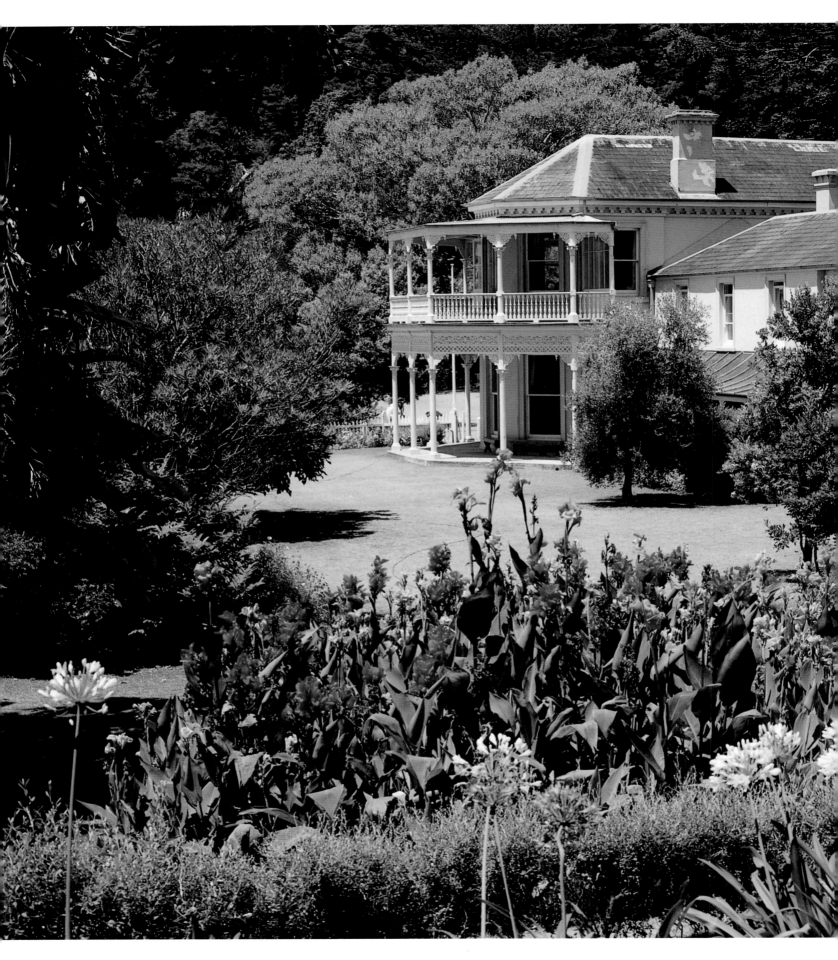

land deals are still being vigorously contested today by a well-educated and articulate Maori population. Maori today make up about ten per cent of New Zealand's population of 3.5 million and are flourishing in a proud revival of Maori tradition - *Maoritanga*.

Although considered a "young" country, 150 years of European settlement combined with a rich tapestry of Maori/Polynesian influence has created a multiracial New Zealand - a nation of pivotal importance in the Pacific basin.

Once solely dependent on its exports of wool, meat and dairy products to the British market, New Zealand has evolved as a modern exporting nation of primary produce on the world stage. Horticultural produce, notably the "Kiwi fruit", and an emerging wine industry have now established themselves as important revenue earners. New Zealand's climate can be considered "ideal" - ranging from semi-tropical in the far north to cool temperate in the south. Summers are never blisteringly hot and winters are relatively short and mild.

New Zealand is roughly the size of the United Kingdom; its three main islands (North, South and Stewart) result in a coastline which is over 6,200 miles long.

New Zealanders, although largely urbanites, are never far from the sea which provides a basis for both industry and recreation. Easy access to bush and mountain country for various forms of recreation is crucial to the well-being of all New Zealanders. From richly-grassed farmlands in the north to high country sheep stations in the south, farming traditions are deeply engrained in the "Kiwi" ethos. New Zealand is a compact land of tall Kauri forest, bubbling mud pools, mysterious forest-clad fiords and slender icy peaks - a special place that is a vital crossroads on the doorstep of both the Pacific and Antarctica.

With a centerpiece of the snow-capped active volcanoes, Ngauruhoe and Ruapehu, the North Island is a buckled landscape of fertile soils and bright green grasslands. The thermal region of the central volcanic plateau around Rotorua and Taupo is a focal point of Maori culture.

Two thirds of New Zealand's population, including over 90% of the Maoris, live in the North Island. New Zealand's biggest cities are in the north with Auckland (over 1.3 million inhabitants) sandwiched between Manukau and Waitemata harbors in Northland while the capital, Wellington, is situated on the blustery southern tip of the island.

Auckland - the "City of Sails"- has every shape and size of craft taking to the water on weekends to enjoy cruising the network of waterways. Aucklanders relish the carnival atmosphere which exists when they play host to the crews of round-the world Whitbread yachts. Auckland has developed into an important center for yacht design and boat-building. The city has a prosperous fast-growing feel to it and is recognized as the commercial capital of the country. Auckland was the official capital until 1865 when it was transferred to the more central Wellington. Sprawling suburbs mushroom across rolling hills from the city center with neat rows of single-story wood or brick houses criss-crossing the landscape.

Most New Zealanders are lucky enough to own their own home and many take great pride in tending a colorful mosaic of flowers, shrubs and vegetables. For a city Auckland also has the largest concentration of Polynesians in the Pacific. As such the city provides a variety of important support systems for the many smaller island nations to the north.

Northland's Bay of Islands, Coromandel Peninsula and the Bay of Plenty are a big draw for both Aucklander and tourist alike. Clean beaches prove a popular attraction during the December-March summer months. Year-round however, sailing, scuba-diving and big game fishing entice enthusiasts to explore favorite haunts around the myriad of islands and channels. While Auckland can appear as busy as any big city, a relaxed outdoor life-style is still possible in the "winterless north".

The Waikato region of the central North Island with its principal city of Hamilton is the hub of New Zealand's dairy, sheep, horse and beef cattle-breeding industries. Many visitors marvel at the greenness of the grass. Despite the continuing importance of such traditional farming, vineyards and Kiwifruit orchards have significantly changed the appearance and economy of the rural scene in recent years.

The sacred peaks of Ngauruhoe, Tongariro and Ruapehu were gifted to the New Zealand people by a Maori chief in 1887 forming Tongariro National Park only 15 years after Yellowstone in USA, the first national park in the world. Every weekend from June to November winter sports fans flock from the major centers to the skifields clinging to the volcanic slopes of

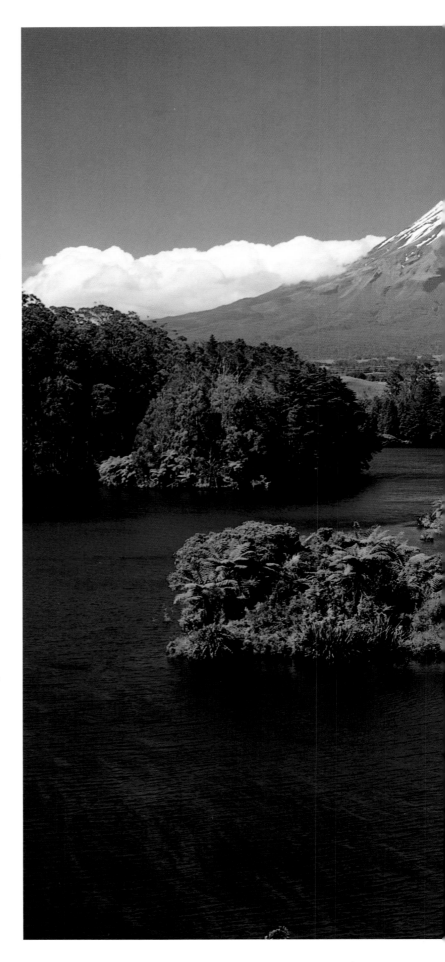

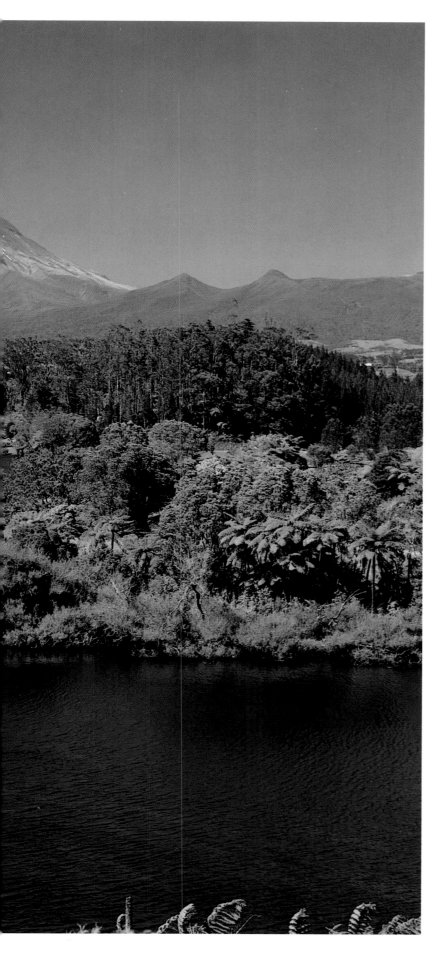

Mount Ruapehu (about 9170 feet) with its simmering volcanic lake. Nearby, Lake Taupo, New Zealand's largest lake, was formed in A.D. 186 by one of the biggest volcanic blasts in history. Ngauruhoe has violently erupted several times in recent decades, yet on the west coast, within sight of the Tongariro peaks, lies the slumbering ice-capped cone of Taranaki (Mount Egmont) a beautiful symmetrical volcano.

On the northern flank of Cook Strait, within sight of the South Island, Wellington sits nervously astride a major fault line which dissects the entire North Island. While New Zealand engineers have been highly innovative in strengthening buildings against earthquake damage it is the "Windy Wellington" reputation which seems to be of more pressing concern to inhabitants on a daily basis. Stacked like toy blocks among thick clusters of native bush, Wellington's brightly painted wooden houses cling to the steep hillsides overlooking a fine harbor. Wellingtonians take a ringside seat to observe and debate the finer points of the government's stewardship of the nation.

The North Island is a dynamic landscape in the throes of constant change - the driving hub of New Zealand's social and economic evolution. For an entirely different pace of life, with smaller cosier cities, more varied and extreme forms of recreation in a wilder untamed landscape, it is necessary to take the three-hour ferry trip from Wellington and start a journey into the South Island.

The South Island is unlike its northern neighbor in almost every way. With a backbone of alpine peaks as glaciated and rugged as any on Earth, the Southern Alps influence most aspects of life in the south. Fast-flowing rivers gouge out the hillsides creating vast outwash plains of shingle. Fertile soils in the east enable grain crops to grow well while in the west luxuriant rainforest is a national treasure, connecting the mountains to the Tasman Sea only 12 miles away.

Christchurch (340,000 people) and Dunedin (120,000) on the east coast are the principal South Island cities and while there has been a definite "drift to the north" in recent years, with people looking for work, both cities are now thriving business and cultural centers with inspiring communal spirit.

Large sheep stations, with their wide-verandahed homesteads located at the head of beautiful river valleys, have been the main-stay of

South Island farming for generations. The high country autumn muster is an essential yet colorful event in the farming calendar. The shepherds on horseback (perhaps assisted by helicopters) drive the sheep down from the alpine tussock country to lower pastures before the onset of winter snowstorms.

The South Island has become well known as a fine producer of both apples and pears with prosperous orchards centered in the Nelson and Otago districts. Introduced deer bred quickly to become a pest throughout South Island forests, however, these days commercial deer farming for meat, hide, velvet and breeding stock is a major export earner.

Tourism is now the principal industry in the south with picturesque spots such as Queenstown attracting foreigners to the skifields above the town. The Southern Lakes of Wanaka, Wakatipu and Manapouri create endless opportunities for the boating enthusiast. The lakes also provide access to spectacular walking routes such as the Milford Track. Other tracks like the Routeburn, Keplar, Heaphy, Rees-Dart and Abel Tasman have now become as popular as the Milford for those wishing to sample the varied environments of the south. Excellent walking tracks are also a feature of Stewart Island which boasts the most likely chance of a visitor observing a Kiwi in the wild. Stewart Island is only a short ferry trip from Invercargill/Bluff at the southern tip of the South Island. With only 12 miles of roads, Stewart Island is an ideal spot to unwind for those stressed by the age of automobiles.

Fiordland National Park with famous landmarks Milford Sound and Mitre Peak is a truly remarkable wilderness of global importance. Whether viewed from the air or from a walking track, the deep sombre fiords with their outlets to the Tasman Sea have a majesty and serenity all of their own especially when blanketed by snow. The rain is measured in metres in Fiordland and while this can be a deterrent for some, storms are a time when the cliffs come alive with waterfalls, creating the most spectacular visual shows of light and water - nature at its best.

It knows how to rain on the West Coast as well, however: on a still peaceful morning in Fox Glacier, Westland has an intimacy and beauty that is unique. At the end of the day as the sun settles into the Tasman Sea, Mounts Cook and Tasman, New Zealand's highest summits, take on a deep

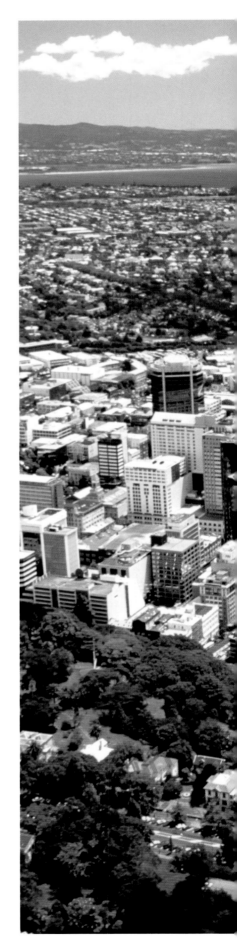

20-21 In addition to the natural setting offered by the gulf of Hauraki, Auckland benefits from a balanced urban layout, open and never oppressive. In this view, along the greenery of Albert Park, the city's most representative skyscrapers stand tall: in the middle, the Sky Tower (1,076 feet), from whose top the view ranges for almost 60 miles in every direction; on the right, the interesting Vero Centre (548 feet), characterized by a tilted "disc" on its top; and, in between the two, the Metropolis Apartments (508 feet), built over the old Magistrate building, of which the façade has been preserved.

22-23 Skiing on the big open glacial neves of the Southern Alps creates an amazing feeling of freedom. This skier is swooping across a crevasse bridge high on the Franz Josef Glacier of Westland National Park. The Tasman Sea is only a few miles away so it is very special to be in an alpine world yet look down vegetated gorges to surf crashing on a West Coast beach.

24-25 Lake Benmore in the center of the South Island and the Waitaki river system's hydro-electric scheme provides an important source of electric power for much of New Zealand. Melt from the snow-covered foothills of the Southern Alps in the background keeps this beautiful lake topped up with water for much of the year.

26-27 Christchurch at dusk takes on a peaceful relaxed air. With 340,000 people, Christchurch is the largest city in the South Island and is an important focal point for the surrounding rural community on the Canterbury Plains. Spring in Christchurch is a special time. The city is filled with blossoms in the many tree-lined streets or carefully manicured private gardens, yet the nearby foothills of the Southern Alps are still draped with snow.

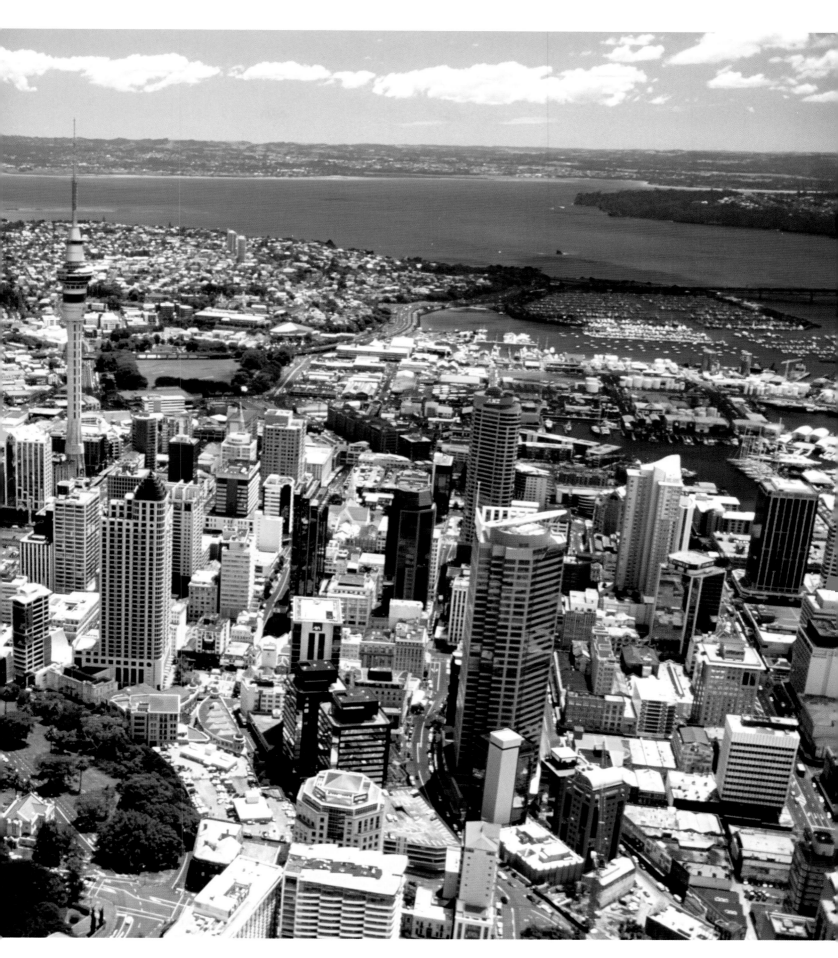

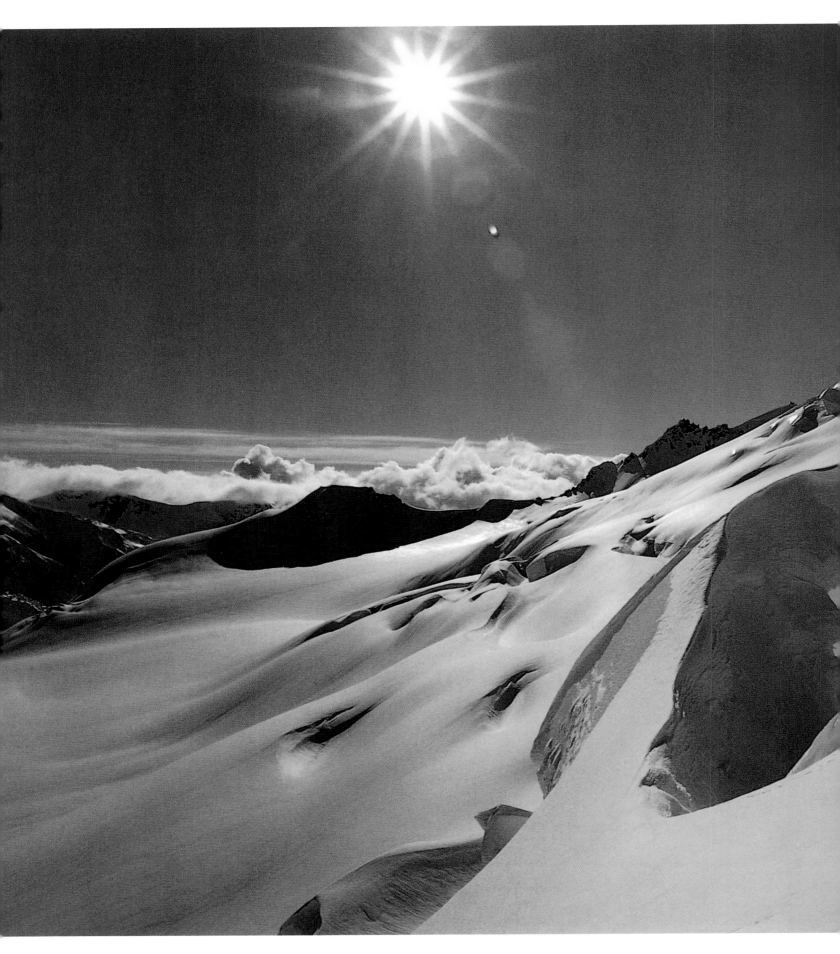

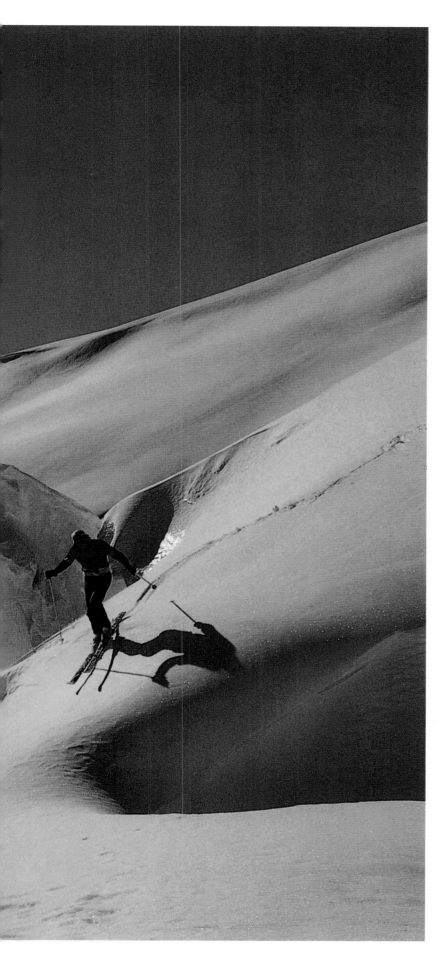

burgundy glow. Inexorably, the Fox and Franz Josef Glaciers grind their way down from the neves of the Main Divide. Their moraine-covered snouts crunch and shove a wall of ice to the verge of the rainforest - an ice-forest interface in a constant state of turmoil only a few miles from the beach.

On the drier eastern slopes of the loftiest peaks lies the famous Hermitage hotel and Mount Cook village - the principal mecca for mountaineers keen to test their ice skills. New Zealand's peaks are not high by world standards (Mount Cook is 12,350 feet); however when their heavily glaciated faces and ridges are pounded by bad weather coming in from the Tasman Sea they take on a fierceness which needs to be treated with respect and judgement. Visitors to the Hermitage are often privileged to witness spectacular mountain vistas as well as a never-ending kaleidoscope of curved wind clouds.

Only two hours north of Christchurch lies the tiny fishing village of Kaikoura which has now developed as the whale and dolphin watching center of New Zealand. Sperm whales routinely come to feed on squid which thrive on the rich upwelling of nutrients off the edge of the Continental Shelf. Some visitors spend hours with the whales, bobbing around with a guide in an inflatable boat while others prefer to swim with the dolphins closer to the beach. Fur seals huff and snort on the rocky platform nearby.

New Zealand has changed much in the past 20 years and is now an active player on the world stage, voicing an opinion or taking action on matters of global politics, conflict and matters of international trade. At home New Zealanders enjoy an easy relaxed intimacy with their environment. They can also take the time to offer hospitality to a foreign guest or perhaps go out of their way to put the visitor on the right road. Both attributes are worth a good deal.

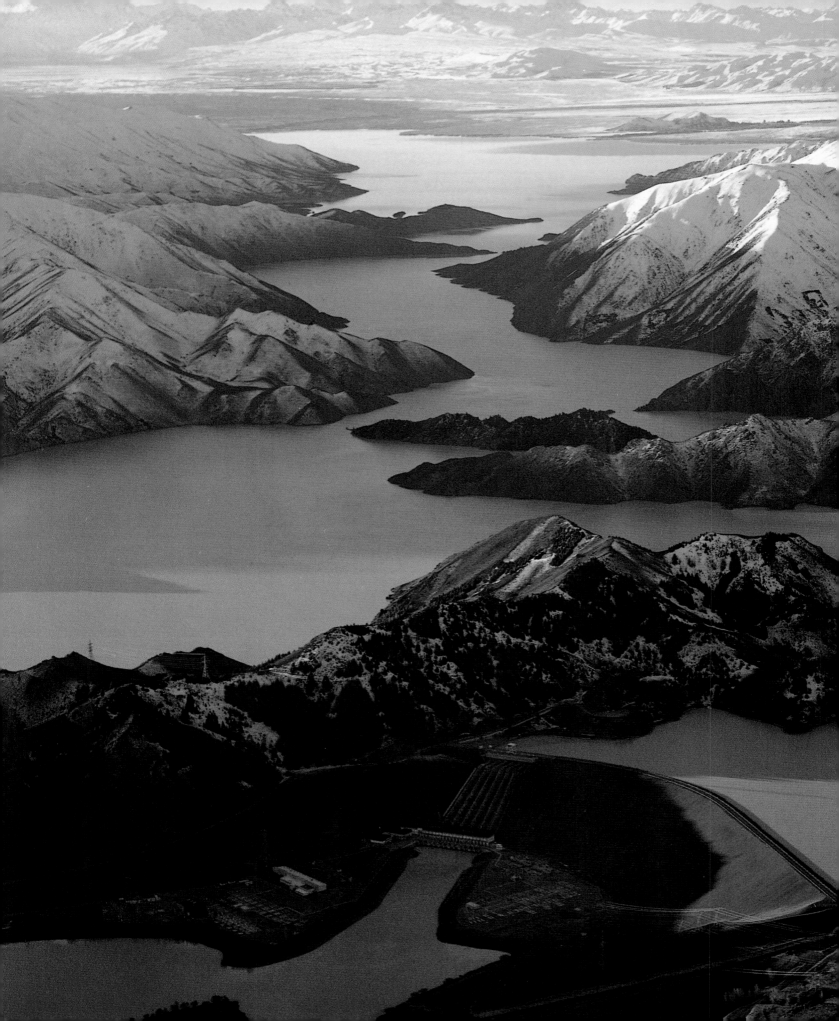

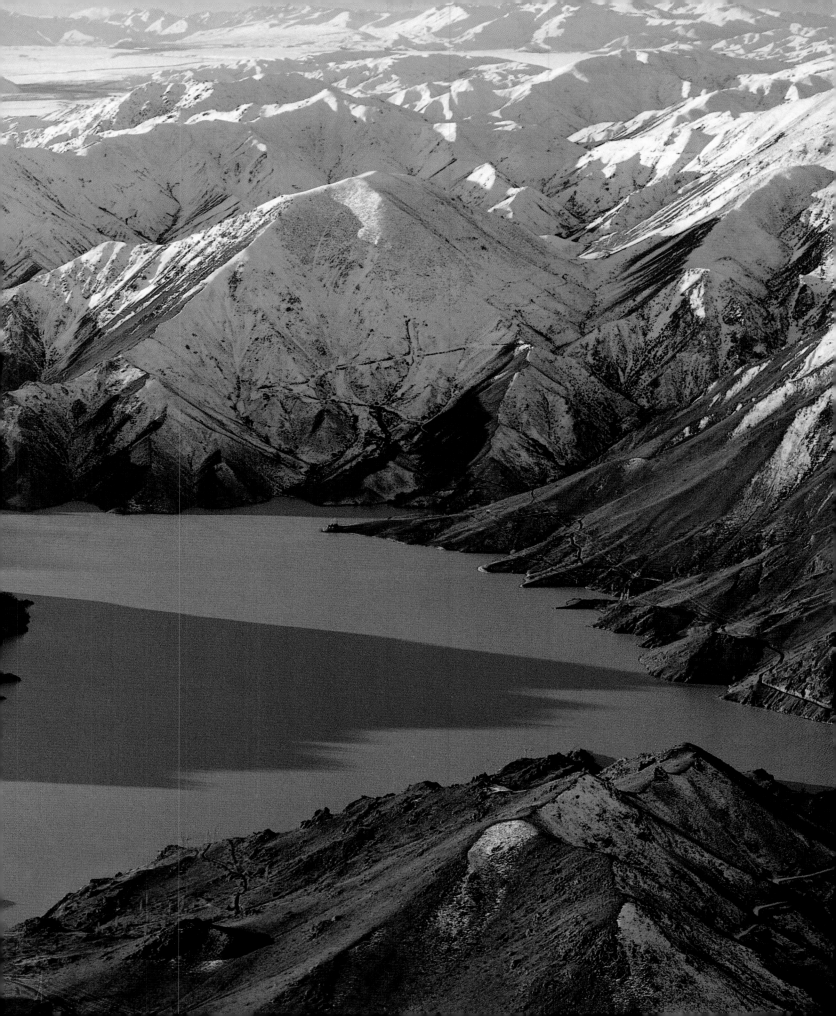

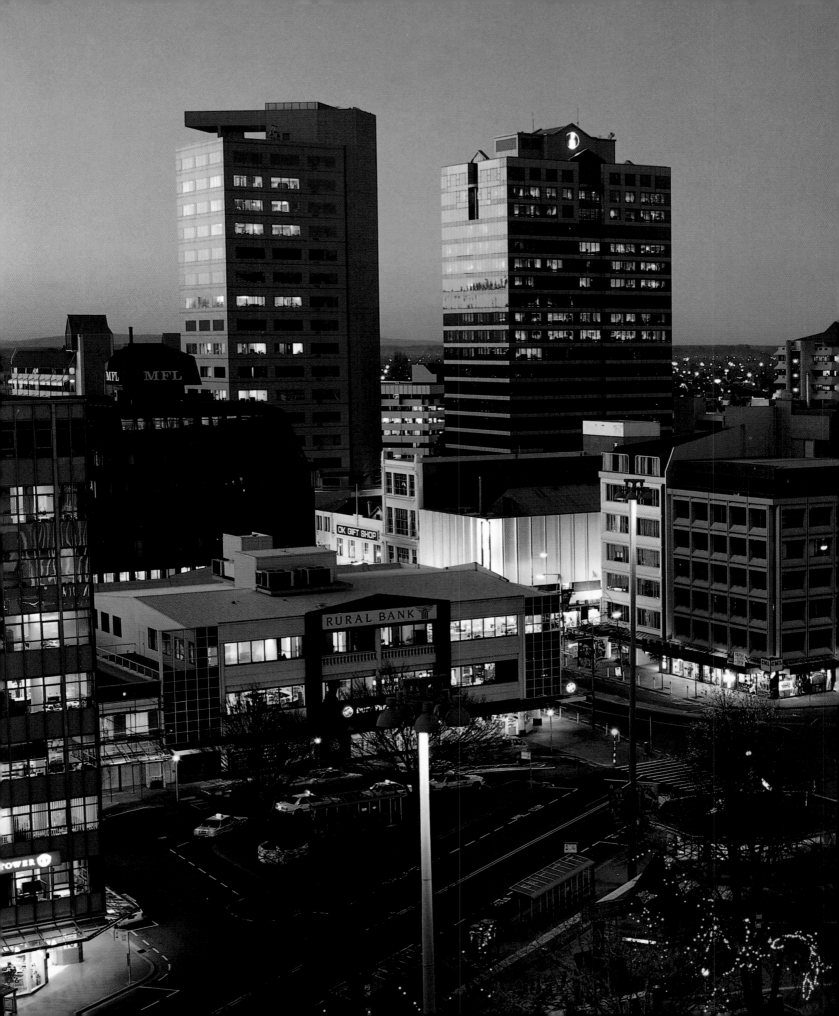

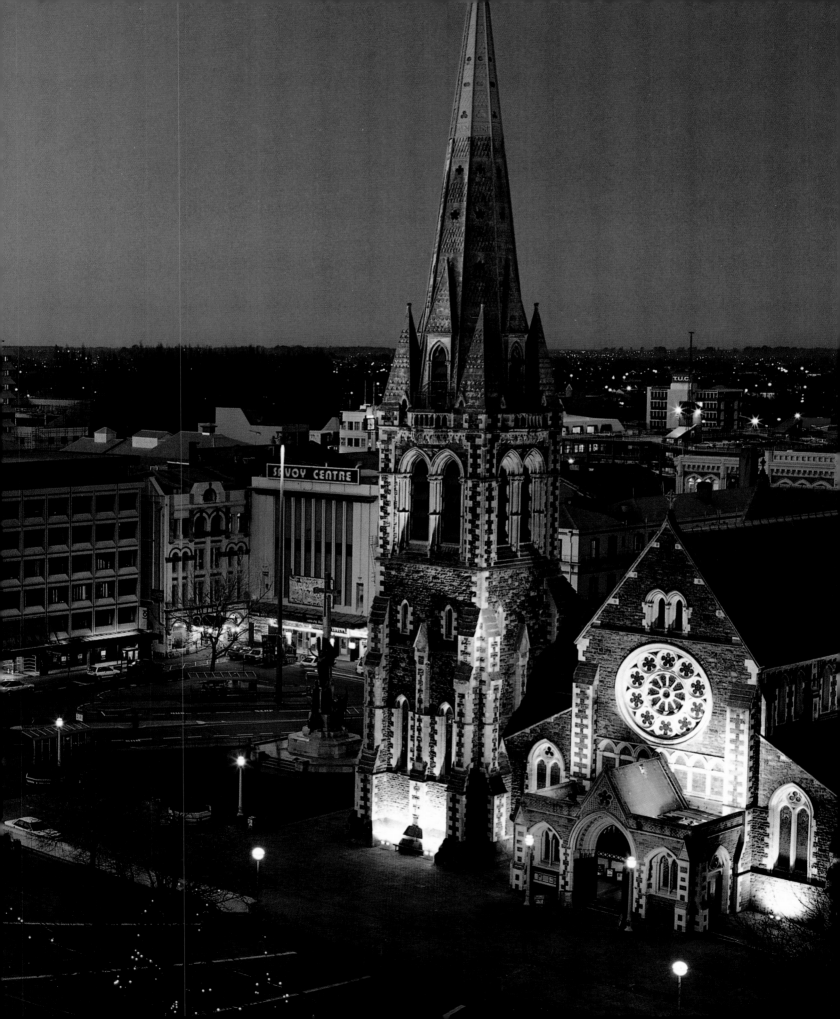

On the Southern Rim of the Pacific

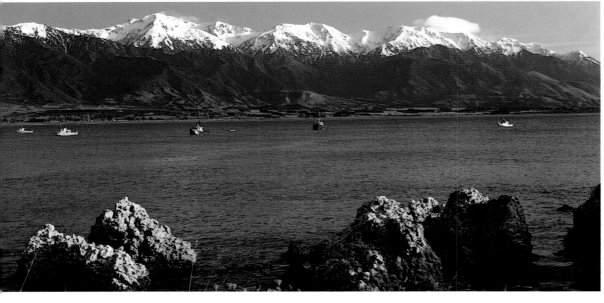

28 top *Kaikoura harbor is the home port for many local fishing vessels which catch both fin fish and lobsters in the rich coastal waters of the Pacific. With a strong up-welling of nutrients where the continental shelf comes close to the township of Kaikoura many sperm whales come to feed. Whale watching and swimming with Hector's dolphins have put Kaikoura on the international map for all nature lovers.*

28 bottom *Heavy rain clouds drift down the Rees and Dart Valleys to blanket sheep paddocks on the fertile river flats at the head of Lake Wakatipu near the township of Glenorchy. With over 80 million sheep in New Zealand fine grades of wool for clothing and carpets as well as meat products have been the mainstay of the country for most of this century.*

29 *Sunset on Mount Tasman (foreground) and Aoraki (Mount Cook) lights up the summit icecaps of the two highest peaks in the Southern Alps. Mountaineers come from all over the world to test their skills on the steep ridges and faces of these peaks. Mount Cook and Westland National Parks lie on each side of these mountains and with easy road access and fine hotels everyone can enjoy the best of New Zealand's unique alpine scenery.*

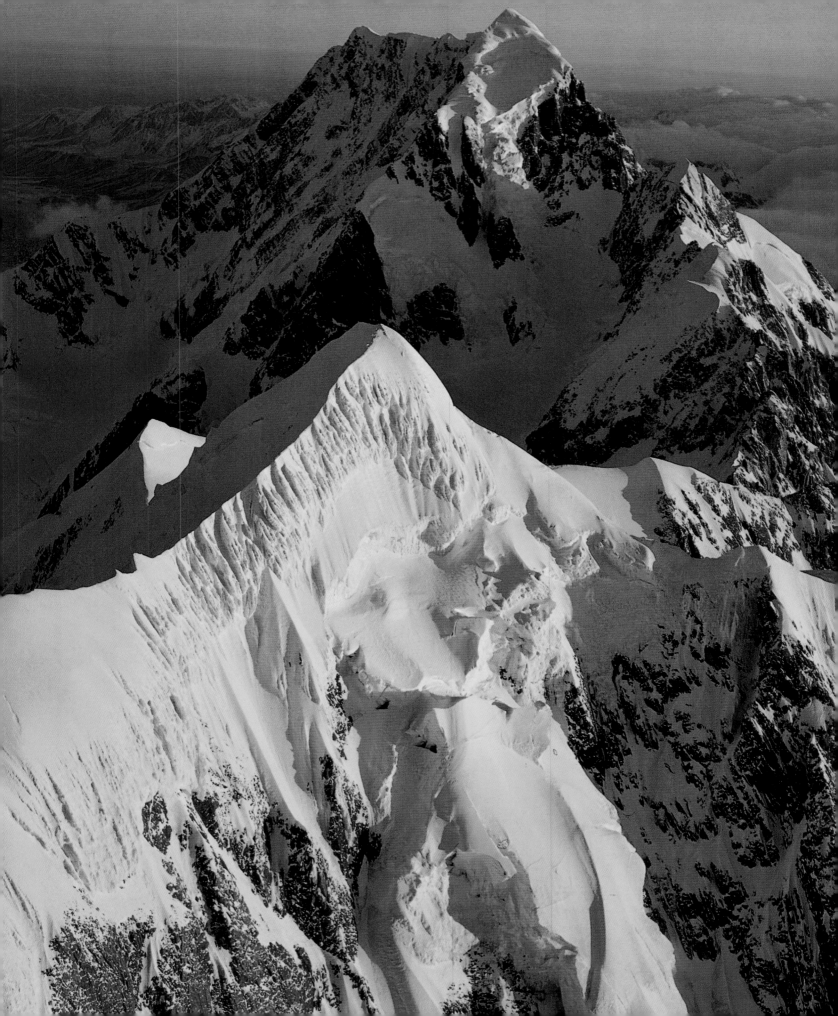

Blessed with bushland
and alpine peaks

30 *Autumn colors light up the poplar trees on the shore of Lake Wanaka in the Southern Lakes district of the South Island. Wanaka is an important center for outdoor recreation with good access to walking tracks, mountaineering, fishing, skiing and boating. Wanaka township is on the edge of Mount Aspiring National Park with its famous Routeburn Track.*

31 *North Canterbury's Waiau valley just north of Christchurch is a relaxing spot for a picnic or a walk in the surrounding forests to enjoy the autumn colors. Waiau's rolling hill country is ideal sheep and cattle country.*

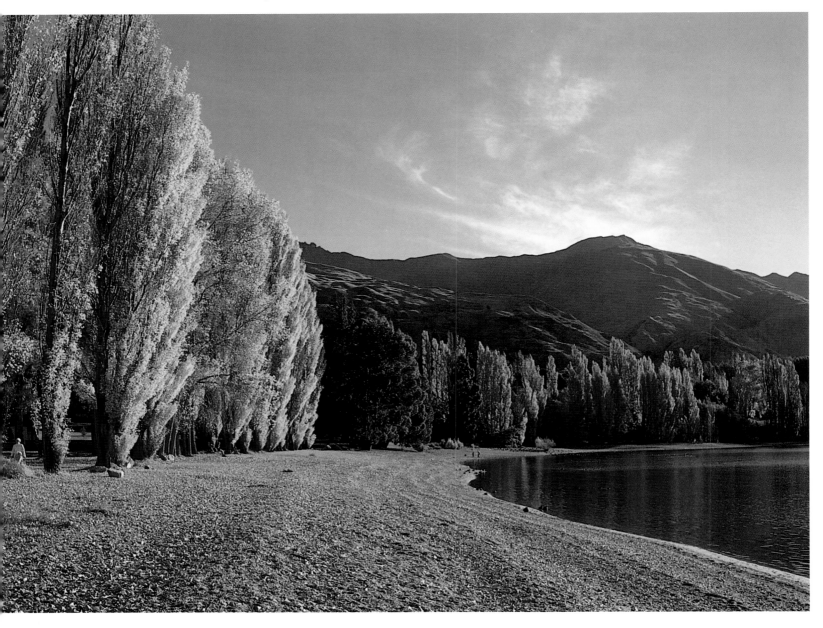

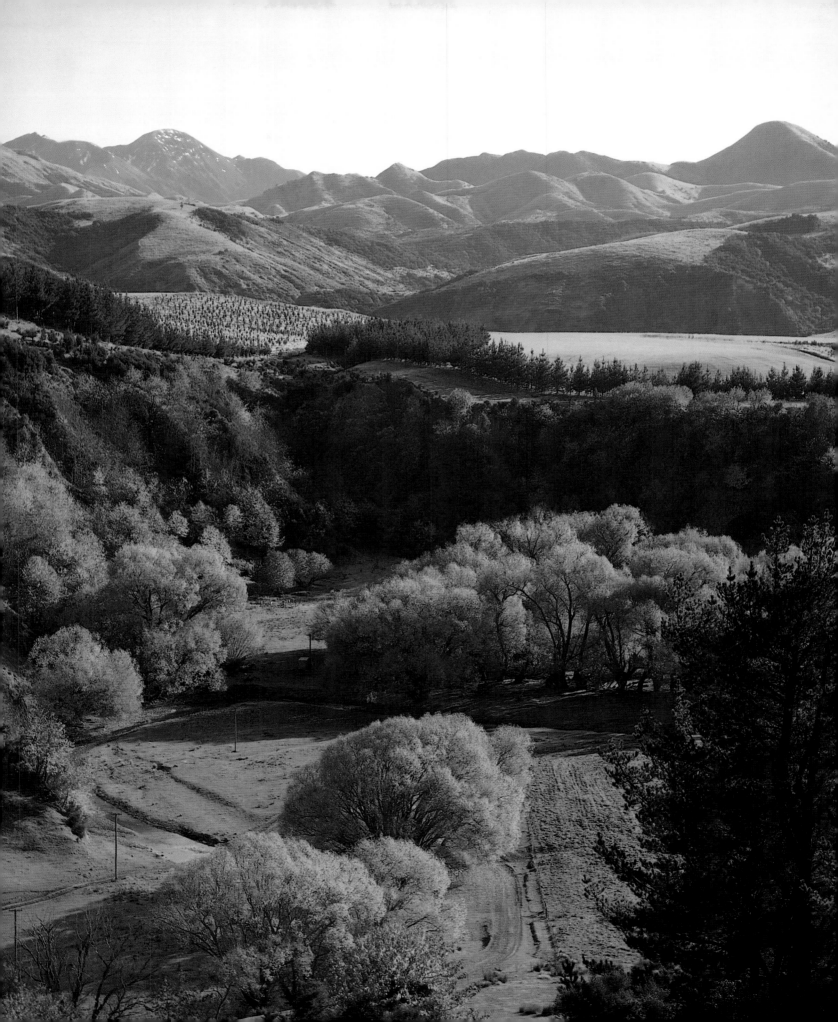

32-33 *The simple stone Church of the Good Shepherd is in harmony with its alpine surroundings, the Two Thumb Range. Perched on the shores of the turquoise Lake Tekapo, the church's stained-glass window affords a stunning view of the Southern Alps.*

34-35 *This aerial view of a Kiwi fruit orchard in Takaka's Golden Bay region in the provence of Nelson illustrates the intensive nature of modern agriculture in New Zealand. Kiwi fruit has become an internationally important crop in the last decade with many farmers in the north of the South Island and throughout the North Island planting orchards. The Golden Bay region is also a popular holiday spot and retreat for many skilled craft workers, notably potters.*

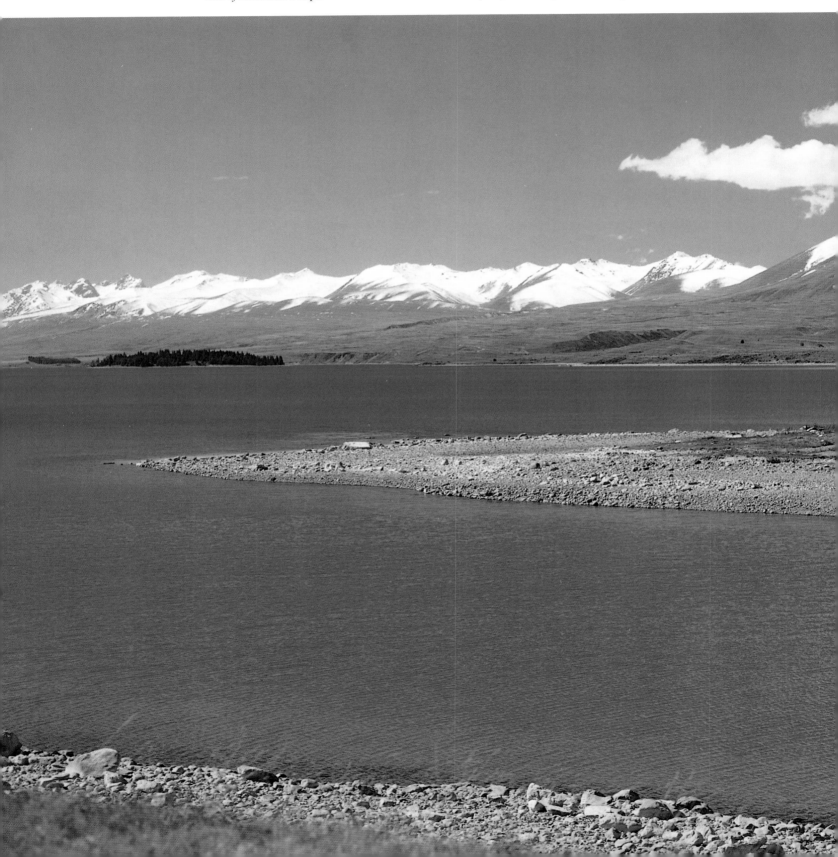

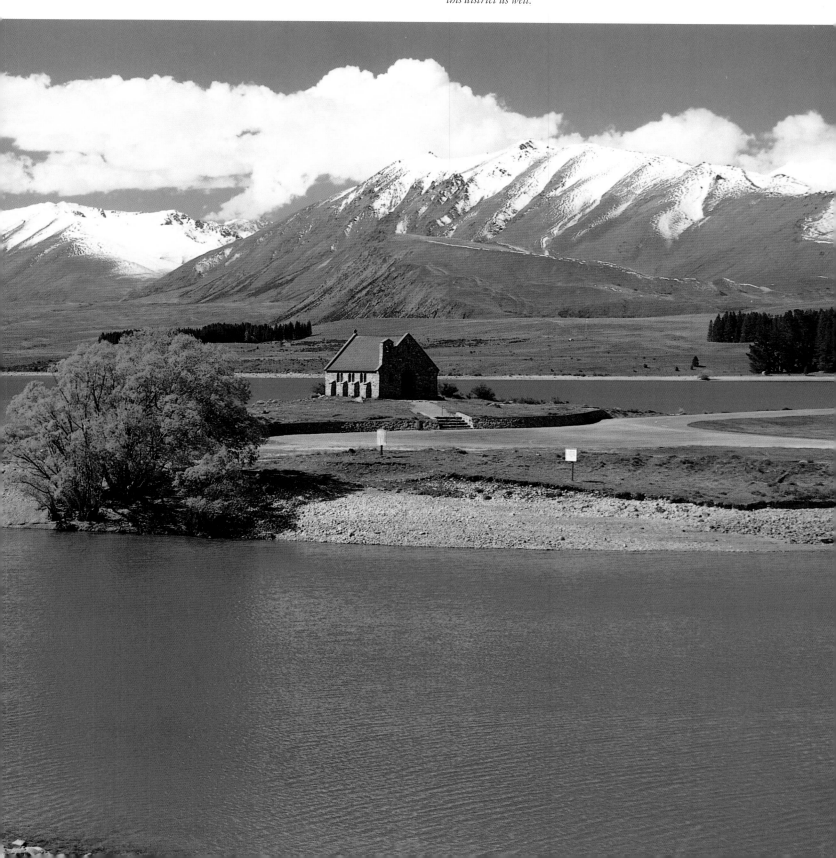

36-37 *An aerial view of the Canterbury Plains provides a graphic idea of the nature of the agriculture between the cities of Christchurch and Ashburton. Crops such as wheat, mustard, oats and barley thrive on the outwash plains fed by melt water from the Southern Alps. There are many quality sheep farms in this district as well.*

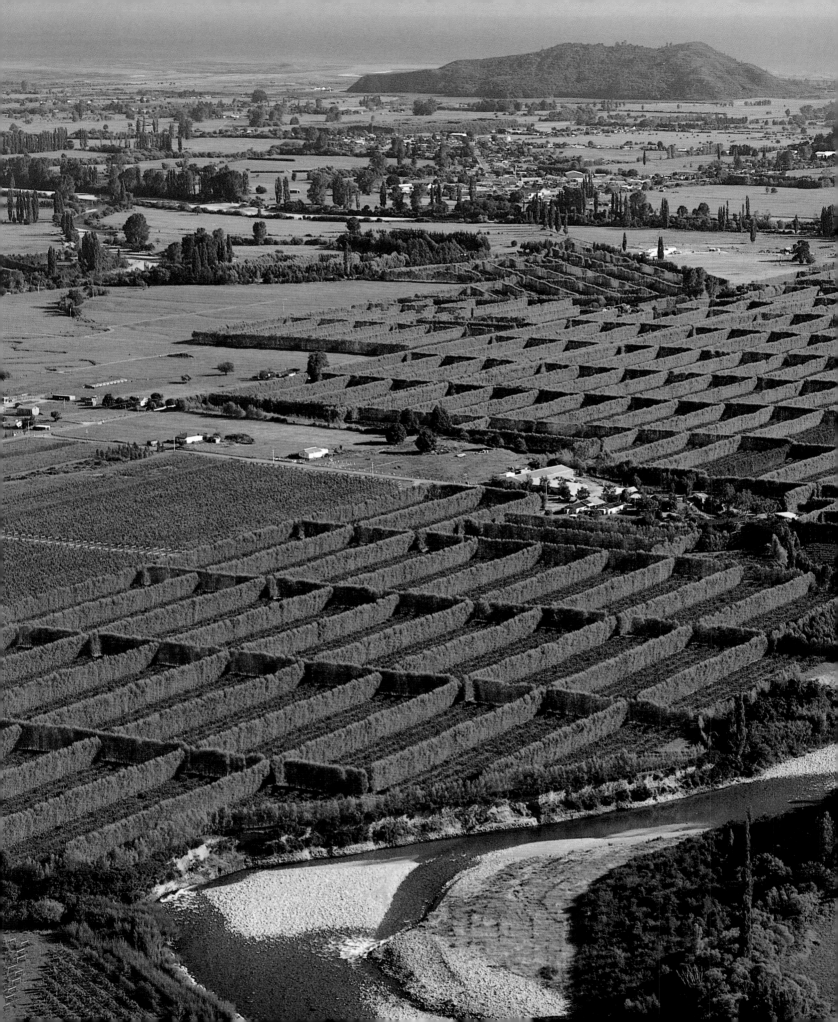

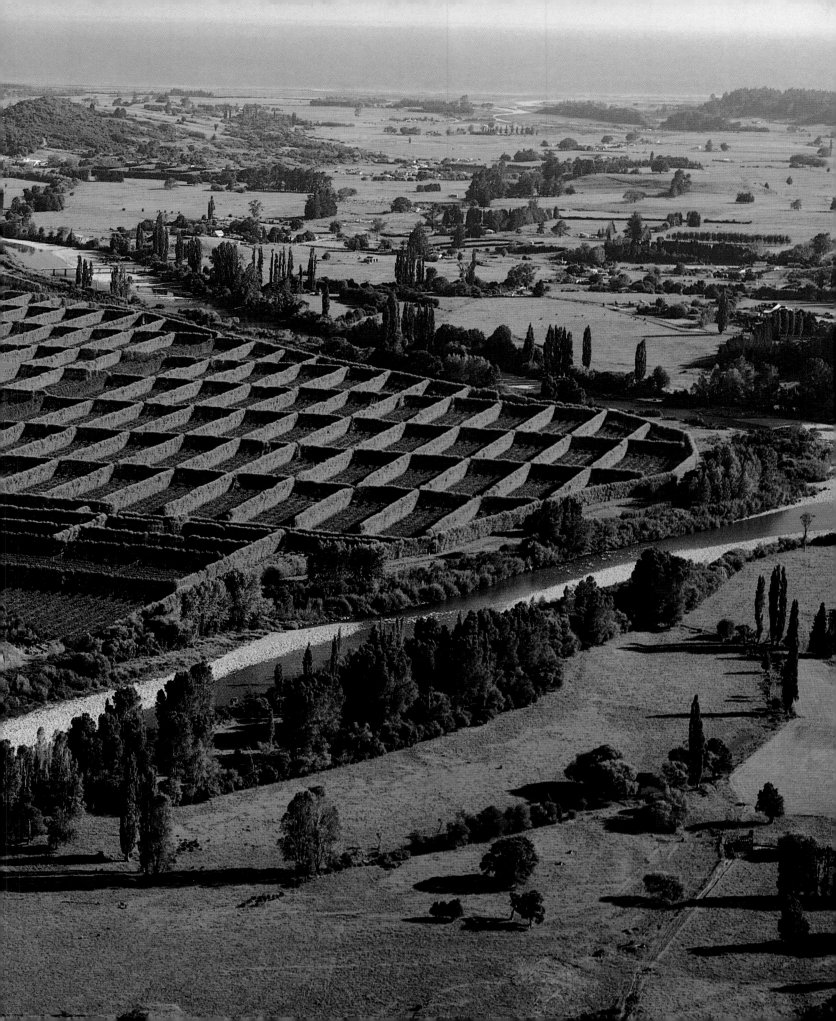

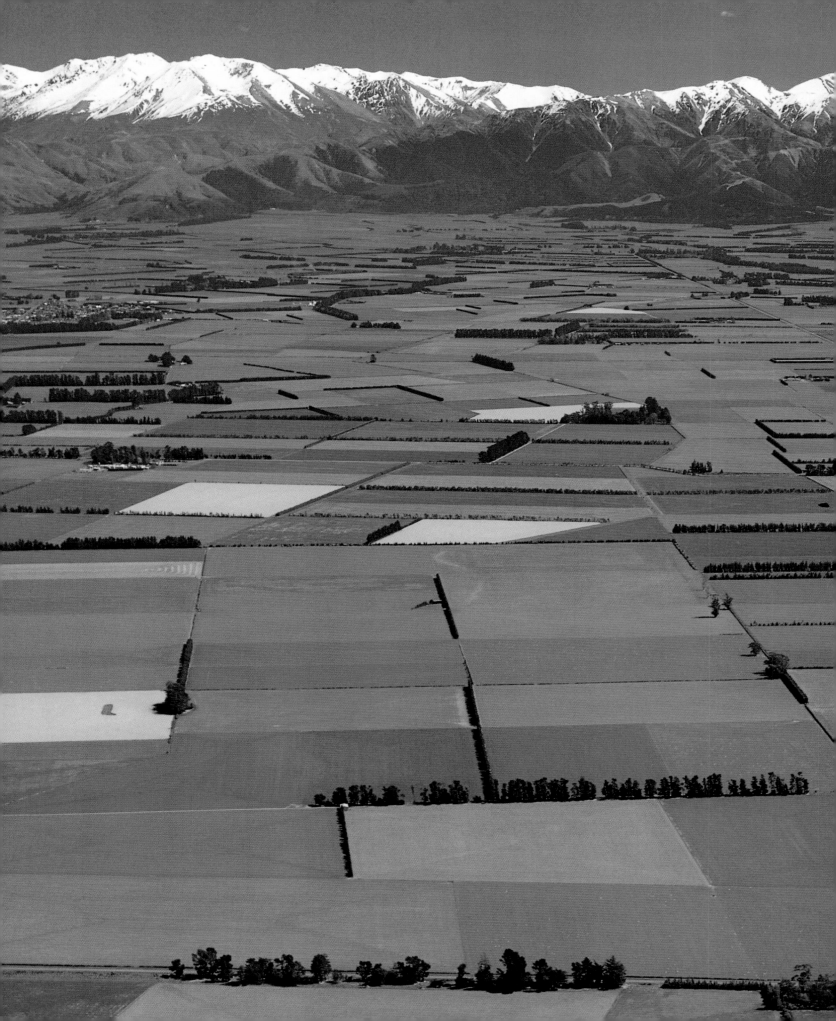

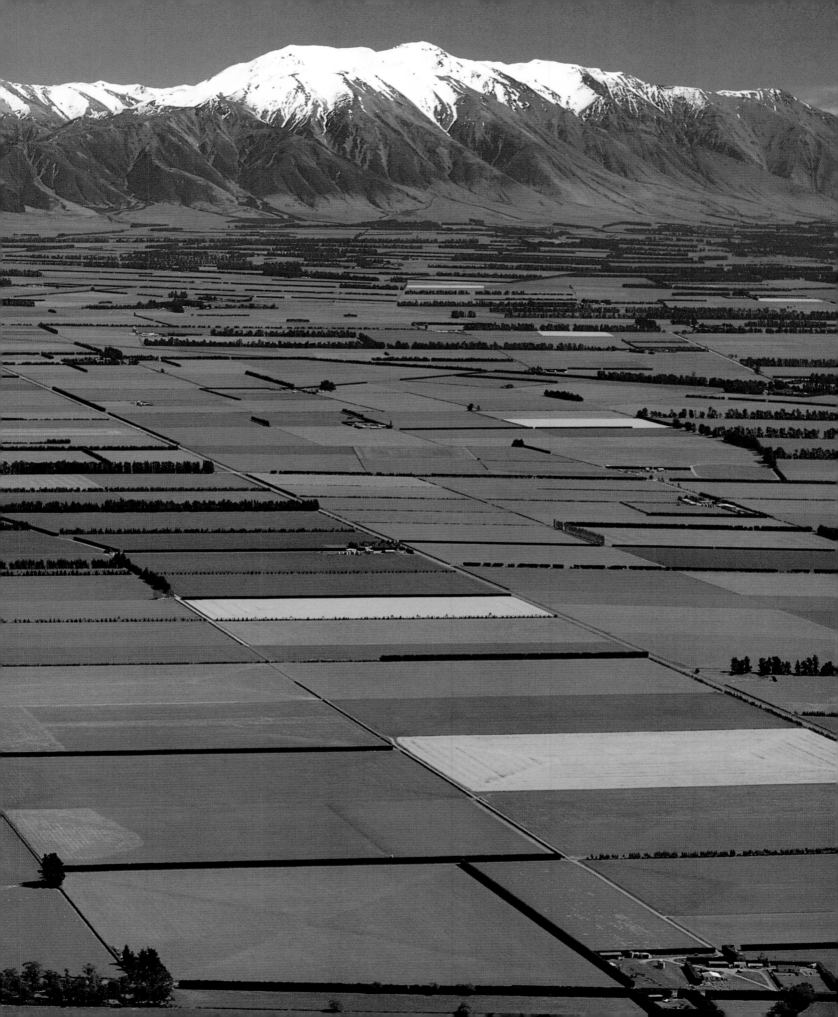

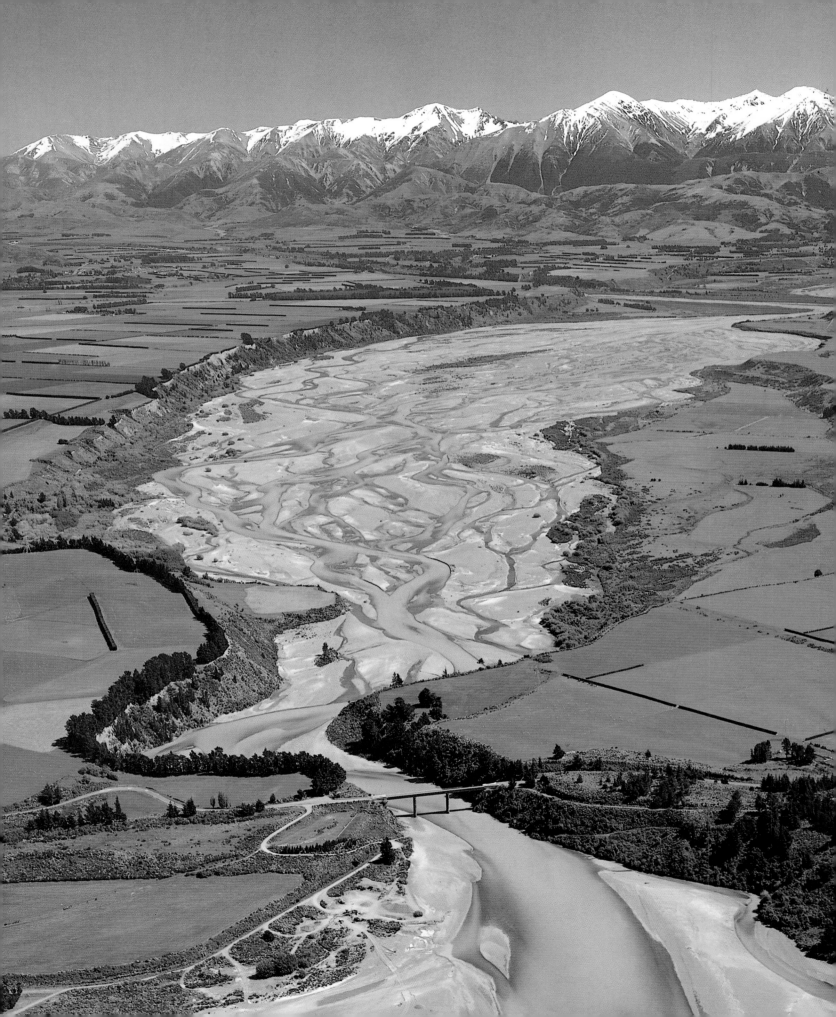

40-41 *The lush vegetation of Urewera National Park, on the North Island, offers an ideal habitat for cuckoos, tui kakas, and pigeons. The expanse of lakes and woodlands extends over a territory of fifty thousand acres, to the northeast of Hawke Bay and to the west of Poverty Bay.*

42-43 *Glenorchy township, tucked away at the head of Lake Wakatipu and only an hour's drive from Queenstown, is one of the most perfect weekend retreats in the South Island. It is the base for walking tracks into the Mount Aspiring National Park such as the Rees-Dart and Routeburn. Fishing, boating and horseriding are also popular with visitors to local hotels on the lake foreshore. Autumn is definitely one of the best times to visit with crisp mornings, warm windless days and lovely colors in the trees.*

38 *The meandering Waimakariri River flows out of Canterbury's Torlesse Range just north of Christchurch. Canterbury rivers are popular trout fishing spots. The braided channels are also a mecca for jet-boating enthusiasts who race their craft over the shallow though fast-flowing water at high speed. New Zealand engineers invented the jet boat, a craft which has now been exported all over the world.*

39 *Banks Peninsula is Christchurch's best-kept secret. Ancient volcanic rims and sunken calderas provide both rugged hilltops and safe secluded harbors. The tranquillity of Bank's Peninsula enchants all who visit. Sleepy little towns such as Akaroa with its early French influence make the peninsula a popular weekend retreat for Christchurch city dwellers.*

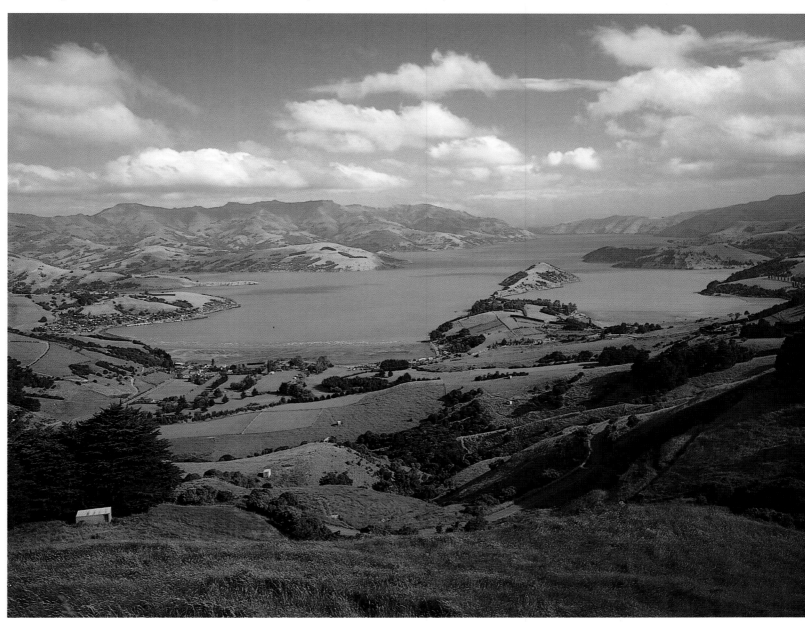

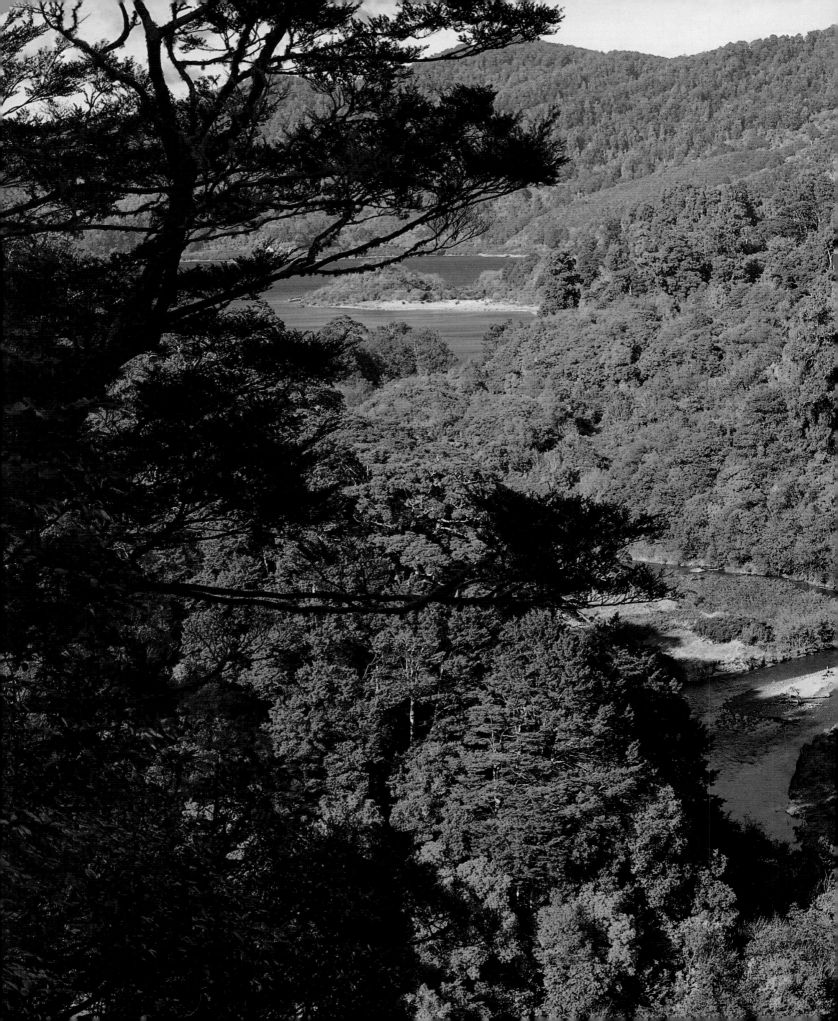

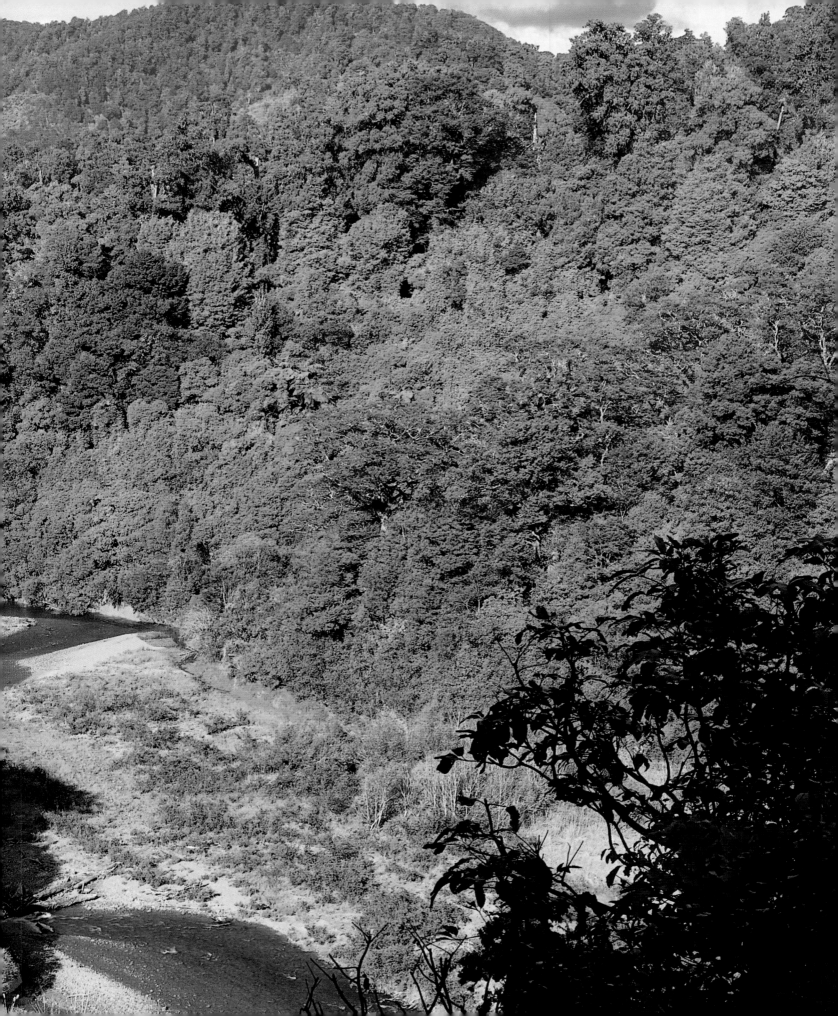

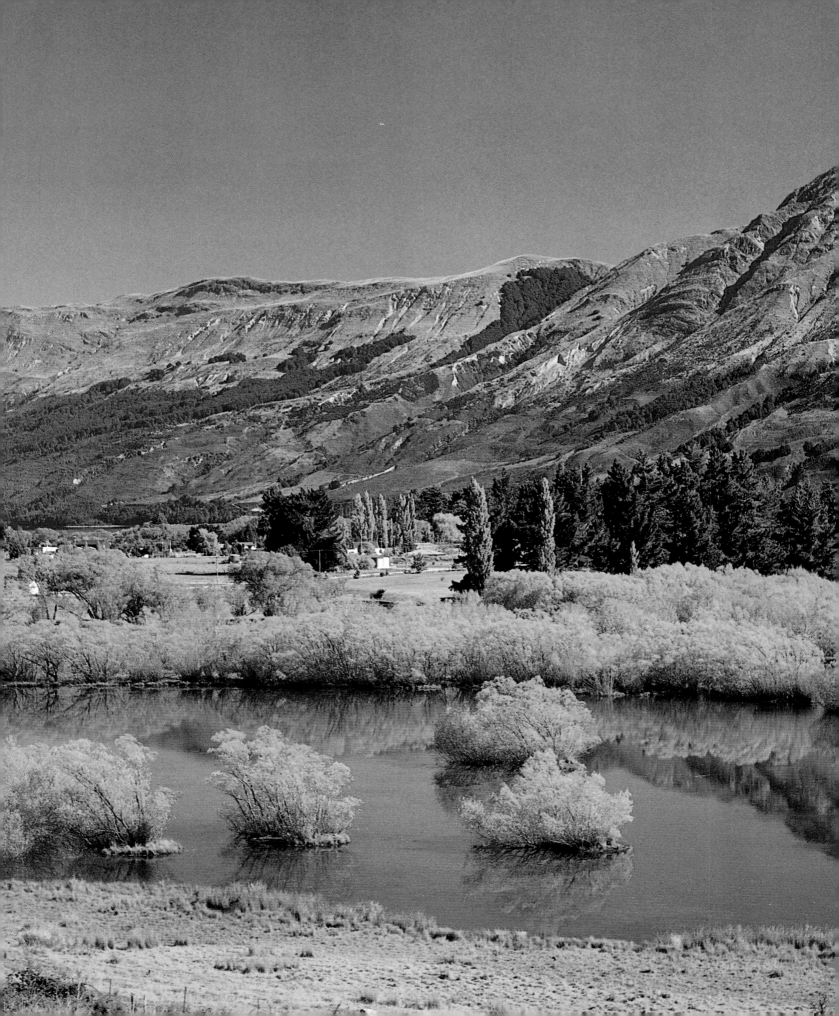

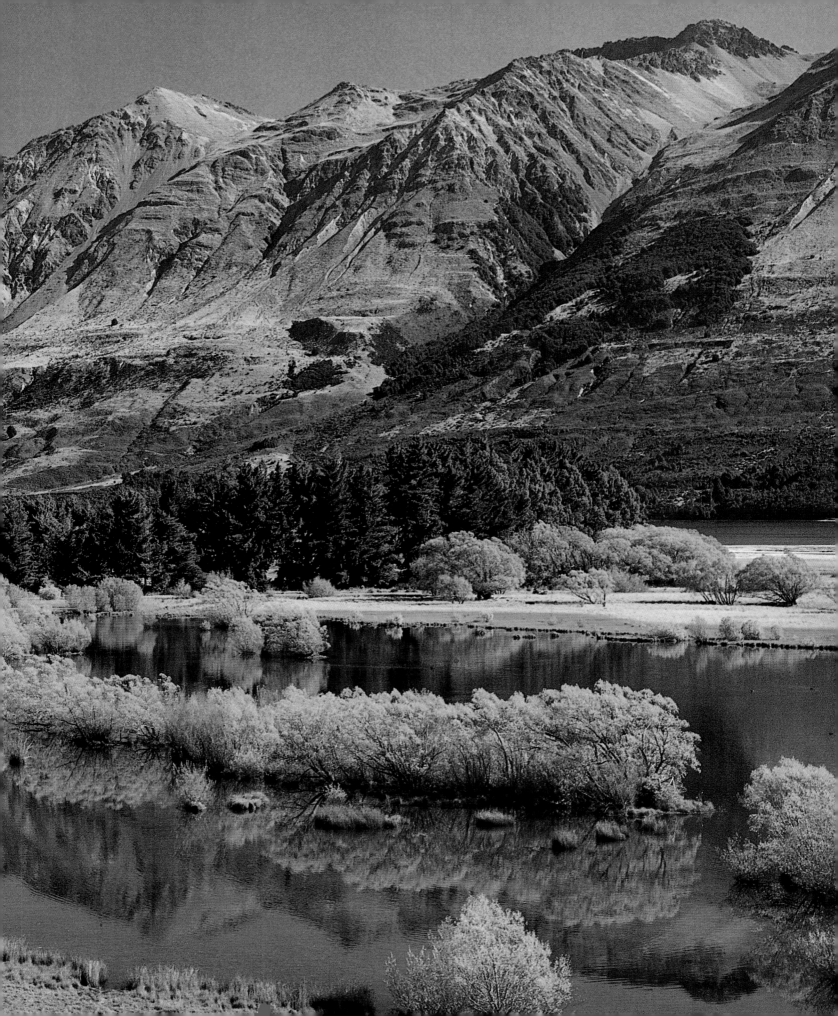

44 Manuska *is a small sailing craft which can be chartered from the township of Te Anau to visit many of the remote trekking and fishing havens on Lake Manapouri in Fiordland National Park. Te Anau is the base for trekkers commencing the famous Milford Track which connects Lake Manapouri with Milford Sound through some of the most spectacular alpine and forest scenery anywhere.*

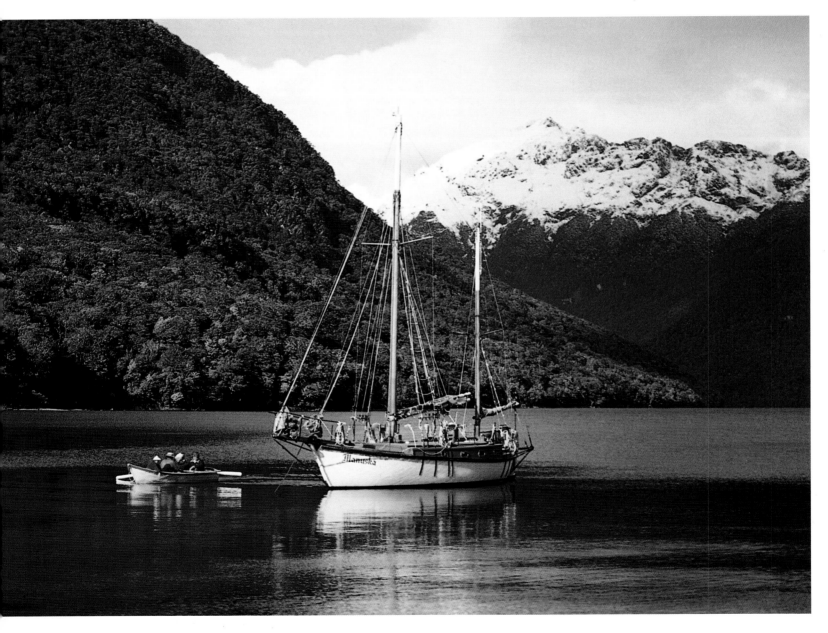

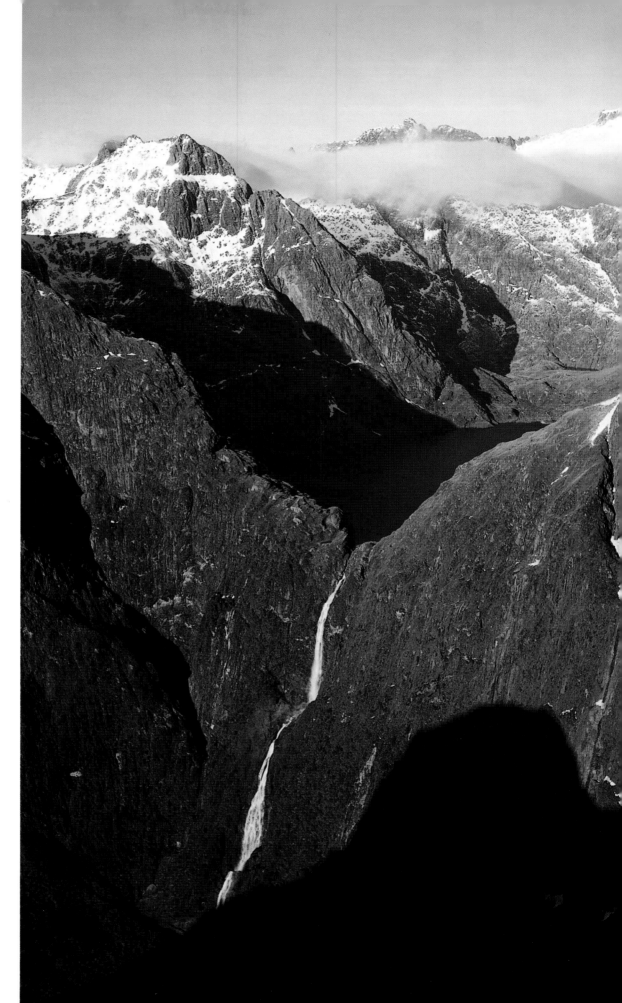

45 *Tucked high among the peaks of rugged Fiordland National Park, Lake Quill overhangs densely vegetated valleys of the Milford Track. Sutherland Falls drop 1870 feet into Staircase Creek. Carved by ancient glaciers the U-shaped valley walls of Fiordland are quite remarkable. Sudden torrential rainfall is a feature of Fiordland which creates hundreds of spectacular waterfalls on the steep vegetated granite walls. Fiordland National Park is an important cornerstone of the South Westland World Heritage region.*

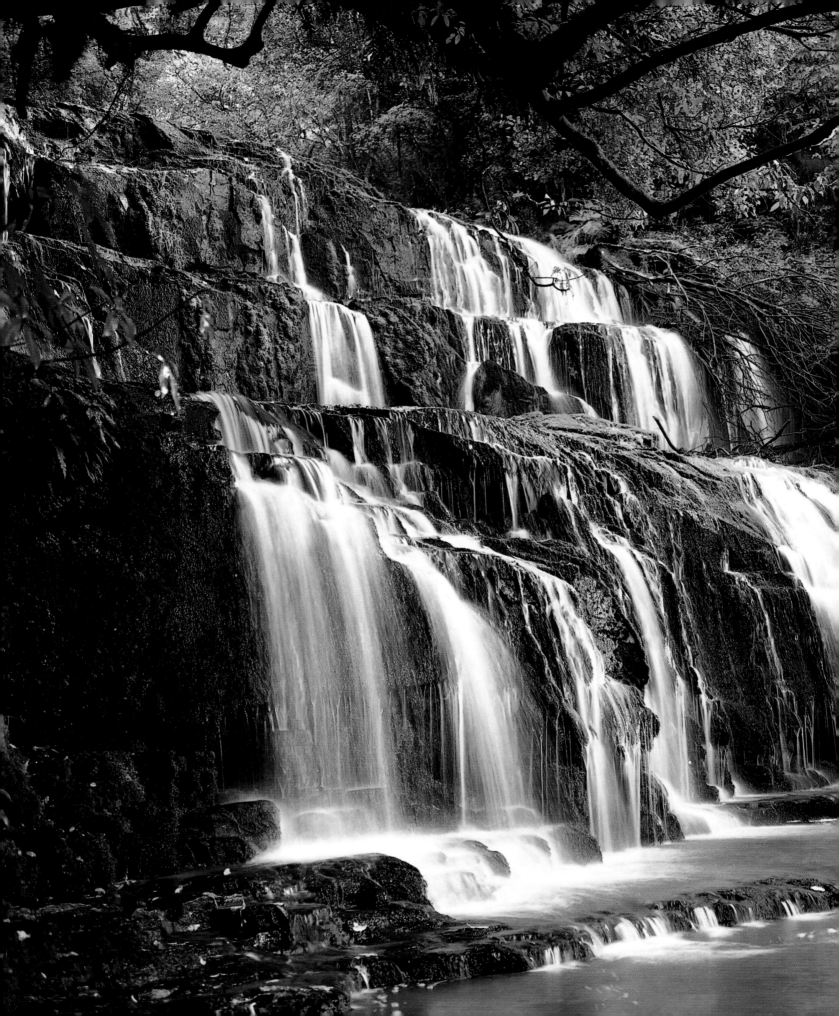

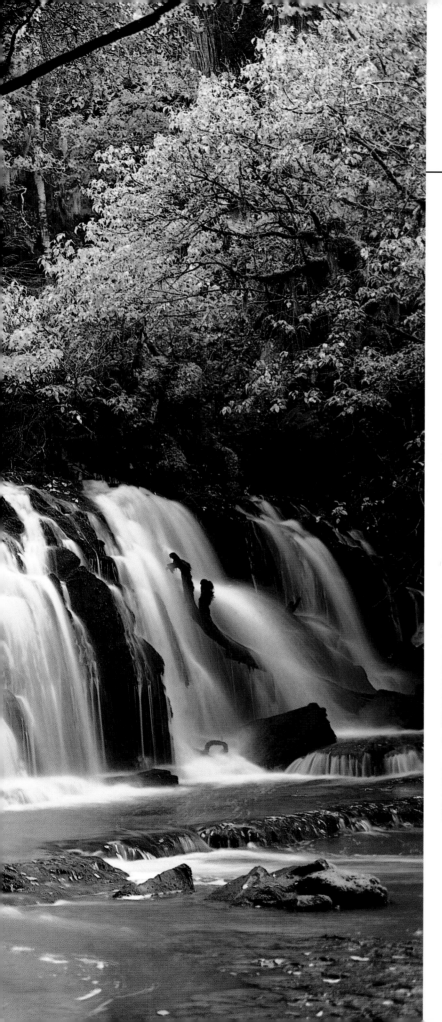

Forests, fronds and falls

46-47 *Purakanui Falls is one of many lovely waterfalls in the Catlins district of southern Otago. The Catlins not only provide really delightful forest walks but allow visitors to experience remote beaches on the South Island's south-east coast, the home of fur seals and yellow-eyed penguins.*

47 *The rain forest of Waipoua extends over an area of six thousand acres, and is one of the largest kauri pine forests in all of New Zealand.*

48-49 *South Westland's unique "World Heritage" region runs down most of the western side of the South Island. Pristine rainforest with tall tree ferns and tangled undergrowth is sandwiched between wild beaches and alpine peaks.*

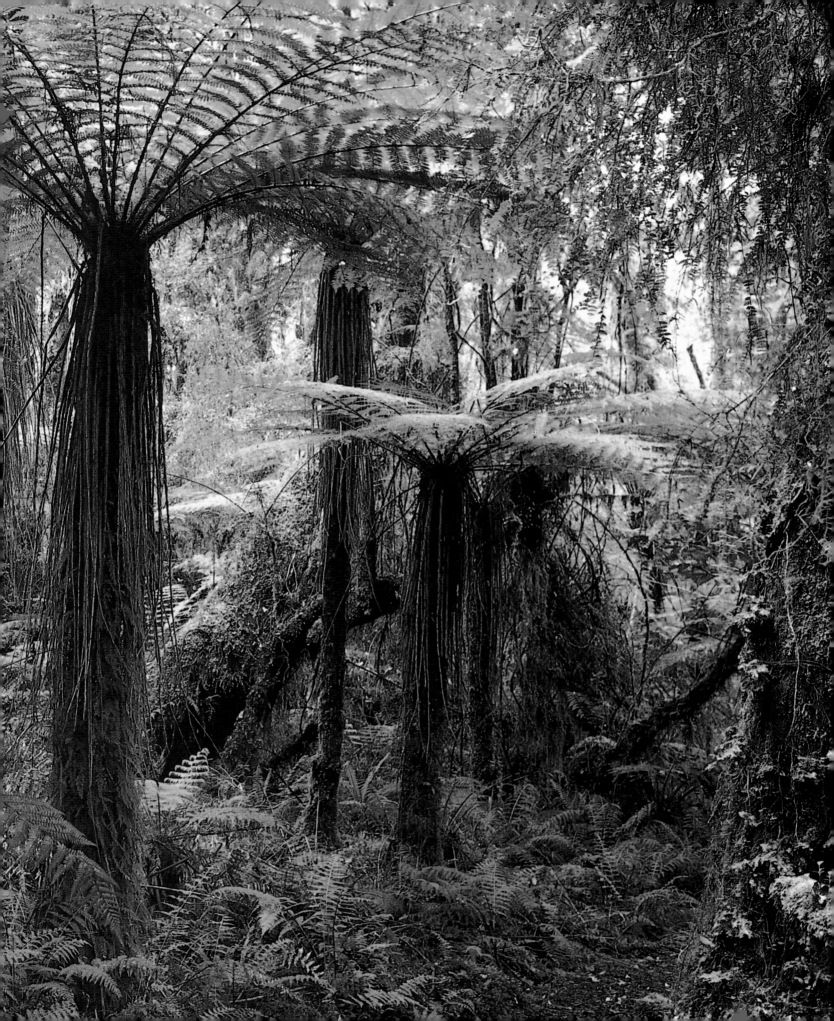

Lakes, fiords and bush-clad coasts

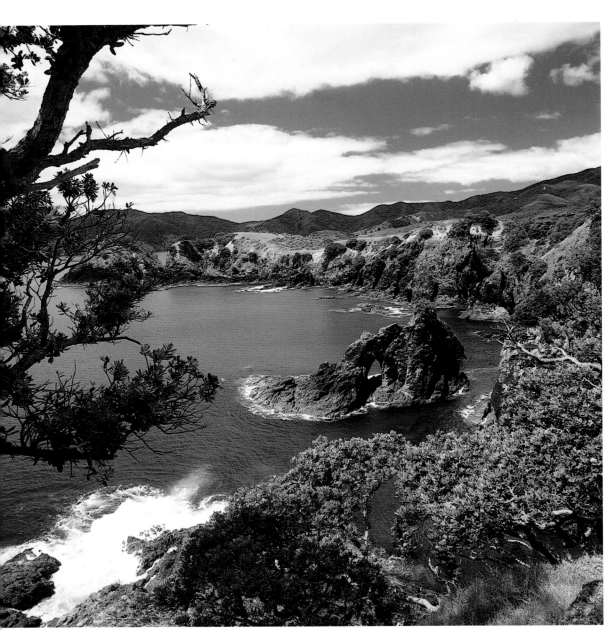

50 *Window Rock at Rawhiti Point is typical of the rugged coastline around parts of the North Island's Bay of Islands. The 500-mile bush-clad coastline embraces 150 islands which impressed Captain Cook when he first sailed into the sheltered waters in 1769.*

51 *This aerial view of Russell in the Bay of Islands is typical of the small townships in Northland which attract many visitors keen on boating and water sports in the summer months from December to March.*

52-53 *The port of Picton on the northern tip of the South Island is the hub for rail and road transport meeting the ferries bound for Wellington, three hours away across Cook Strait.*
This aerial view gives a good impression of Picton's location on the edge of Queen Charlotte Sound. The Marlborough Sounds is a boating and fishing paradise for the many New Zealanders who have private holiday cottages or "batches" tucked away in the forest. Water taxis and float planes take visitors to the many beautiful lodges now developed in the region. The Queen Charlotte Walkway is becoming more popular with trekkers keen on an easy trail through tree fern forests with view down to beautiful waterways.

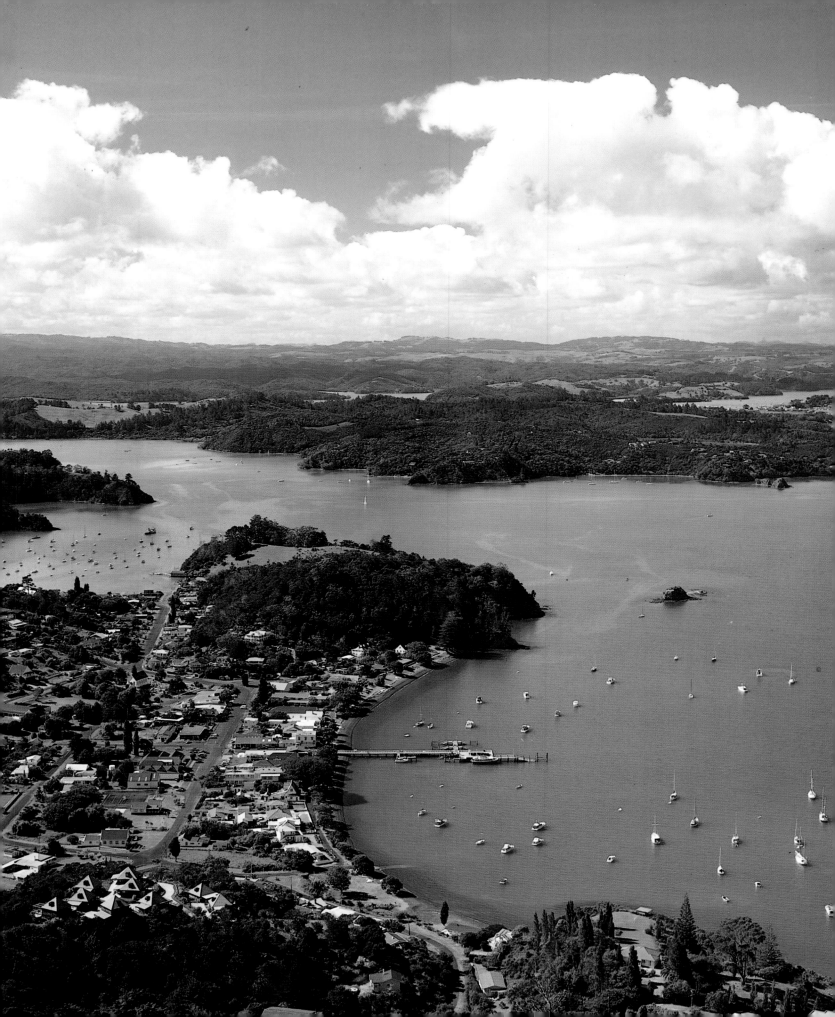

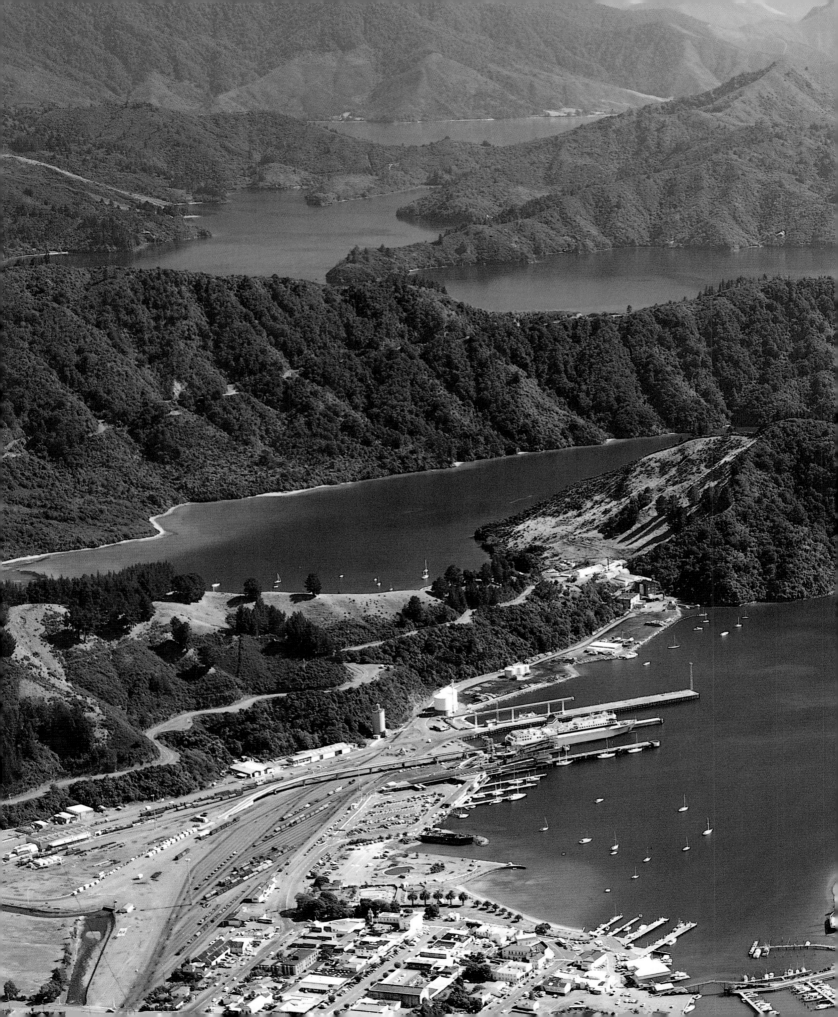

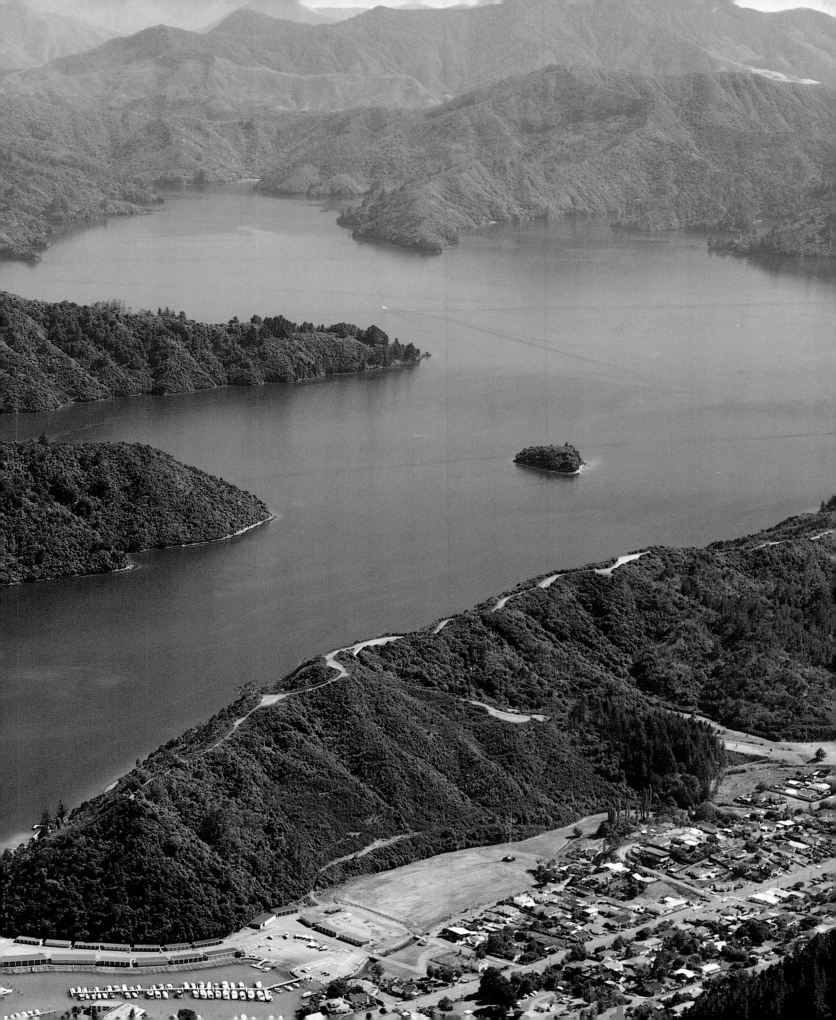

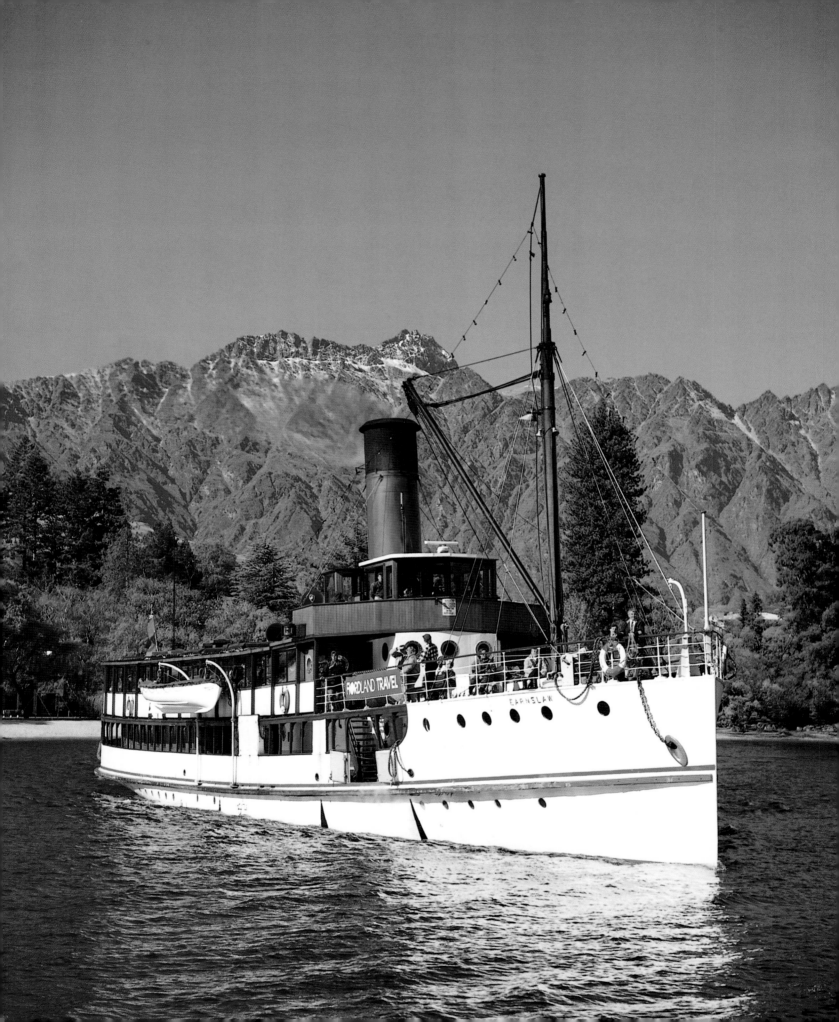

54 *The old steamboat* Earnslaw *with its polished brass and nuggety wooden fittings has been used on Lake Wakatipu since the 1920s. Initially used to service remote sheep stations further up the lake from Queenstown the* Earnslaw *is now used for tourist cruises on the lake. Passengers can get off at sheep stations to enjoy a cup of tea and scones with fresh cream and jam as well as to watch sheep being hand shorn.*

55 *Milford Sound is rightly famous all over the world for its superb boating excursions out past Mitre Peak and down heavily vegetated fiords to the edge of the Tasman Sea. Dolphins often frolic in the bow wave of the launches. The vessels thrill passengers by going underneath some of the many spectacular waterfalls which cascade down the granite rock faces.*

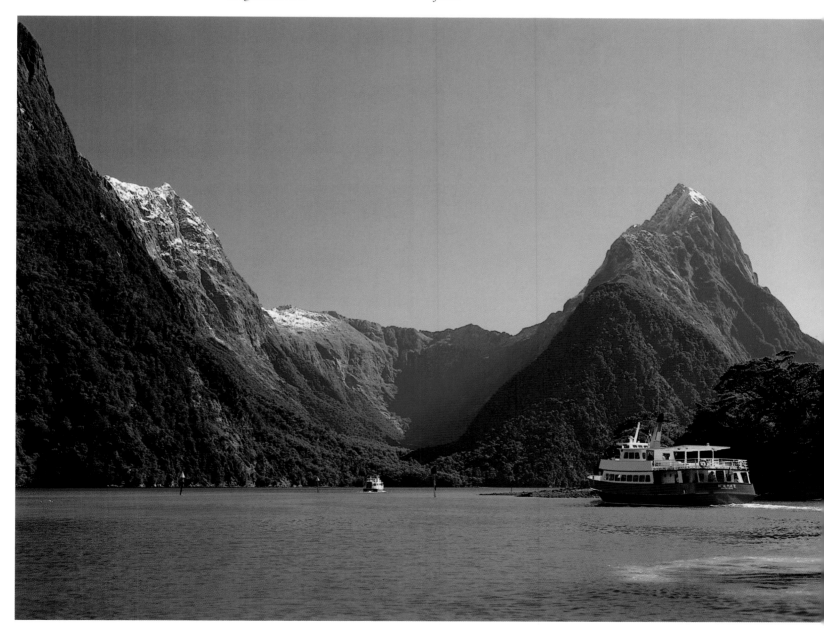

56 left *Cape Kidnapper's in Hawke Bay, near the North Island cities of Hastings and Napier, is a popular spot for those who wish to observe a gannet colony at close quarters.*

56 right *This aerial view of the Kaikoura Peninsula illustrates that even on the east coast of the South Island the mountains come down almost into the sea. Kaikoura is a small fishing port but is a focal point for breeding seals, sperm whales and dolphins.*

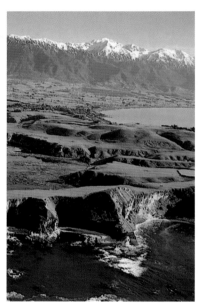

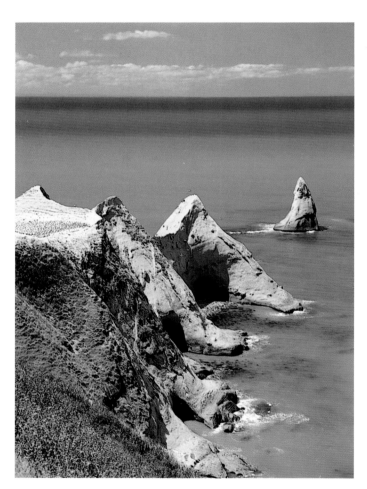

56-57 *Stewart Island is the third major island of New Zealand and it lies only a few miles south of the South Island across Foveaux Strait. With only a dozen miles of road on the whole island visitors explore the forests and bays on foot or by launch. Stewart Island forests are one of the best places to see the unique Kiwi, New Zealand's famous flightless bird. In many places the bush comes right down among the boulders on the beach allowing the visitor the experience the feeling of exploring while fossicking along the coast. Fishing, lobster, mussel and and salmon farming are the main industries on Stewart Island.*

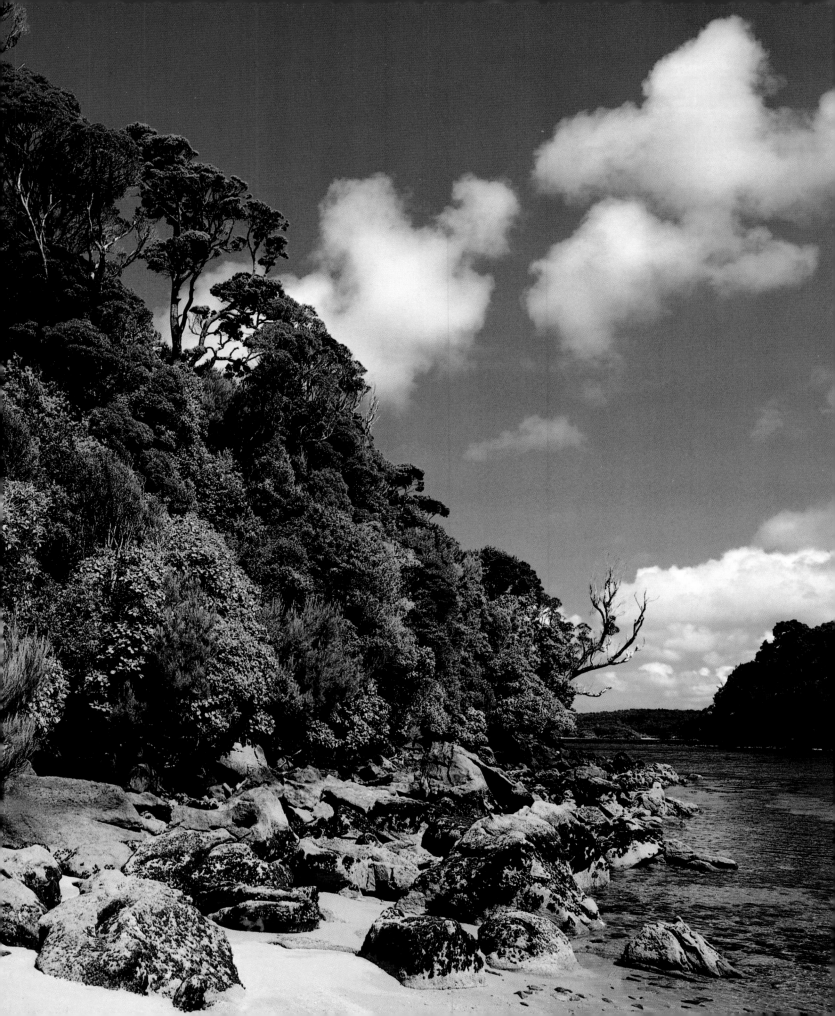

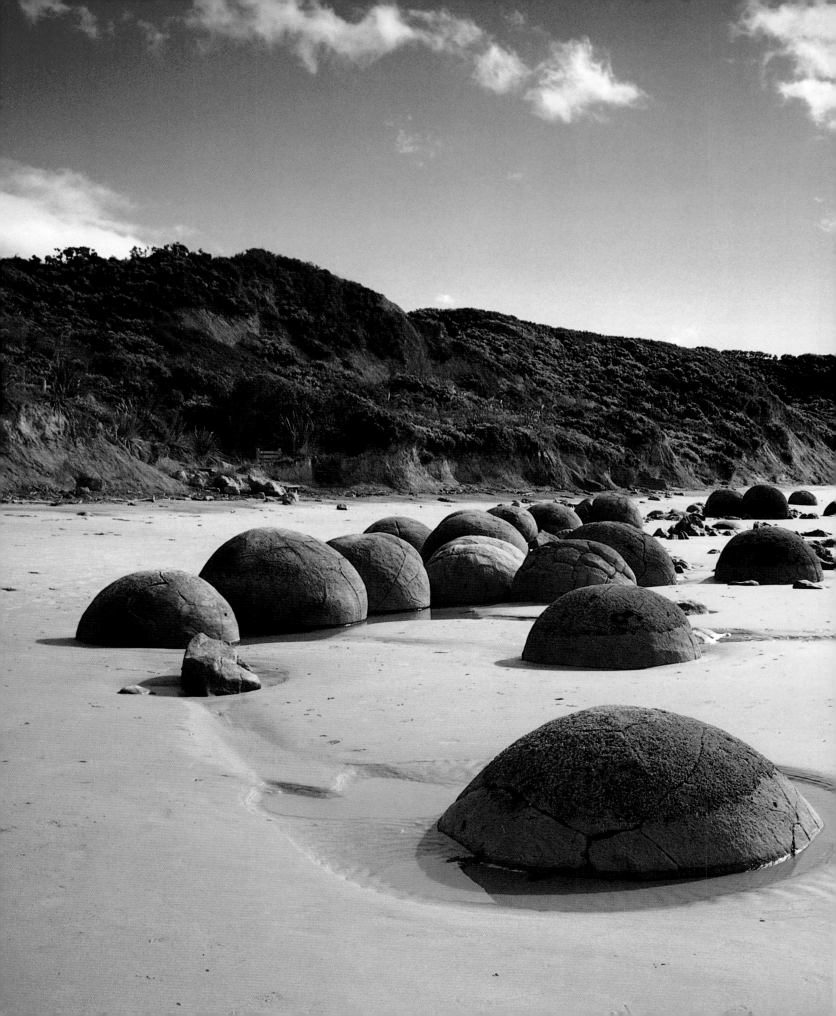

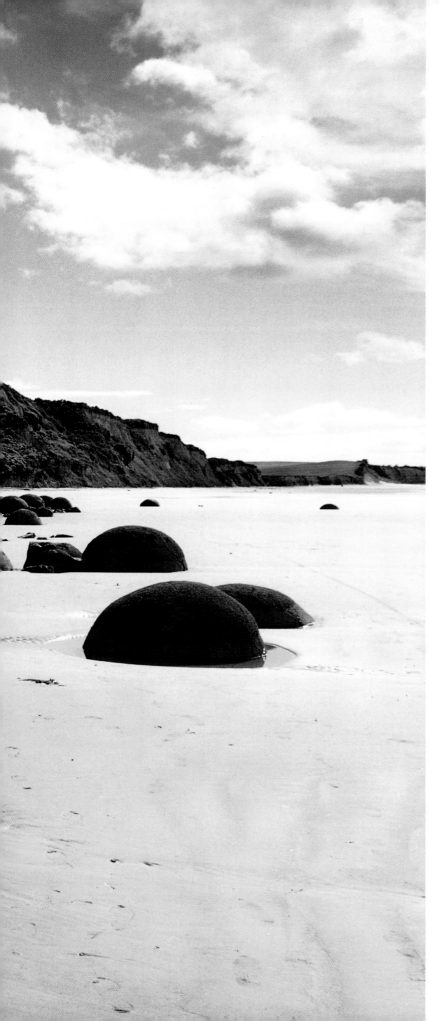

58-59 *The moon-shaped Moeraki boulders emerge each day as the tide recedes on the south-east coast near Dunedin. Formed 60 million years ago the spherical boulders are formed by lime salts gradually solidifying around a small center. Maori legend prefers to consider them the food baskets from a ship-wrecked canoe.*

59 *The layer-cake limestone rocks at Punakaiki on the West Coast north of Greymouth have been eroded in such a way that spectacular blowholes send incoming waves high into the air. It is really exciting to visit these "pancake" rocks when there is a storm out in the Tasman Sea.*

60-61 *Mitre Peak is perhaps the most famous mountain in Fiordland National Park. Its shape, together with the mirror-calm waters of Milford Sound, has become as well-known a symbol of*

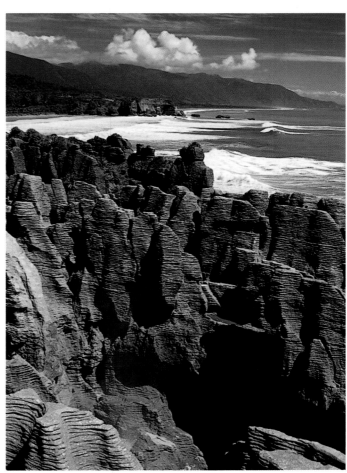

New Zealand as the Kiwi. This view is taken from the lawn in front of the Milford Hotel, the base for all launch trips and scenic flights in the region.

62-63 *Nugget Point lighthouse on the Catlin's Coast south of Dunedin is one of the first places in New Zealand to witness the sunrise over the Pacific Ocean. Fur seals and yellow-eyed penguins inhabit the rocky beaches around the lighthouse.*

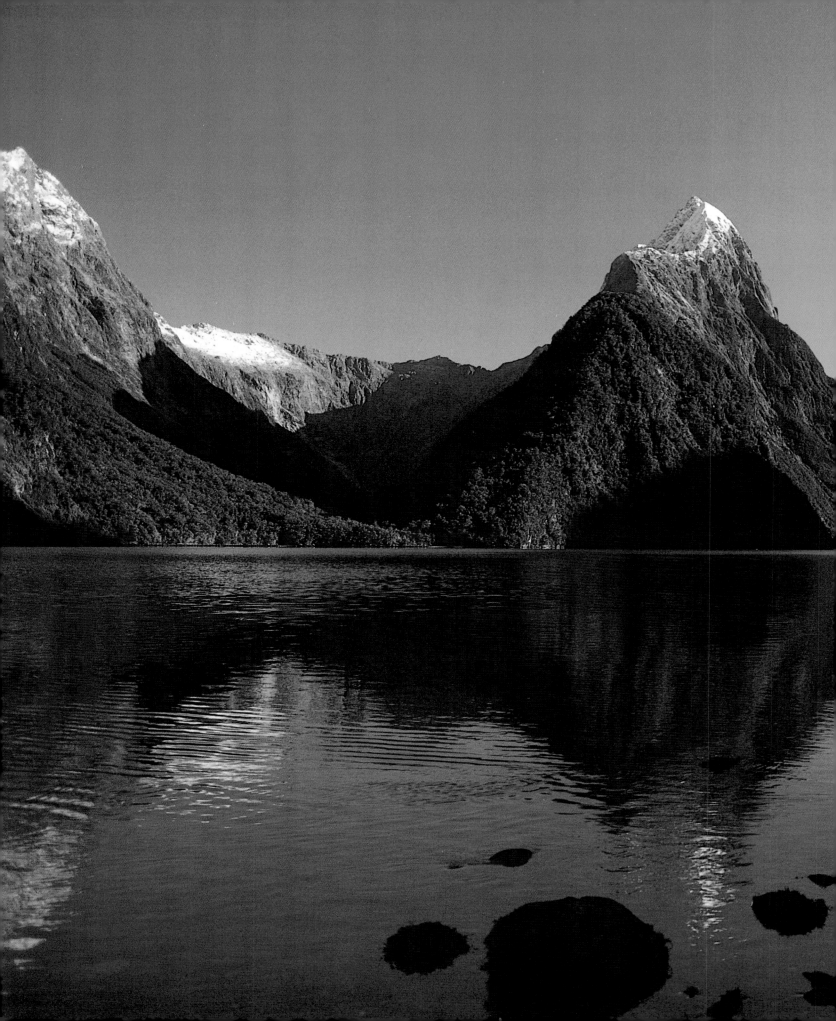

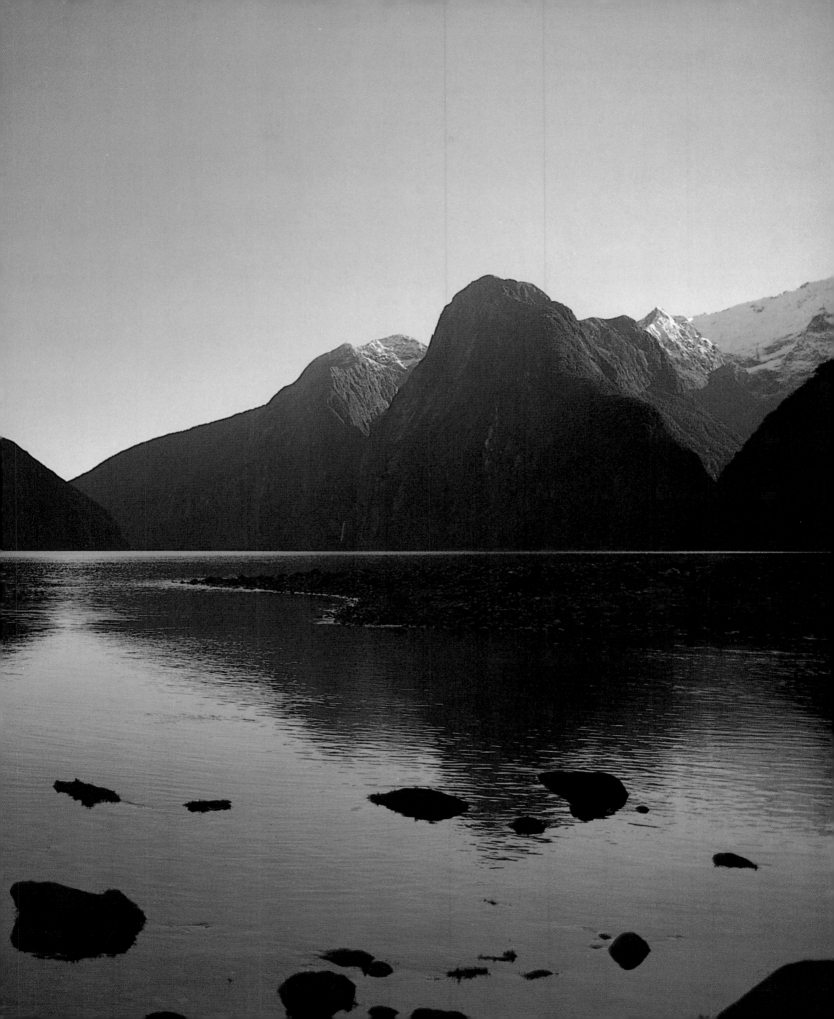

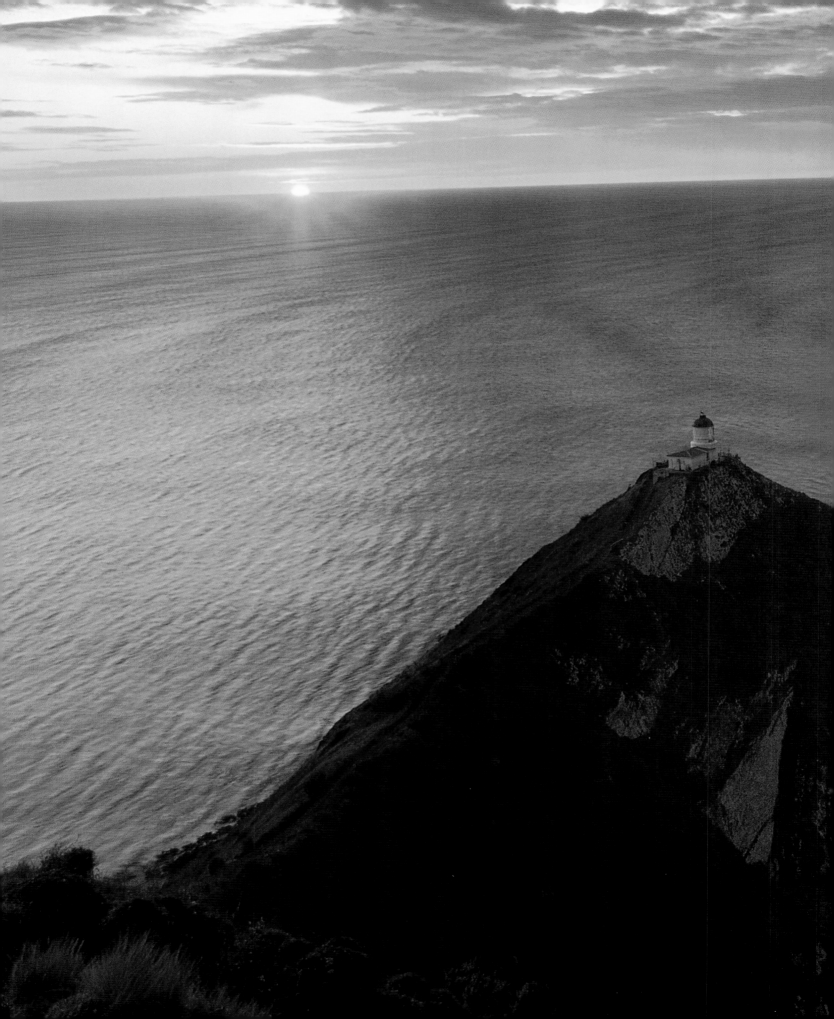

The icy heart of the South Island

64 *Sunset from the summit of Magellan Peak in Westland National Park lights up the short steep glaciers which curl down into the West Coast forested valleys. The Southern Alps run the complete length of the South Island and in places are no more than 12.5 miles from the beaches on the fringe of the Tasman Sea. A massive alpine fault runs through the alps with associated hot springs providing a welcome bath for weary climbers and trekkers.*

65 *Evening light illuminates the western side of Aoraki (Mount Cook) and some of the lower peaks of the Balfour and La Perouse glaciers of Westland National Park.*
New Zealand is a skier's and climber's paradise particularly as most of the national parks are empty during winter months.

66-67 *Sunset on Mount Cook (foreground) and Mount Tasman (left), the two highest summits in New Zealand. A blanket of cloud in the distance covers the West Coast forests and the Tasman Sea. On Christmas Day 1894 a small party of New Zealanders made the first ascent of Aoraki by climbing the north ridge (left hand rocky skyline) then up the summit icecap.*

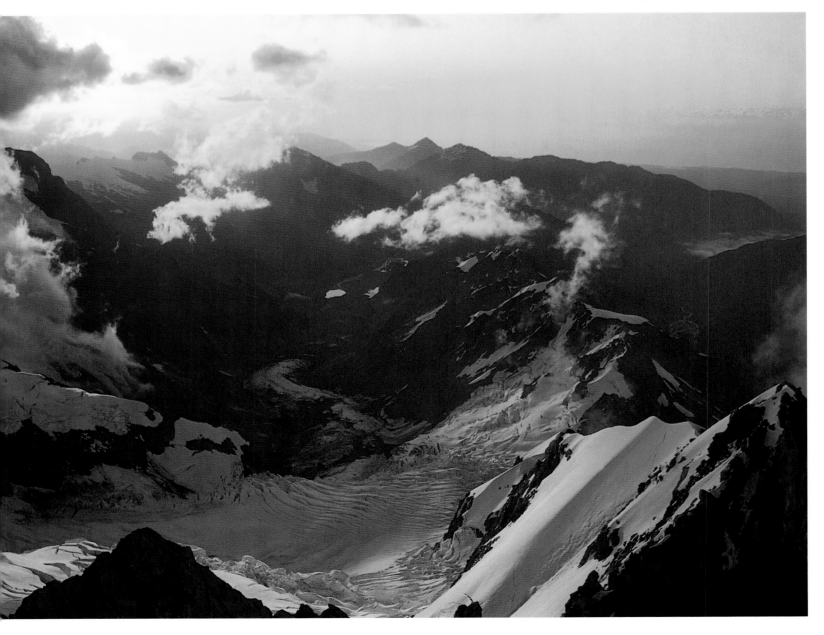

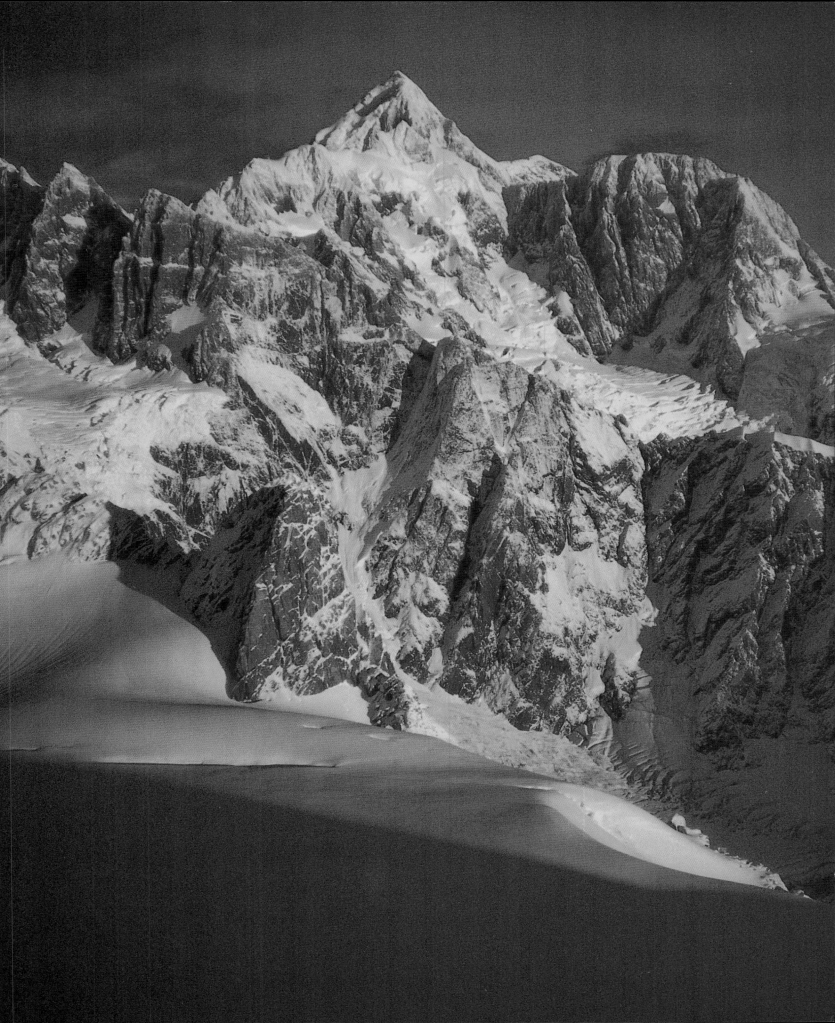

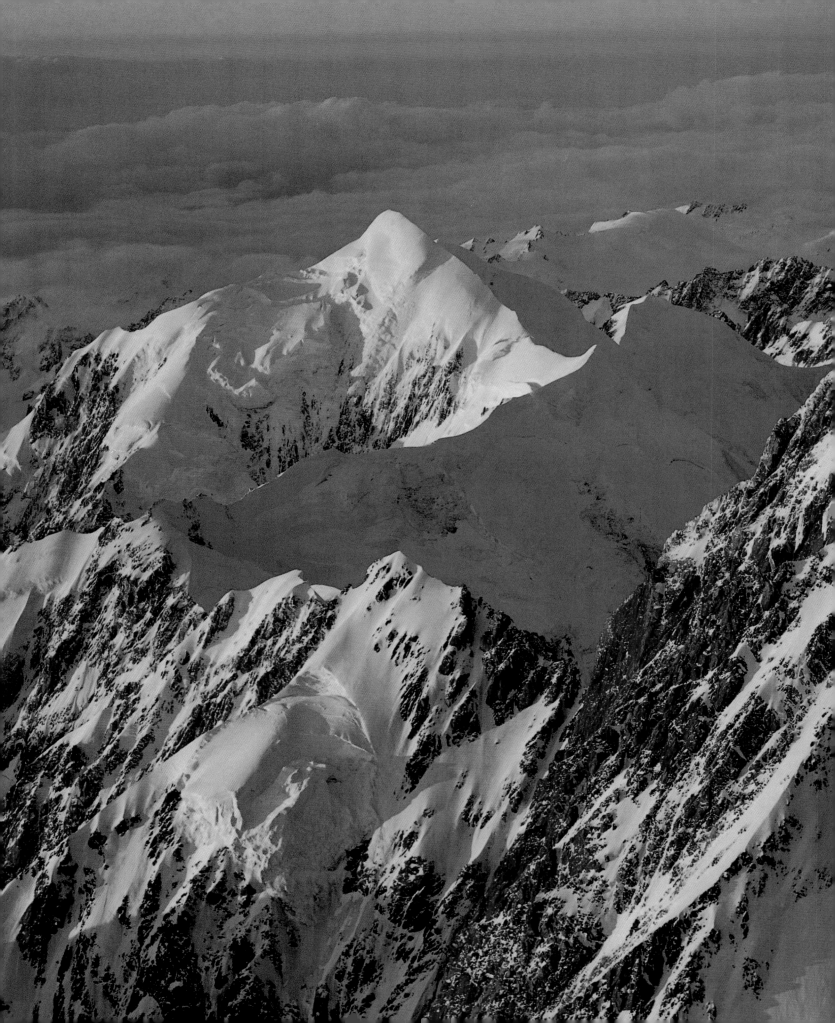

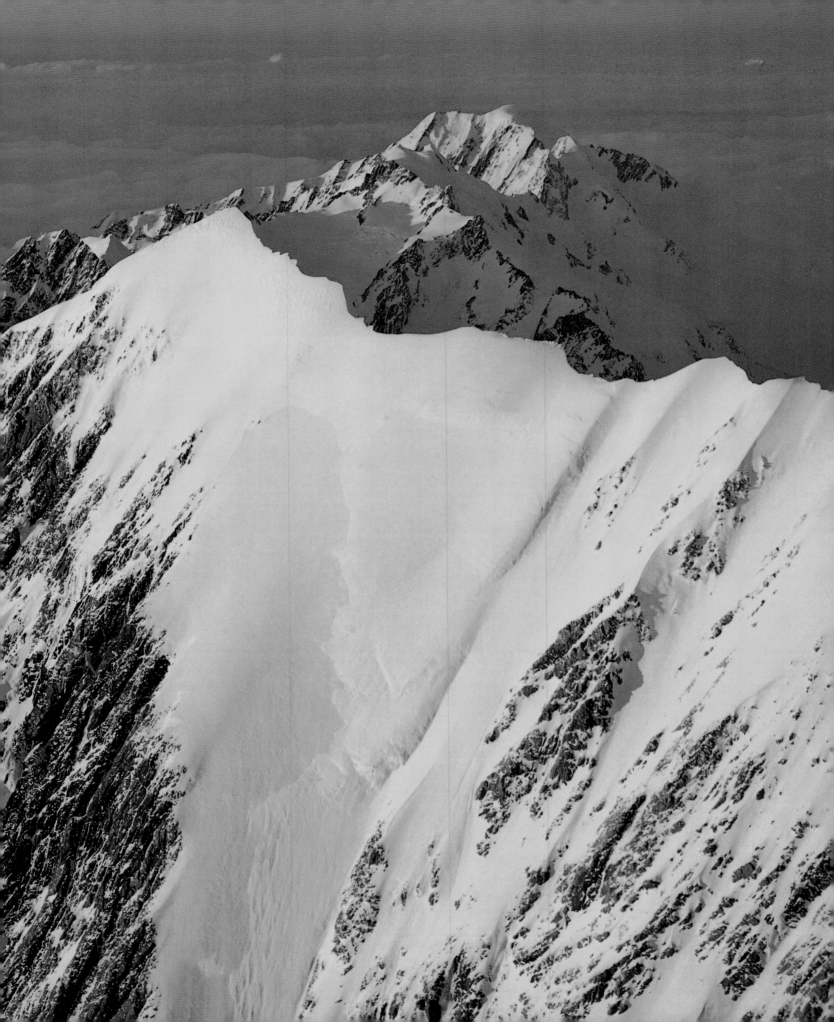

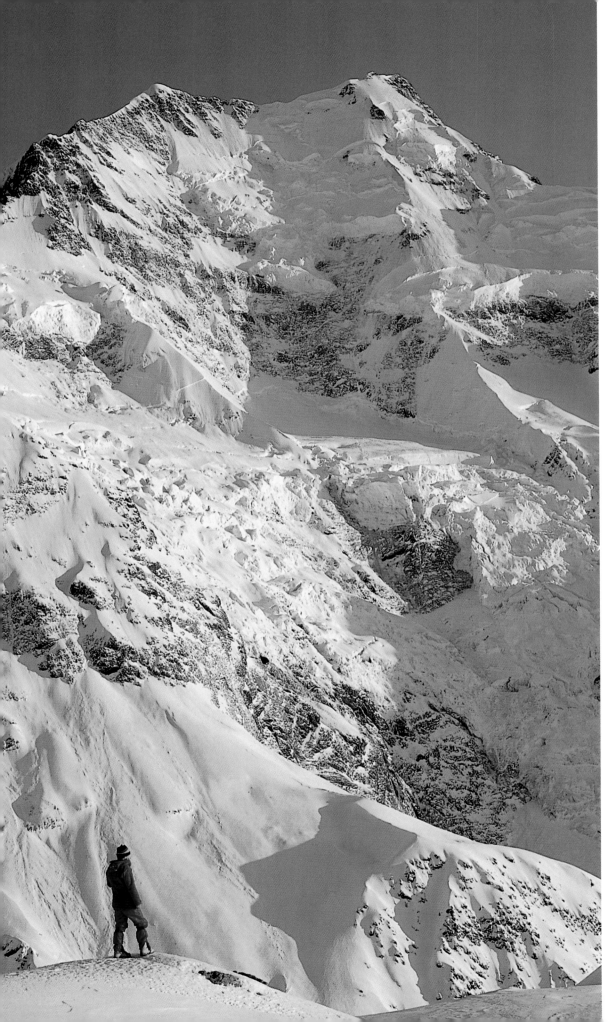

68 *Dawn on the 8,200 feet icy rampart of the Aoraki's Caroline face can be enjoyed from an easy-to-reach vantage point on the Furggen ridge above the Tasman Glacier in Mount Cook National Park. The high peak of Aoraki (Mount Cook) is not visible in this photograph being hidden by the Middle Peak* (top right of picture).

69 *This aerial view of the Main Divide Peaks in Mount Cook National Park has been taken during summer from above the Tasman Glacier. Aoraki, New Zealand's highest summit, is visible on the far left of the range.*

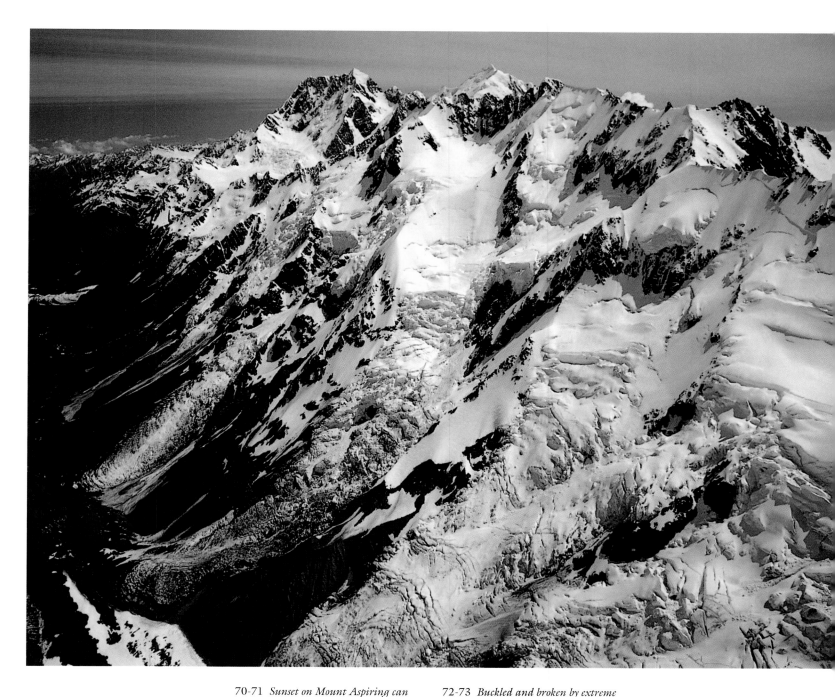

70-71 *Sunset on Mount Aspiring can be enjoyed from a vantage point on Mount French above the Bonar Glacier. Mount Aspiring National Park is a major mountain wilderness in the central South Island with easy access from the township of Wanaka. Scenic flights from Wanaka provide another way to enjoy the Southern Alps for those who do not wish to trek into the high mountains.*

72-73 *Buckled and broken by extreme pressure, the Balfour Glacier of Westland National Park cascades over a cliff into gloomy forested gorges beneath the clouds. The setting sun lights up the cloud cover over the Tasman Sea. Storms roll in from the Tasman Sea bringing very high winds and rain during summer months with heavy wet snowfalls in winter. Movement on West Coast glaciers such as the Balfour, Fox and Franz Josef is extremely rapid.*

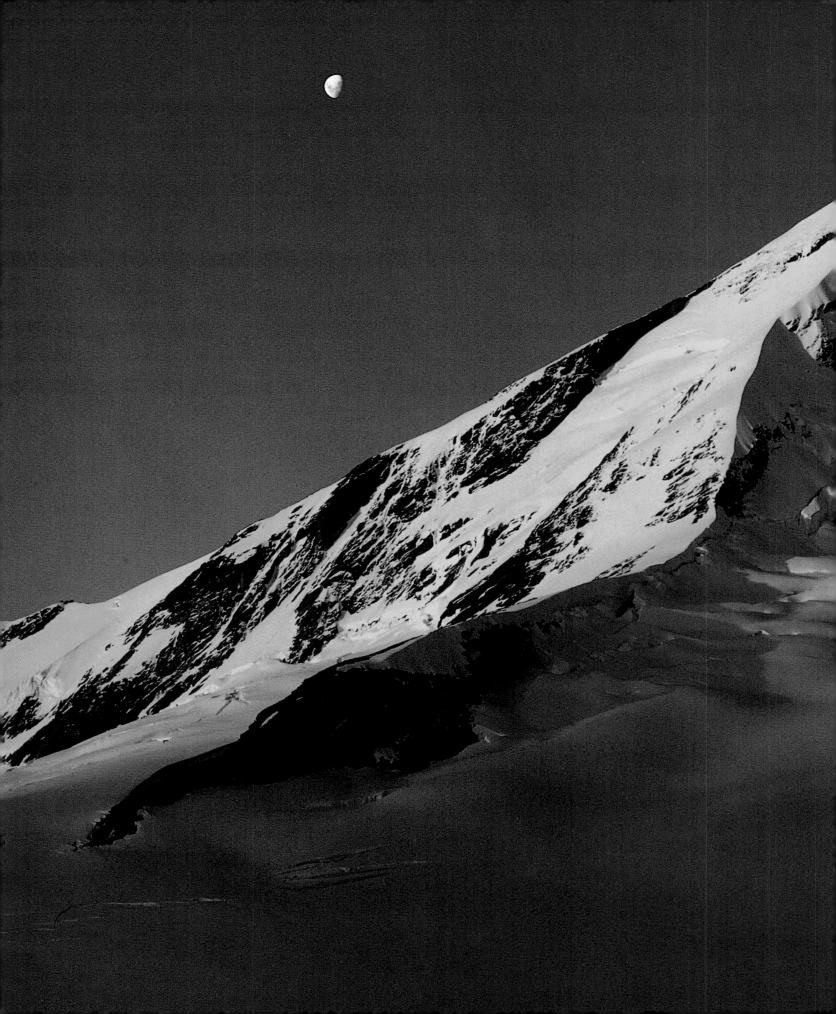

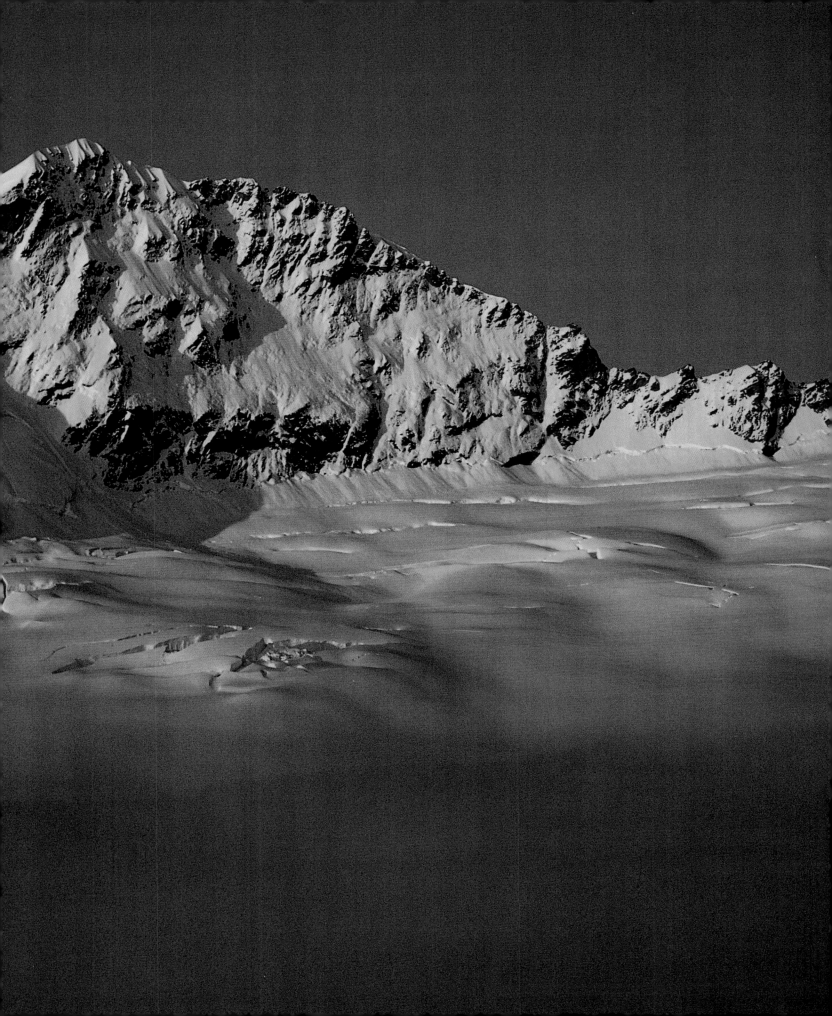

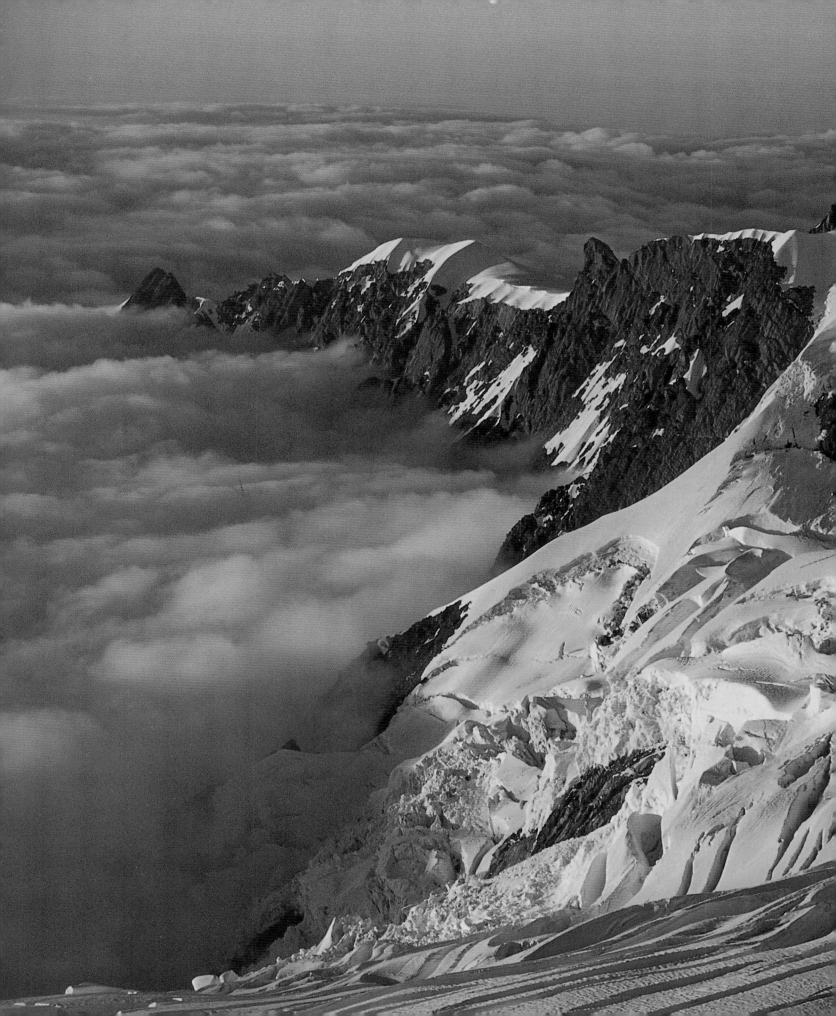

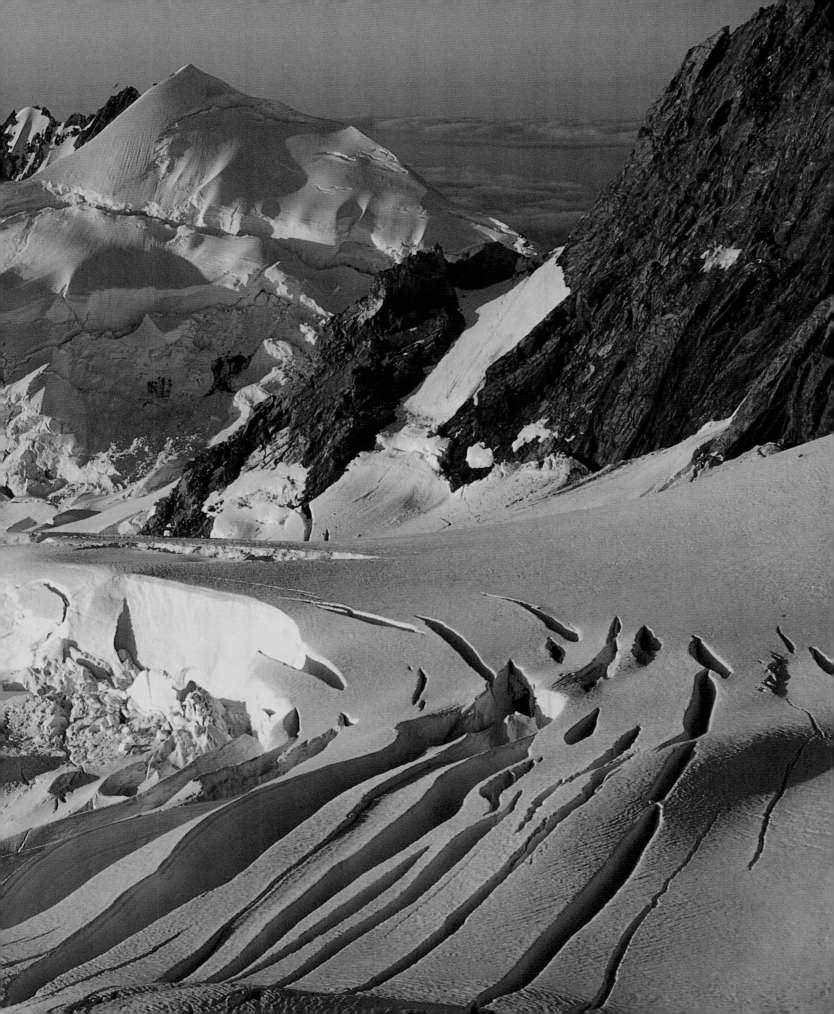

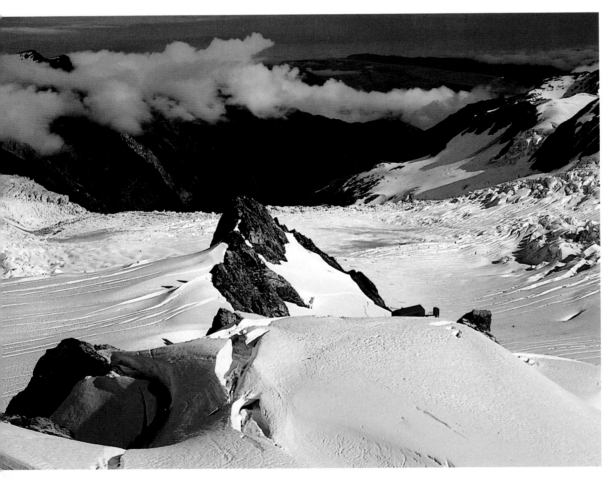

74 The New Zealand Alpine Club recently constructed this red 20 bunk cabin to celebrate 100 years of the NZAC. The "Centennial" hut is located on the Franz Josef Glacier snow and has already proved popular with ski-mountaineers and climbers. This view of the Franz Josef shows how dramatically the glacier drops away into the gorge under the clouds.
The narrow coastal plain and Tasman Sea can be seen in the distance.

75 Evening light casts a soft purple glow across the crevasses of the Franz Josef Glacier in this view from the balcony outside the New Zealand Alpine Club's new Centennial hut.

76-77 The township of Frankton near Queenstown is dwarfed by the peaks of the Remarkables which are coated in a light autumn snowfall. Lake Wakatipu is a popular resort for yachting.
The Remarkables and nearby Coronet Peak have some of the South Island's best skiing in winter months from June to October.

78-79 For many years the Milford Track has been called "the finest walk in the world". Fiordland National Park has many similar walking routes but there is no question that the Milford, with its modern cabins and well-maintained track, is perhaps the most beautiful, combining launch trips at the start and finish of the trip, easy river flats and a steep though short climb over the spectacular McKinnon Pass.

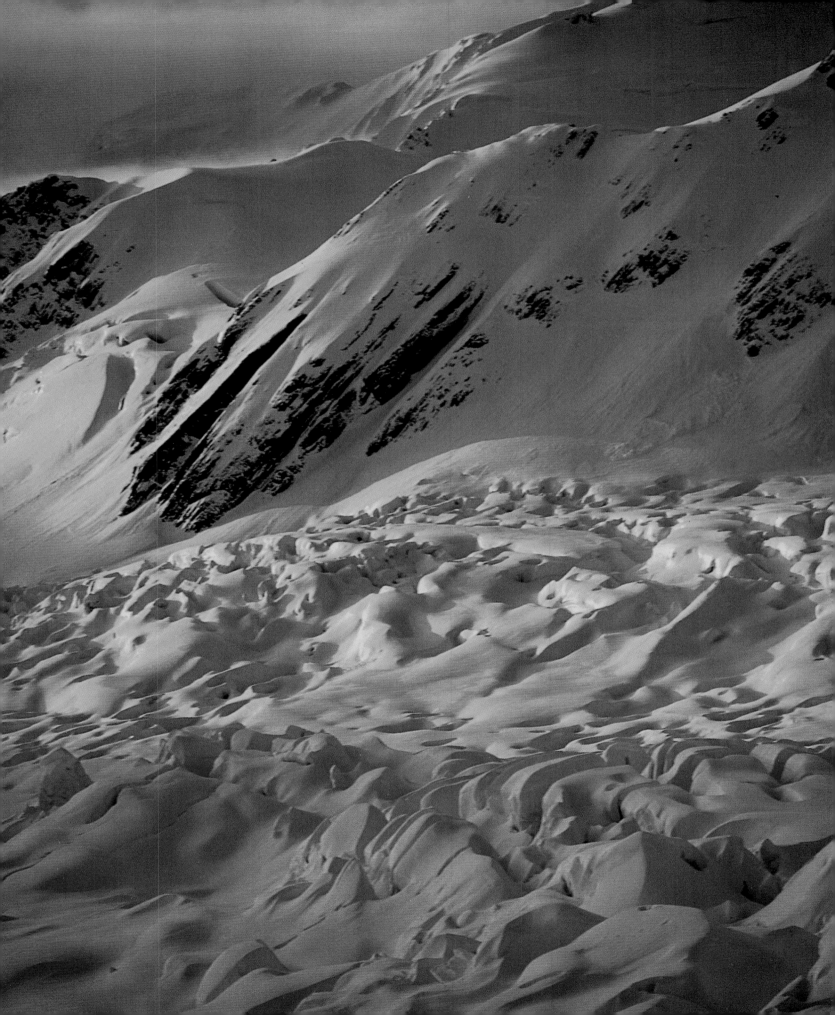

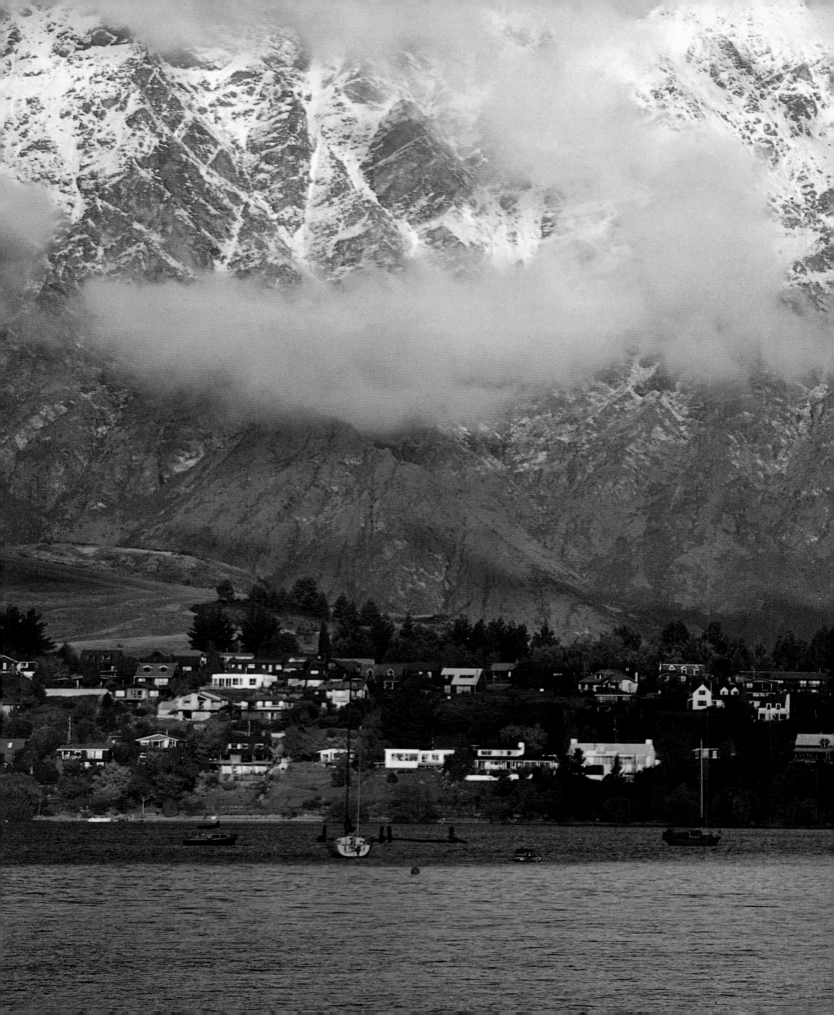

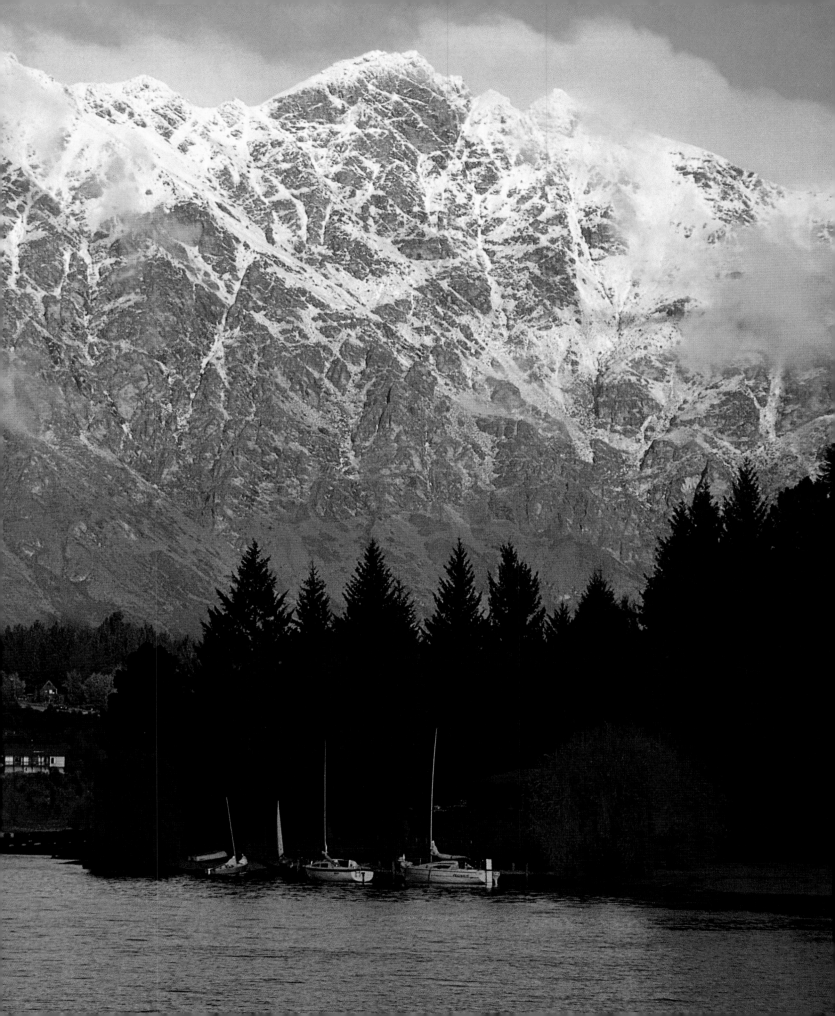

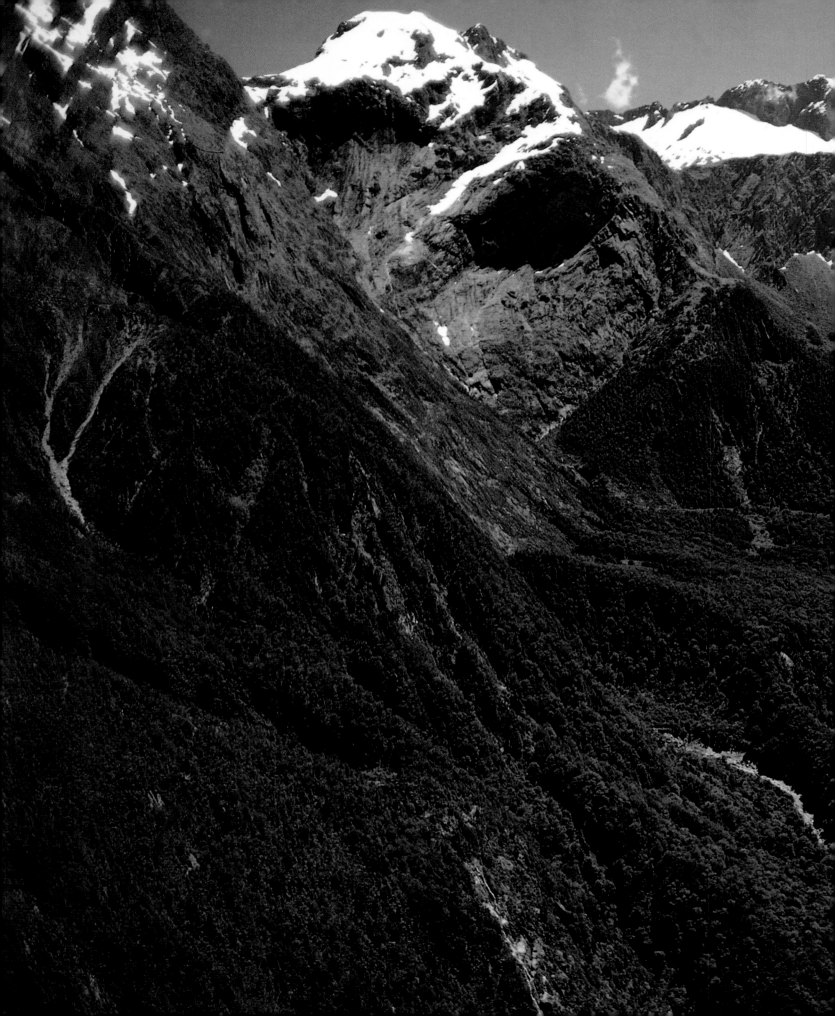

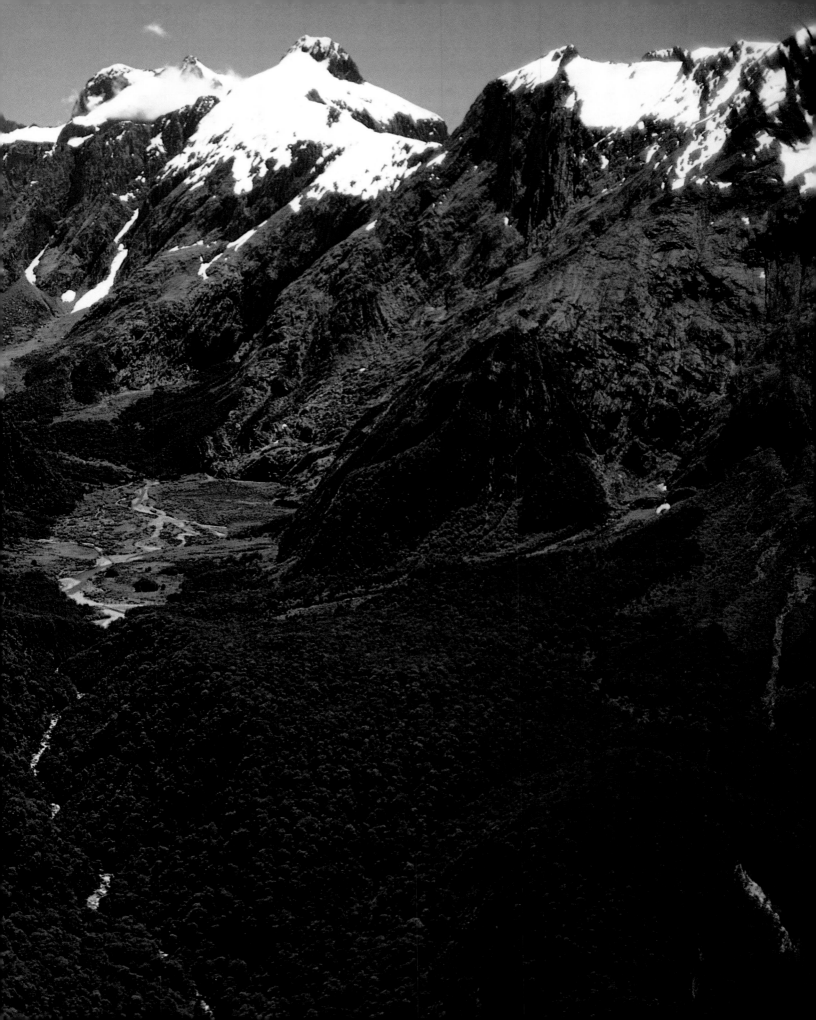

The bubbling, boiling heart of the North

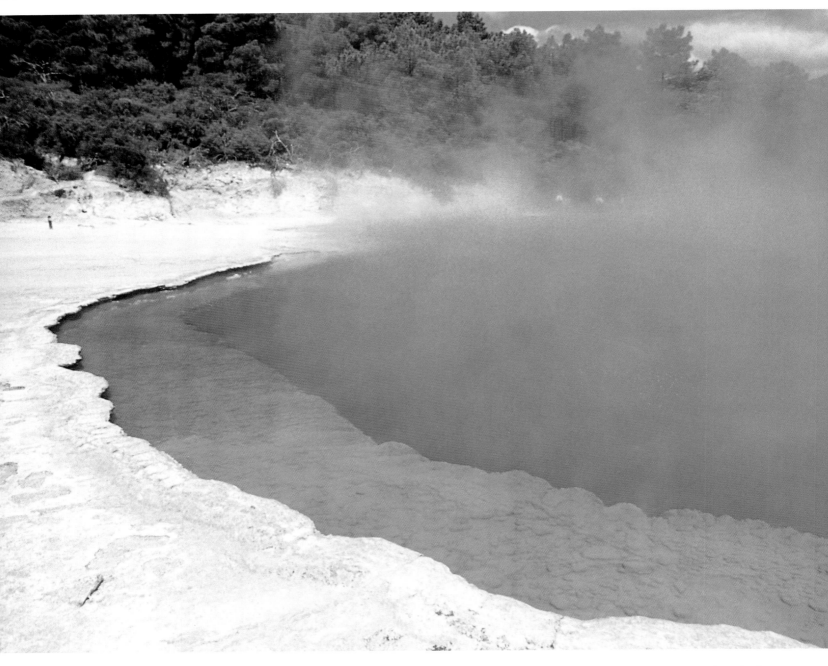

80-81 *The dramatic colors of the "Champagne Pool" (left) and the sulphur-crusted edges of Whakarewarewa geyser (right) add force to playright George Bernard Shaw's comment after visiting the Rotorua district in 1934 "I was pleased to get so close to Hades and be able to return". Once a visitor has adjusted to the pungent sulphrous smell around Rotorua there is no question the region has many fascinating features centered on the active vulcanism, hot springs and strong Maori culture. "Pohutu", the biggest geyser in New Zealand, thunders into the sky more than 98 feet several times each day. Trout fishing in the crystal-clear waters of Lake Taupo is also a major attraction of the area.*

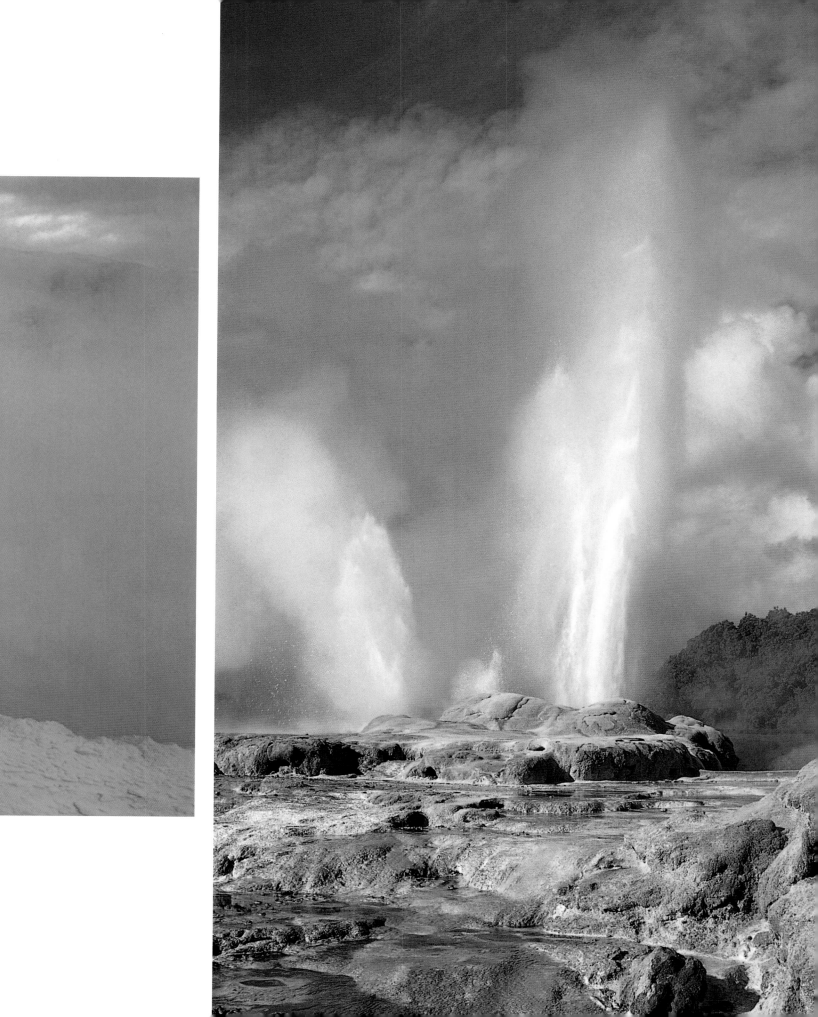

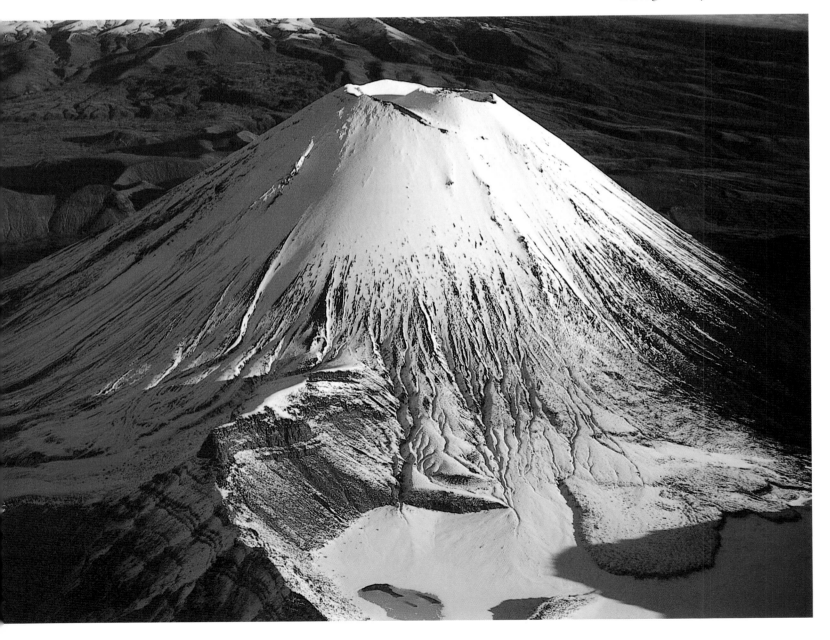

83 *Tongariro National Park's "Chateau" hotel is tucked under the highest peak in the North Island, the volcano Ruapehu. In the foreground is part of the Chateau's 18-hole golf course. Secuded walking tracks criss-cross the forests which cloak the volcanic slopes of the mountain. Ruapehu's crater lake can exhibit violent eruptions of boiling water and mud. There are several major ski fields on Ruapehu catering for Auckland and Wellington enthusiasts.*

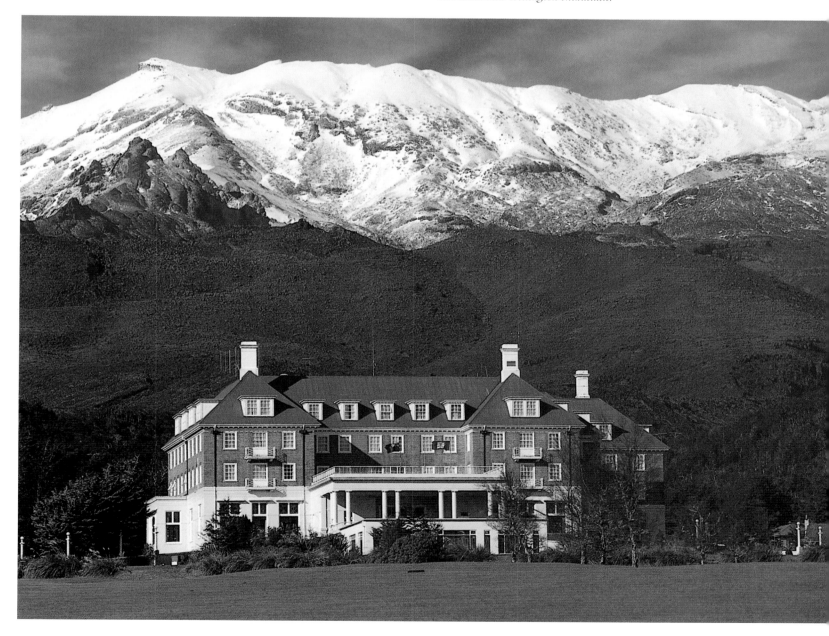

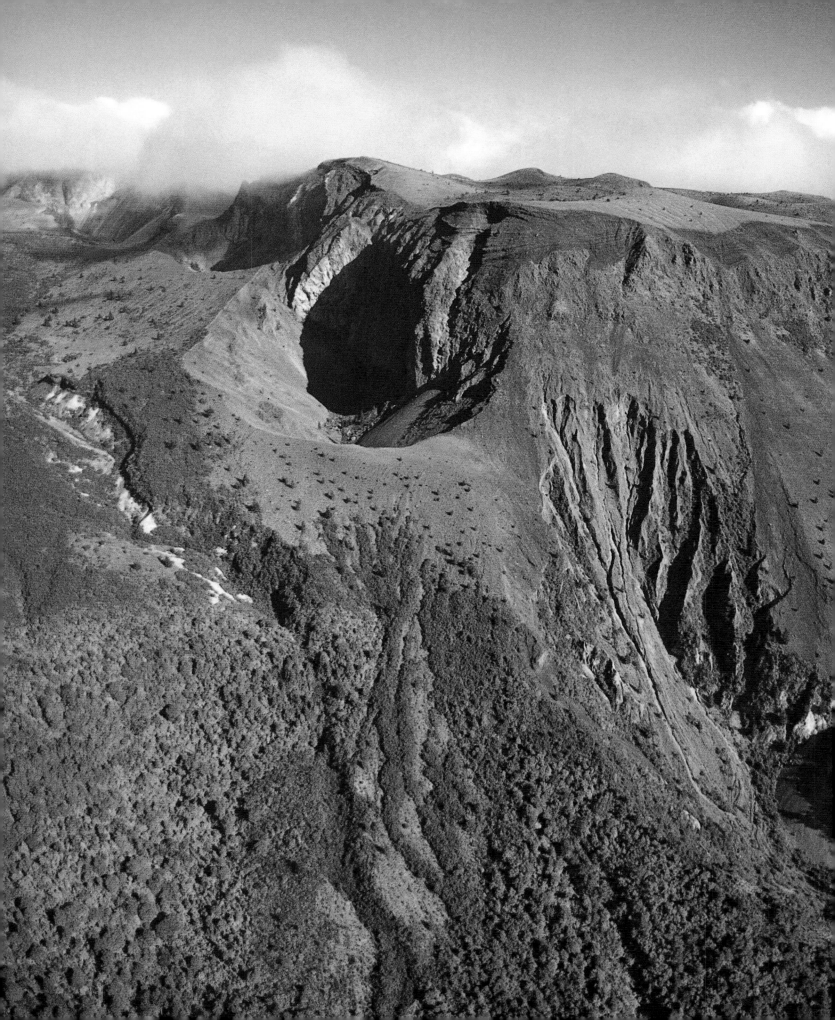

84-85 *This aerial view of Mount Tarawera illustrates how violent volcanic eruptions can be in this central part of the North Island. The 820 feet chasm almost split the volcano in two. Scenic flights around Rotorua, the Tongariro National Park and over Mount Tarawera provide a new perspective on this ever-changing region. Light aircraft can even land on the summit caldera of Tarawera to allow closer inspection of the crater.*

85 *About twelve miles to the south of Rotorua is a still unspoilt area of hot springs: the Waimangu Valley. In this photograph, one can admire the Emerald Pool, one of the many volcanic lakes that distinguish the entire area.*

86-87 *Muted winter light on the snowy flanks of the dormant volcano Taranaki (Mount Egmont) illuminates old lava flows which carve a path down into forests below. Taranaki is the centerpiece of a rich dairy farming region on the West Coast of the North Island. The mountain often catches violent weather coming in from the Tasman Sea which can be seen in the background of this aerial view.*

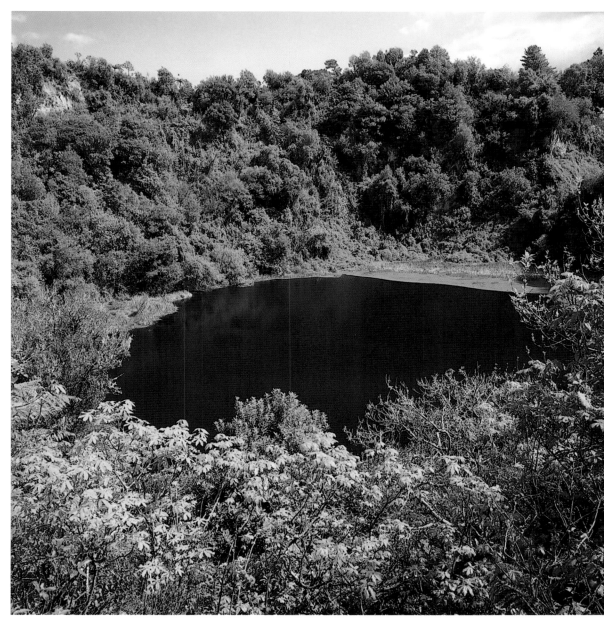

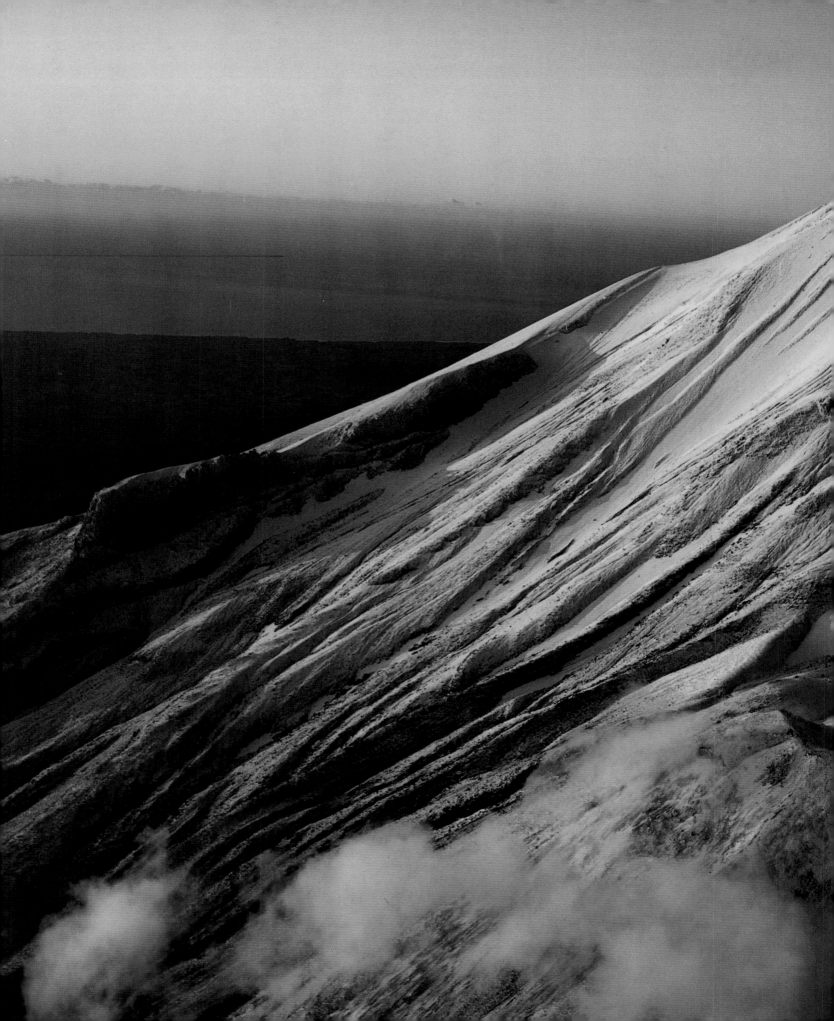

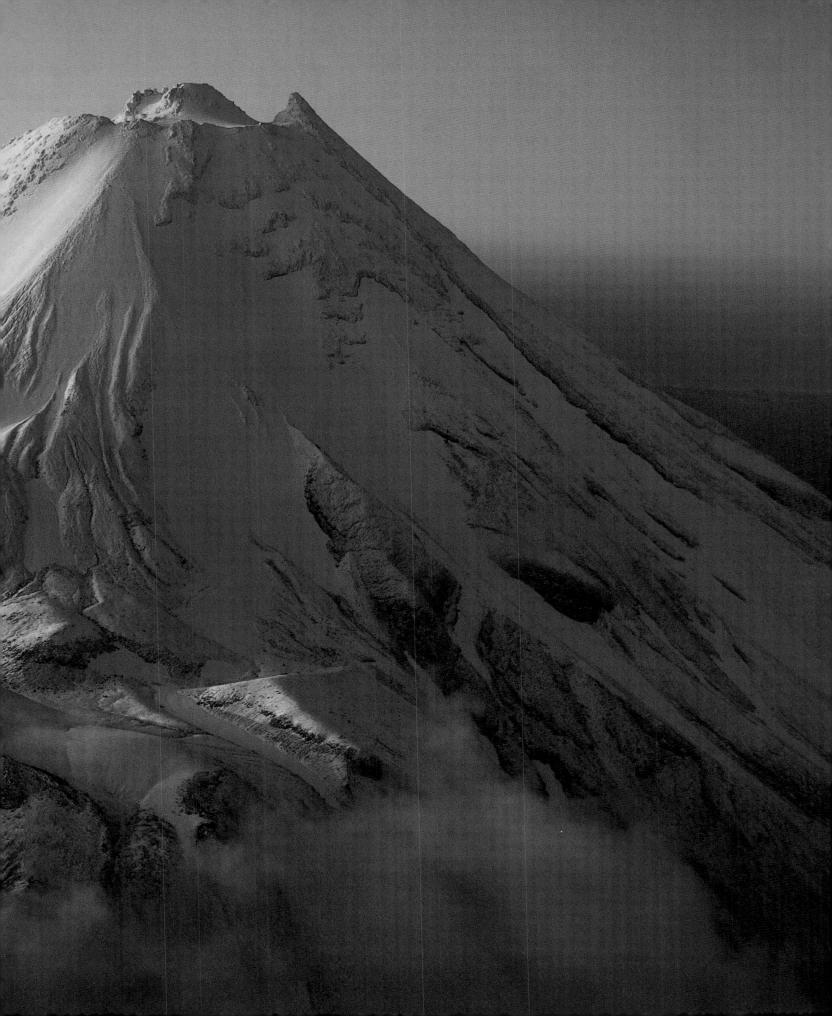

Cities in a Tranquil Land

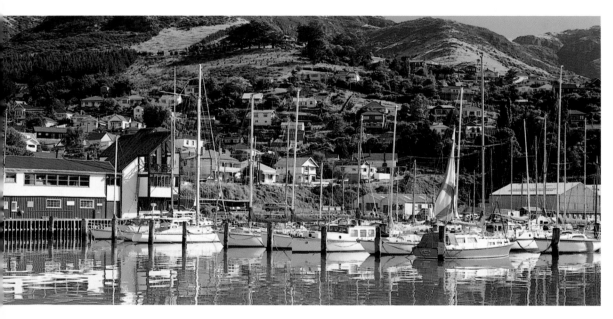

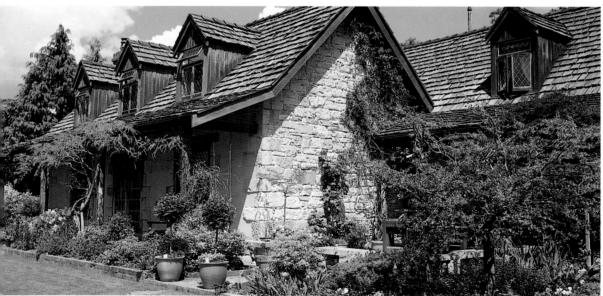

88 top *Lyttelton, Christchurch's port just a few miles from the city over the Port Hills, is as sheltered a harbor as any in the country. From container ships and fishing vessels to private yachts, Lyttelton is a hive of industry, yet on a calm summer's day the harbor is a peaceful place for a family stroll or relaxed lunch in one of the wharf cafés. Lyttelton is rapidly becoming a fashionable place to live for long-time Christchurch residents looking for a change of outlook. Brightly colored wooden cottages cling to the steep hills rising above the harbor. Pioneering Antarctic voyages in the early 1900s used Lyttelton as a base before finally venturing into the Southern Ocean.*

88 bottom *Taunton Gardens in Governor's Bay near Christchurch was built in 1853. This lovely stone cottage with its magnificent garden typifies many of the historic homes that can be visited in New Zealand.
The Christchurch and Bank's Peninsula region enjoys a near-perfect growing climate with temperate plants such as roses, rhododendrons and azaleas bursting into flower in the warm spring weather.*

89 *Wellington, the nation's capital with its kaleidoscope of multi-colored roofs, clings to the northern edge of Cook Strait on the tip of the North Island. Suburbs sprawl through rugged bush-clad ridges which descend steeply right into the business and political heart of the city.*

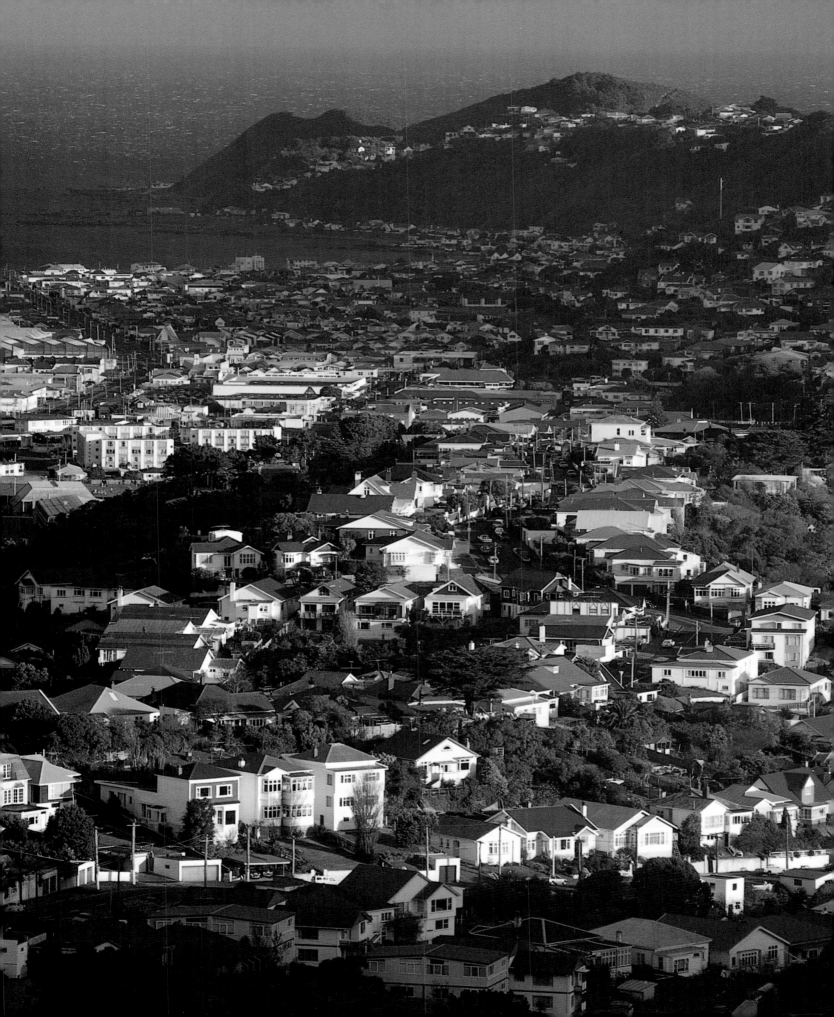

Auckland, the City of Sails

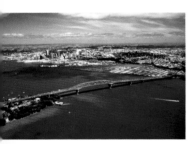

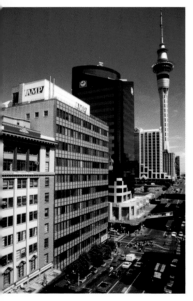

90 top *This boundless view pretty well gives the idea of what it means to live on an island that chance, and tectonic forces, have conspired to situate in one of the planet's most advantageous places. Auckland, seen here from the northwest, with Harbor Bridge in the foreground, the port of Waitemata behind it, and the Central Business District, visible in the distance with its skyscrapers, stretches out across a once-underwater, ancient valley system, which creates a shoreline of great beauty and complexity.*

90 bottom *Blue seems to dominate Auckland pretty much everywhere, a city suspended between two seas and capped by frequently clear skies: 5.1 inches of rain a month, on average, is the maximum during the rainy season.*

90-91 *By chance, in Auckland everything seems to orbit around the Sky Tower, whose spire is the focal point for esthetic "tensions" created by the other skyscrapers. To maintain first place as the tallest free-standing structure in the southern hemisphere, beating Sidney, the tower was raised 302 feet with a telecommunications antenna.*

92-93 *A stormy sky hangs over Westhaven Marina, in the large circular bay that contains the port of Waitemata. The harbor area, situated in the north part of the city, faces onto the island's east coast, the side less exposed to precipitation. These rainstorms, at times intense, normally come from the west, carried by the strong and humid oceanic winds that blow from that direction.*

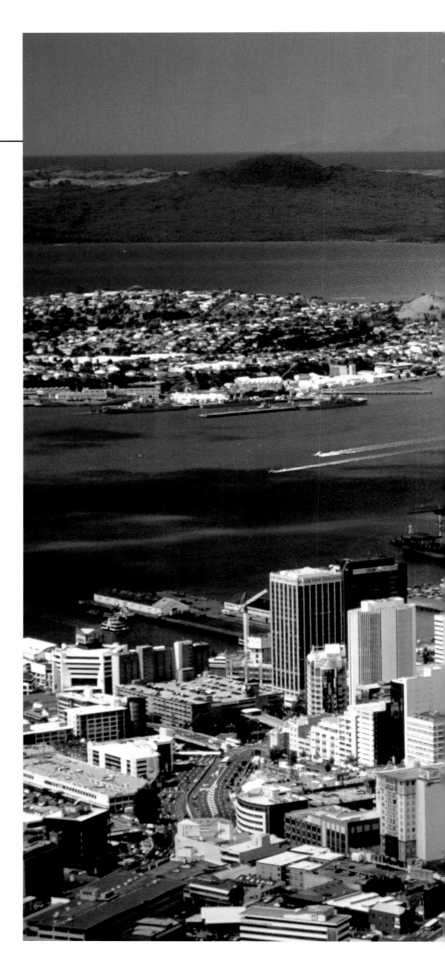

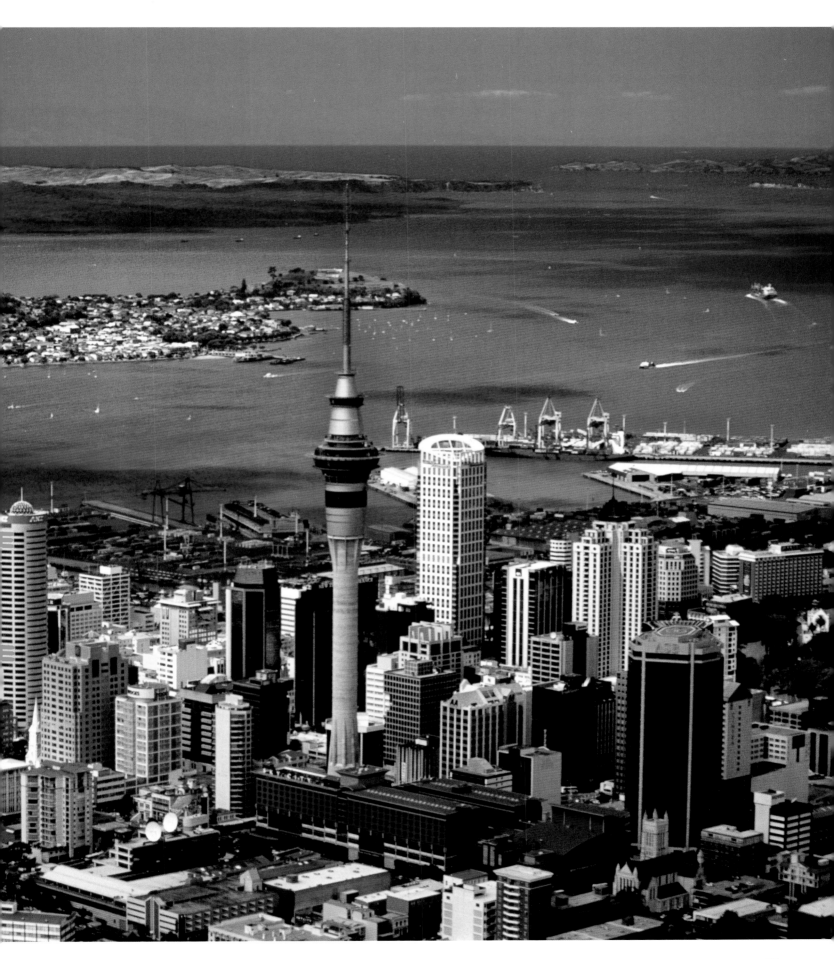

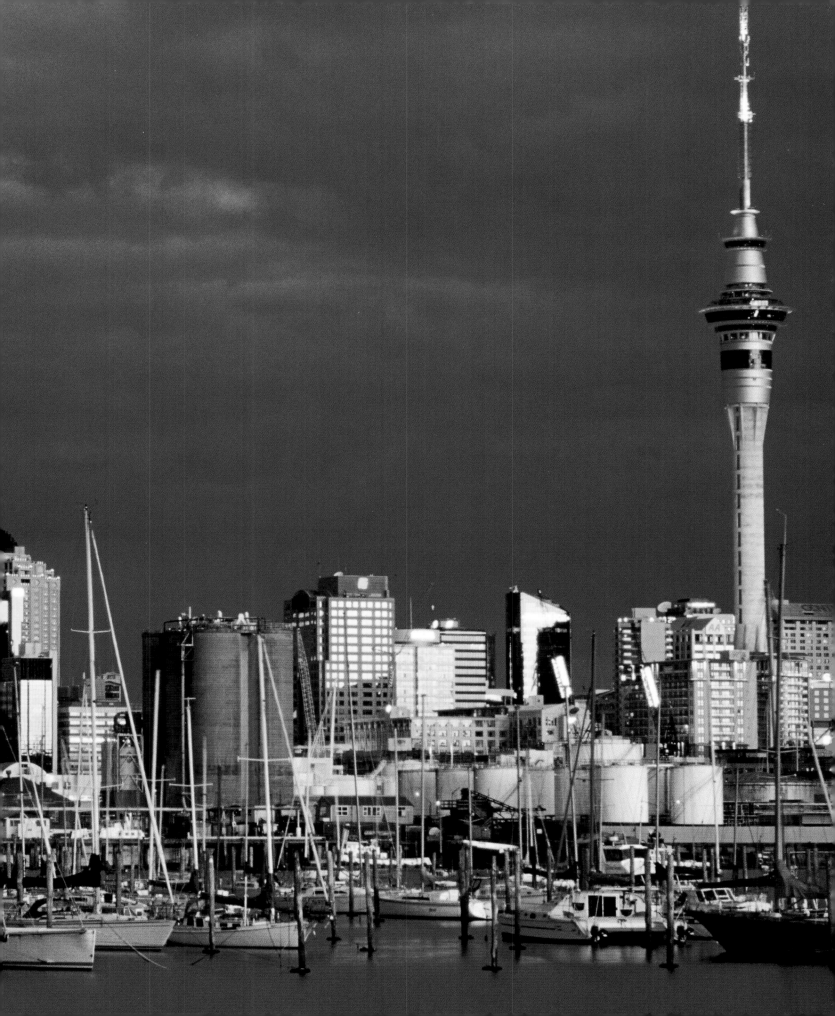

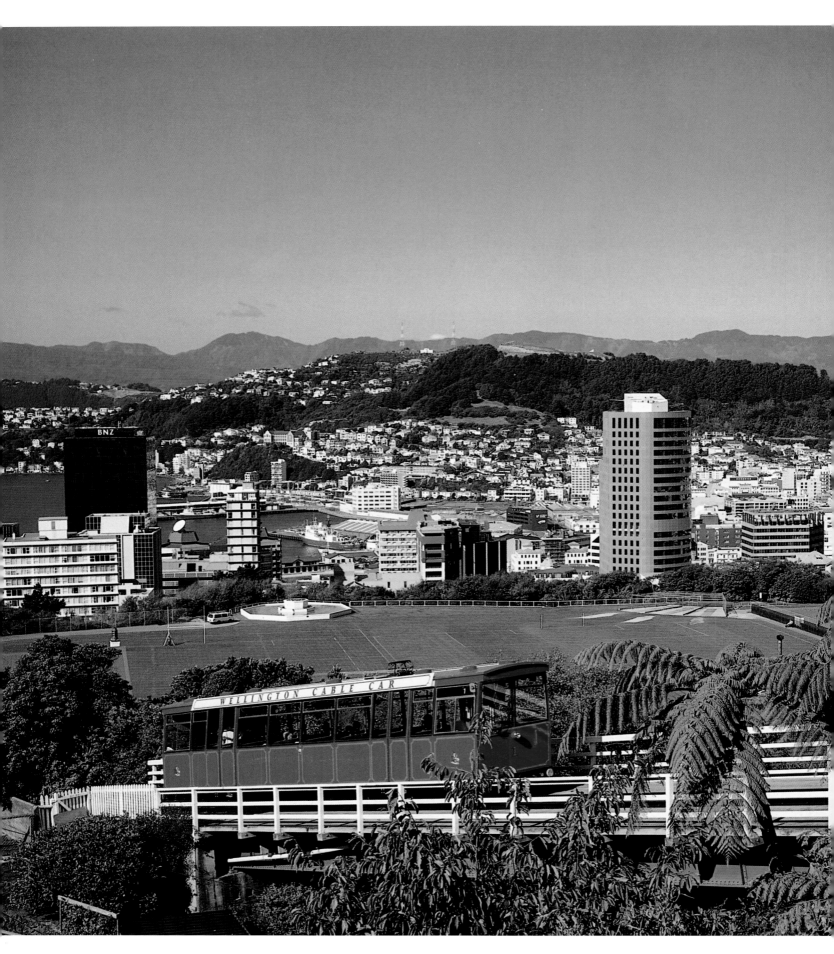

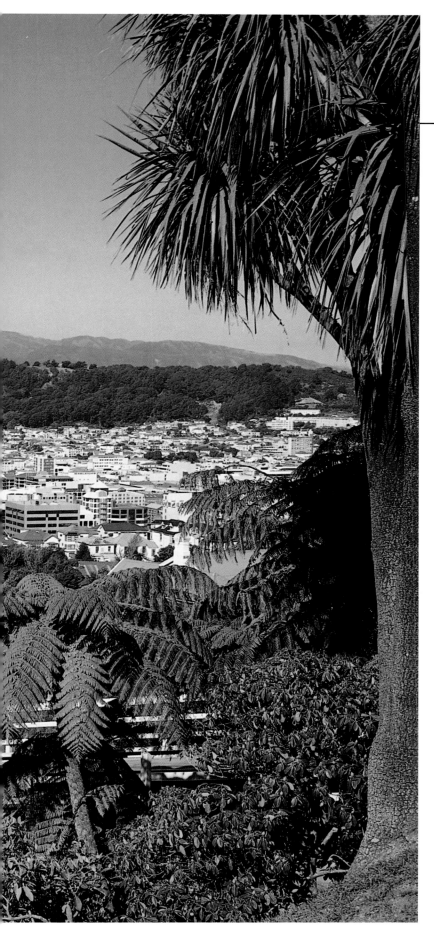

Windy Wellington

94-95 *Wellington's cable car climbs steeply from the harbor-front city center to the suburbs around Victoria University. Tree ferns called "pungas" overhang the rails in places. Visitors to Wellington often use the cable car to reach vantage points overlooking the harbor.*

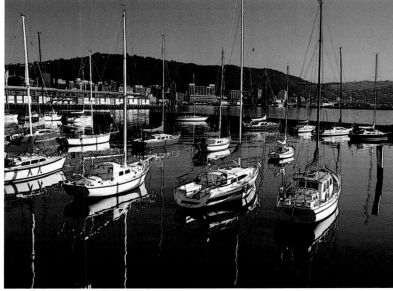

95 *Wellington breeds tough sailors, for although this down town yachting marina looks placid enough, nearby Cook Strait is a storm-tossed stretch of water - certainly no place for the inexperienced. Although Wellington is one of New Zealand's busiest cities, residents only have to travel a few miles before they can relax in open countryside or on a wild coastline.*

96-97 *Well protected on the west side of the bay, marking the southernmost end of North Island, facing onto the Strait of Cook, Wellington stands in an extremely picturesque position. Despite being off-center with respect to the island it is on, the city stands in the exact geographic center of the isolated nation, as suits one of the most pleasant and livable cities in the world.*

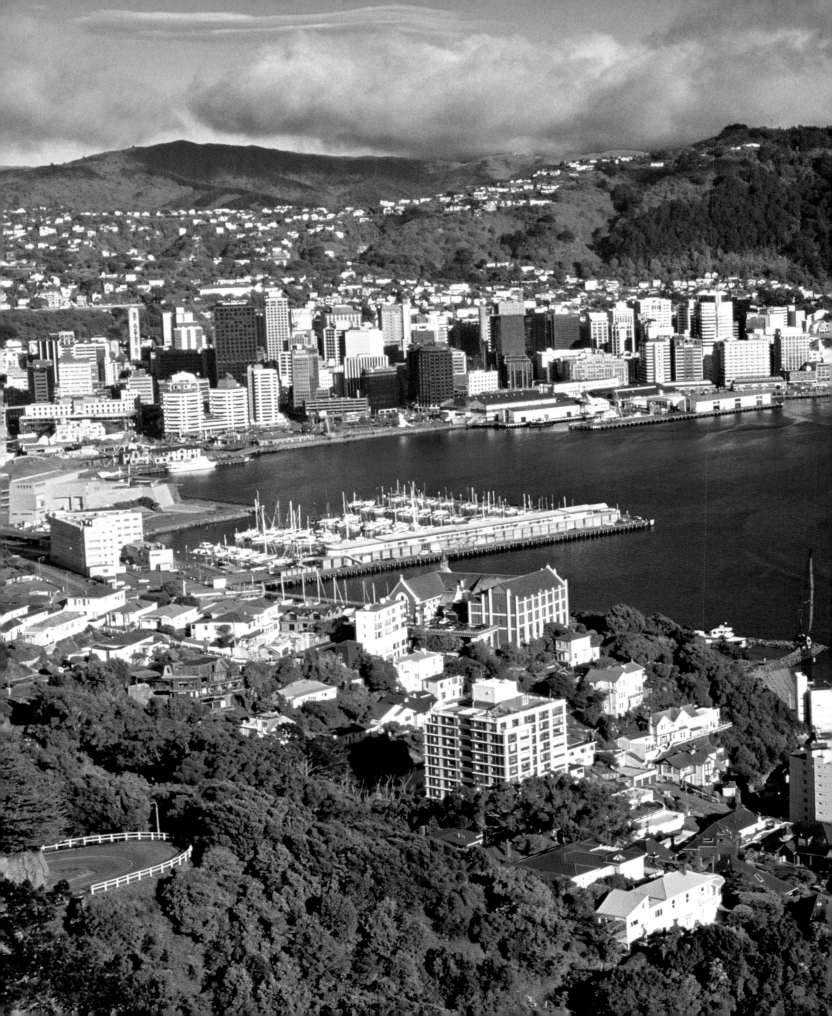

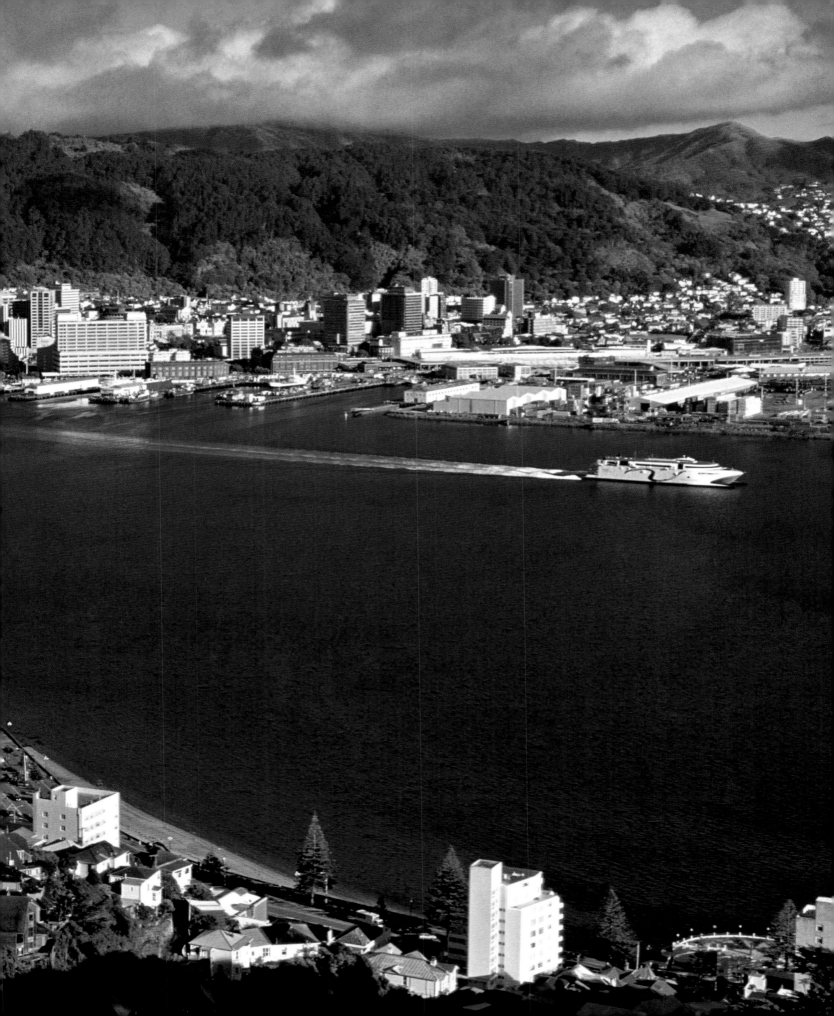

Christchurch, the garden city

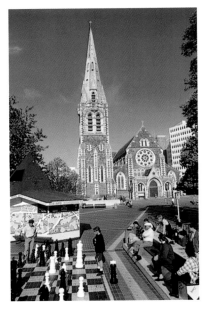

98 top *Playing chess with giant pieces is a popular lunchtime activity in Christchurch's Cathedral Square. Food stalls, concerts and soap box speakers such as the city's very own "wizard" also help to enrich life in the city center.*

98 bottom *Visitors to Christchurch can escape from their rental car or bus tour to stroll around the museums, art galleries and gardens. Some prefer to sit back and be guided around in the back of a horse-drawn carriage. This view of Christchurch shows the old sandstone building of Canterbury Museum which is located beside the Botanic Gardens.*

99 *The old Canterbury University buildings and courtyards have been turned over to a thriving arts and crafts community who sell their wares in a variety of shops and outside stalls. Buskers, musicians, acrobats and the town crier enliven a Sunday afternoon's entertainment for the whole family.*

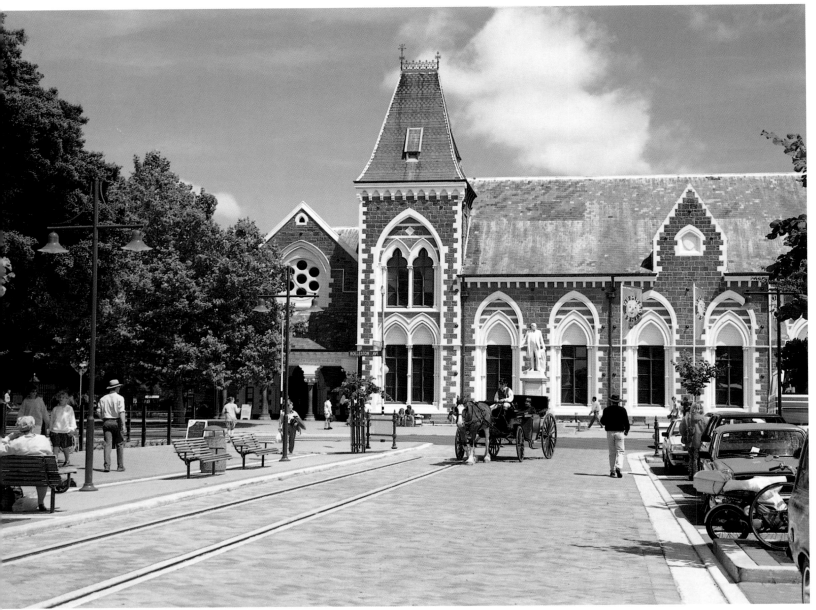

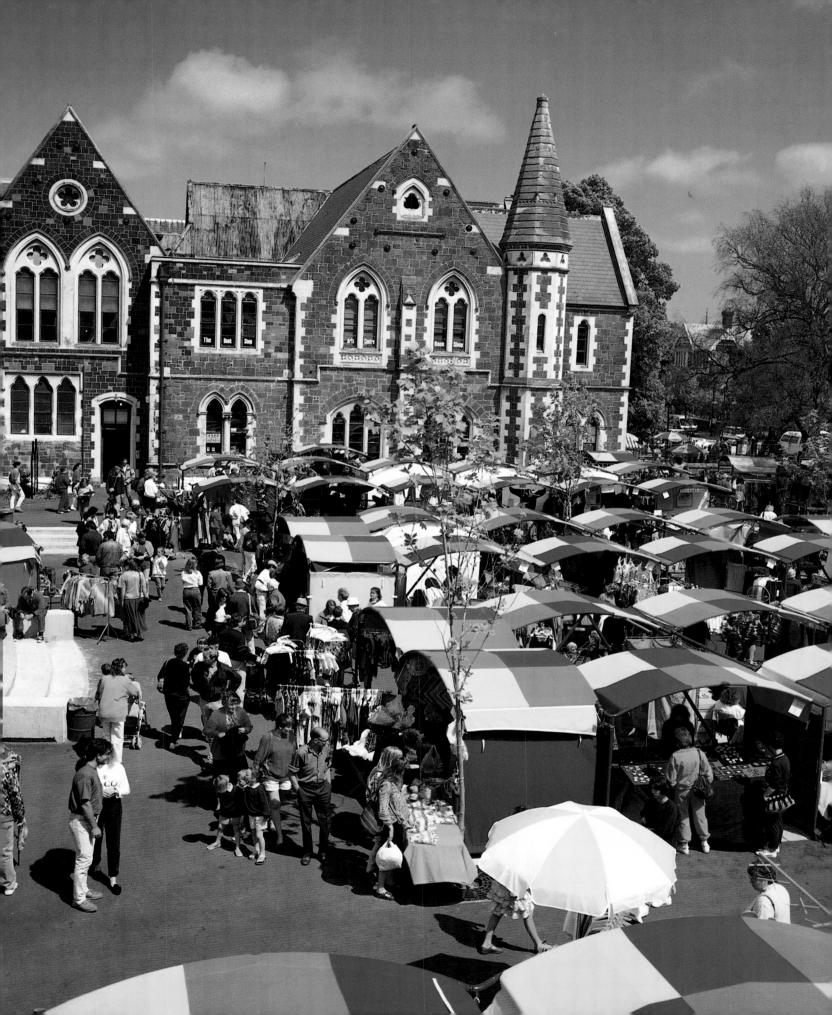

Dunedin,
the University City

100 *On the banks of the Leith river The University of Otago dominates the northern end of Dunedin. City life is influenced by the large student population who come from all over the world to study there. With a strong Scottish heritage Dunedin residents have to live with the title of "Dunedin - Edinburgh of the South" though there is also a feeling of the English university cities of Oxford and Cambridge as well. Dunedin services a large rural community stretching across Southland and Otago. In the 1860s, following the discovery of gold, Otago experienced a rush of immigrants similar to that of California. Dunedin rapidly became the financial capital of New Zealand.*

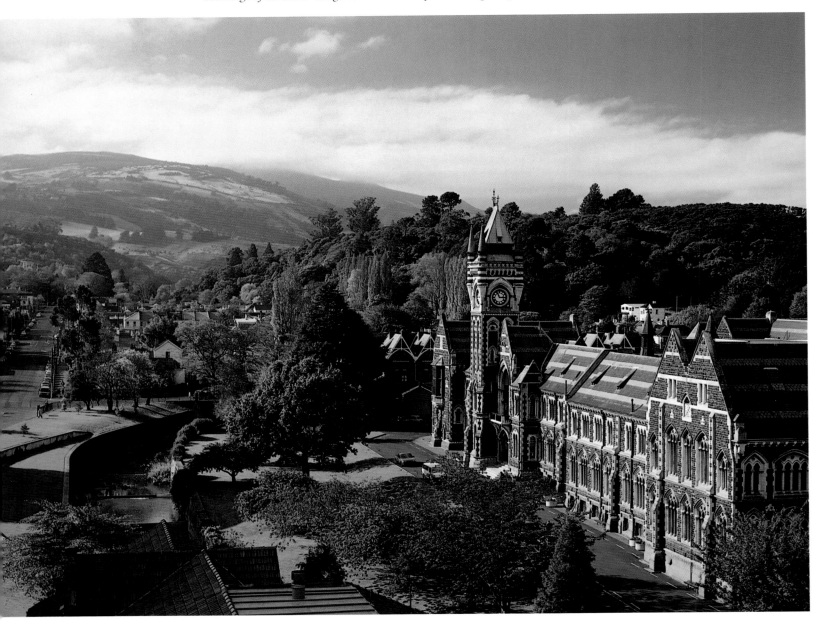

101 *St. Kilda beach photographed from
St. Clair headland is a popular beach
resort town within an easy drive of
Dunedin. Wind-blown sheep farms on
the Otago Peninsula come to the edge
of the headland in the background.*

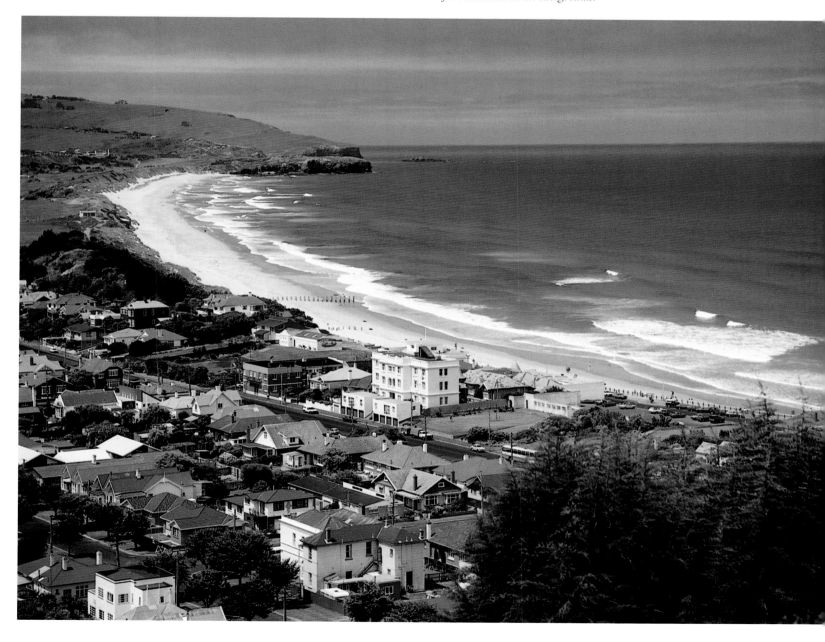

Living with the Pace of the Land

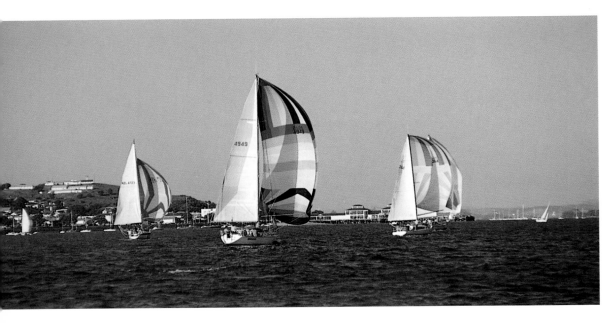

102 top *New Zealanders love their water sports - be it sailing on Auckland's many bays, skin diving in the Bay of Islands or kayaking down a mountain torrent in the Southern Alps.*

102 bottom *Well-trained sheep dogs assist a South Island farmer herd part of his flock along the road to another paddock. New Zealand was built on the wool and lamb market principally to Europe. Visitors to New Zealand often cannot believe how green the grass is.*

103 *Float planes are an ideal way to get about Lake Te Anau in Southland. Te Anau is also the base for exploration of remote corners of Fiordland National Park, a mountainous wilderness of high alpine peaks, dense vegetation and secluded fiords.*

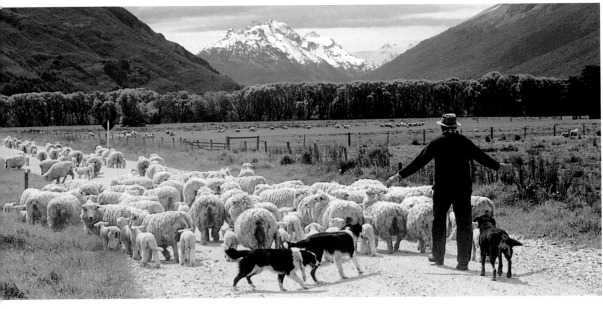

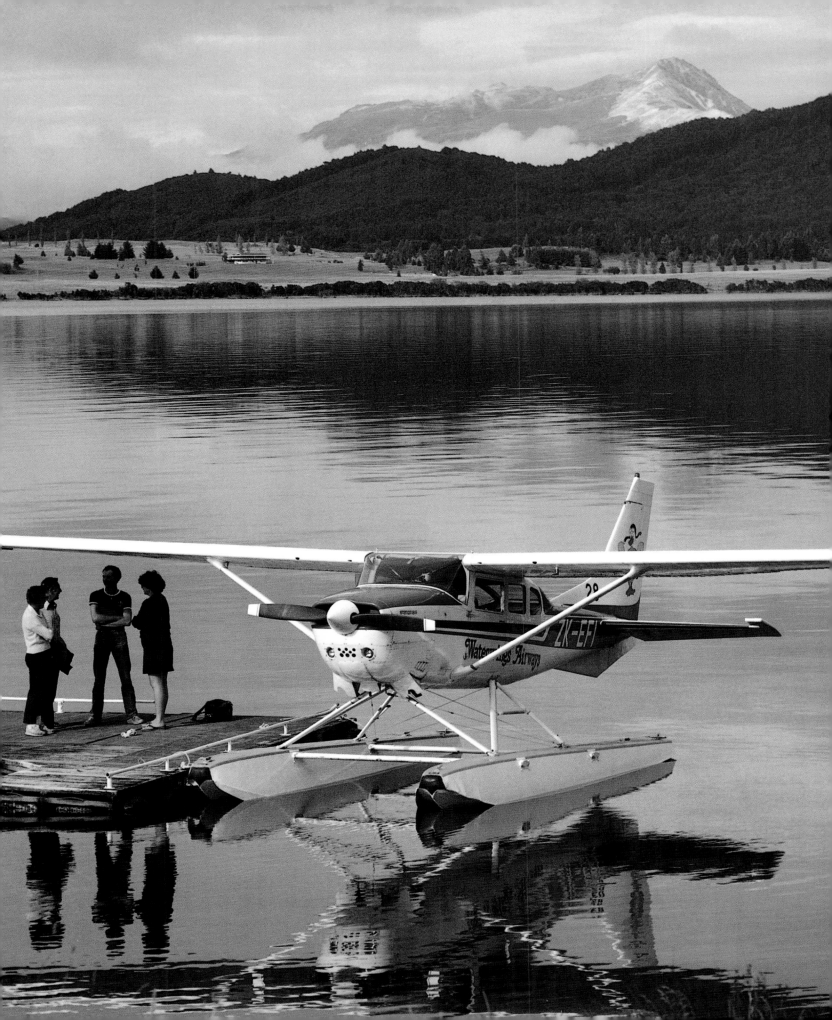

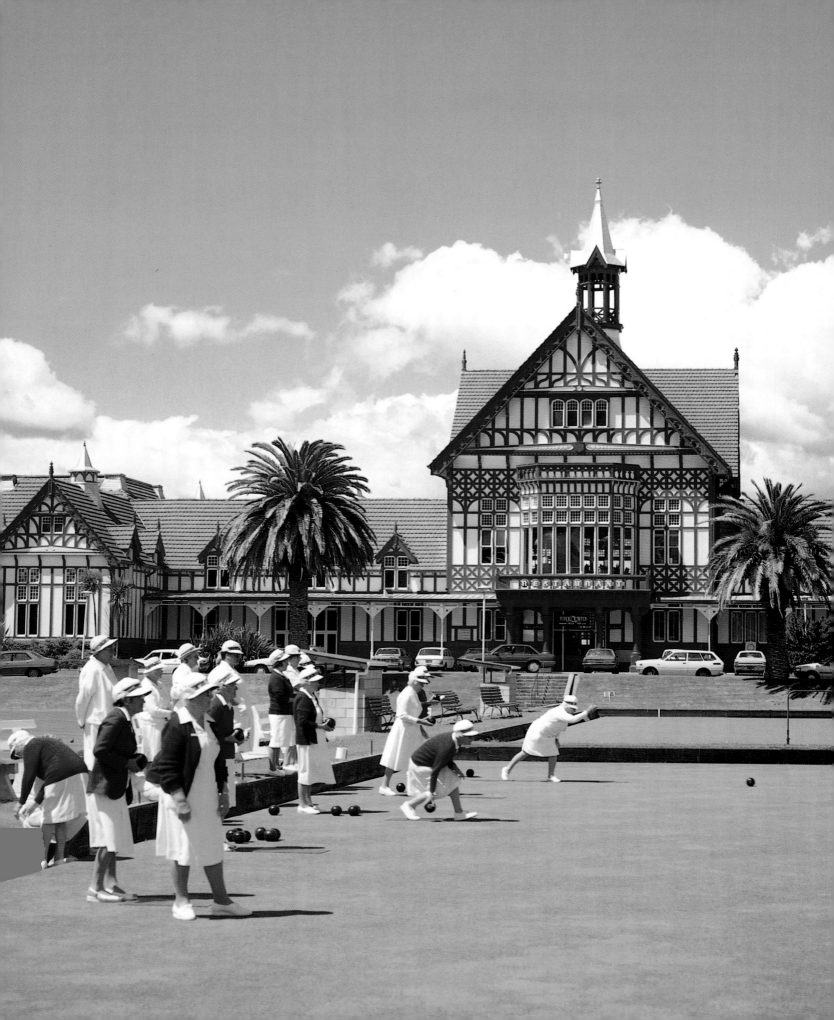

104-105 *Rotorua bowlers enjoy their game before retiring to the Tudor Towers restaurant for lunch. This fine old building also houses the Rotorua Art Gallery which exhibits work by New Zealand artists such as Rita Angus and Colin McCahon.*

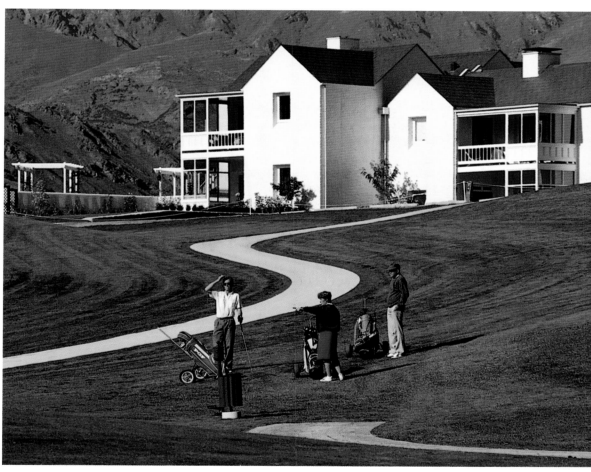

105 *Arrowtown's "Millbrook' Resort" features a golf course designed by New Zealand's famous left-hander Bob Charles. The resort is only a 20-minute drive from Queenstown and Coronet Peak skifield. New Zealand has many great golf courses and many visitors to the country simply come to enjoy the unhurried nature of the game in beautiful surroundings.*

At one with the natural world

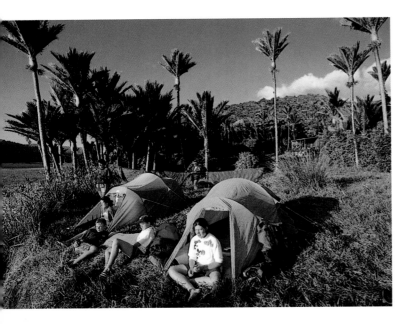

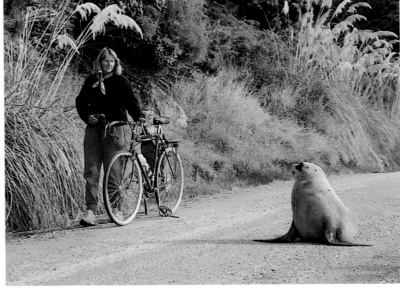

106 left *Family camping on the Heaphy Track is the perfect way to spend the Easter weekend. Nikau palm trees dominate the vegetation in this unusually warm micro-climate in the north-west of the South Island. Camping and trekking holidays introduce many young New Zealanders to outdoor life at an impressionable age, allowing them to grow up with the ability to recreate and enjoy simple inexpensive pursuits.*

106 right *This cycle tourer has had to give way to a curious female Hooker's Sea Lion ambling across the road on the Catlin's coast south of Dunedin. These sea lions mainly breed on the sub-antarctic islands south of New Zealand; however, many find their way to South*

Island beaches. New Zealand is home to many endemic birds and animals making the country a paradise of those keen to observe the natural world.

107 *New Zealanders are proud that you can drink from virtually any fresh water stream in the country. This young girl is quenching her thirst under Punchbowl Falls in Arthur's Pass National Park west of Christchurch.*

108-109 *The Heaphy Track traverses beautiful forest country in the north west of the South Island: however, the first day on the trail north from Karamea winds along beaches and Nikau palm groves. These shags do not seem to mind the two hikers walking along the edge of the surf.*

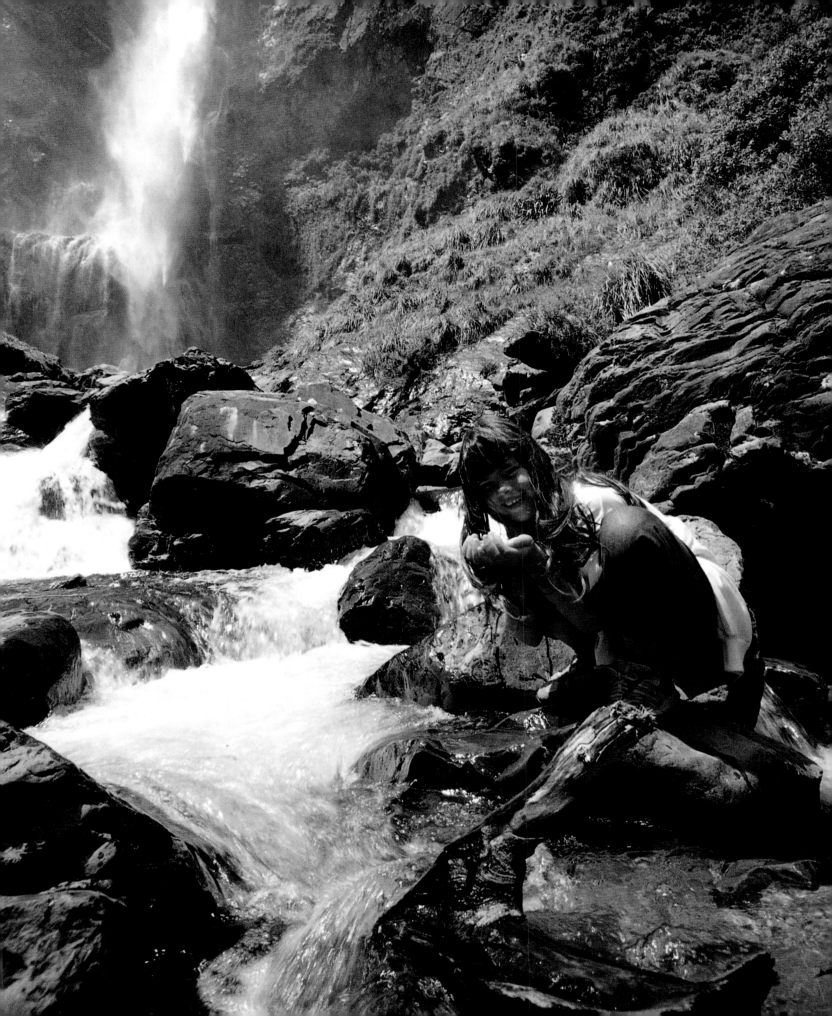

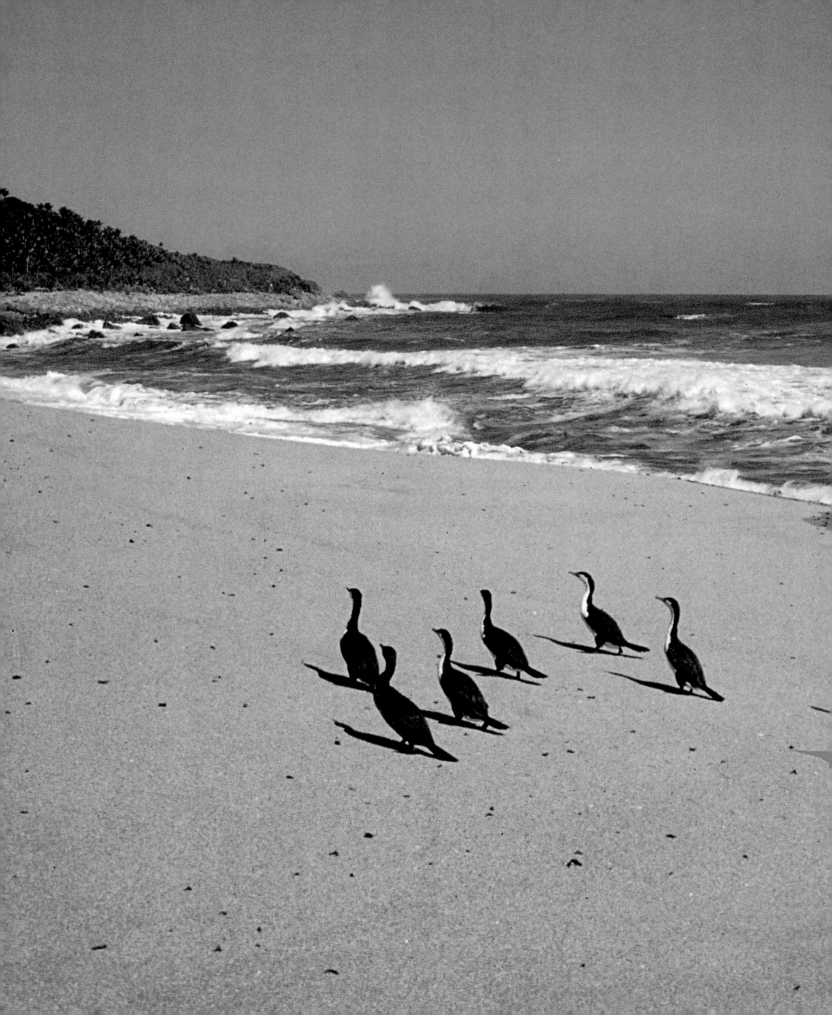

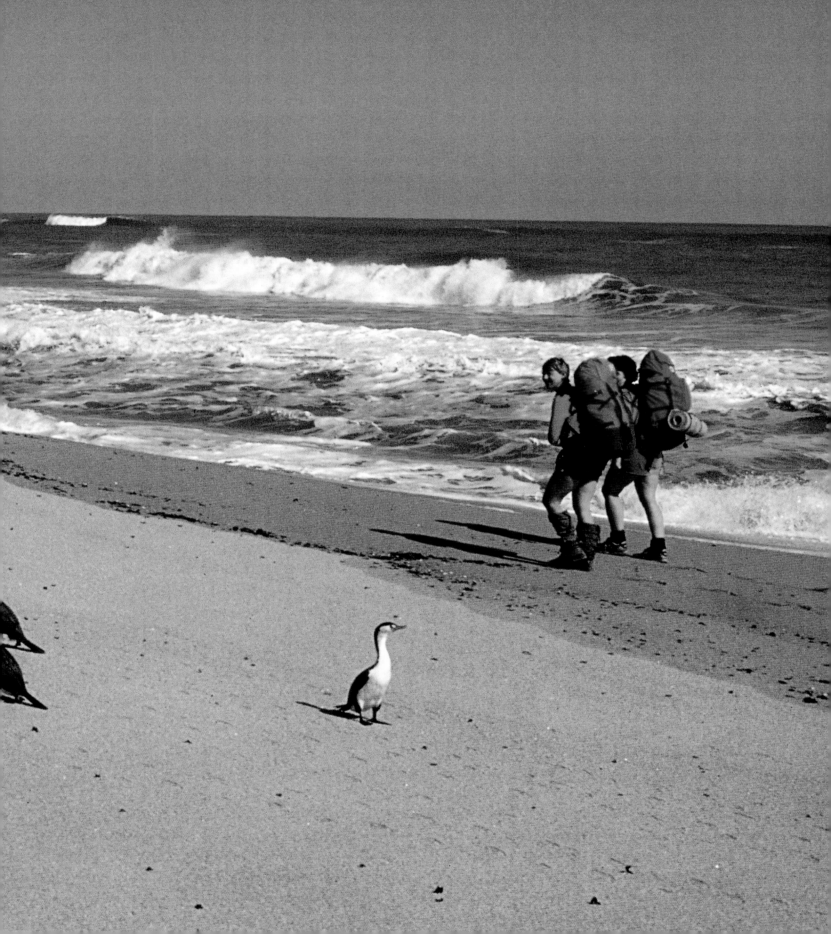

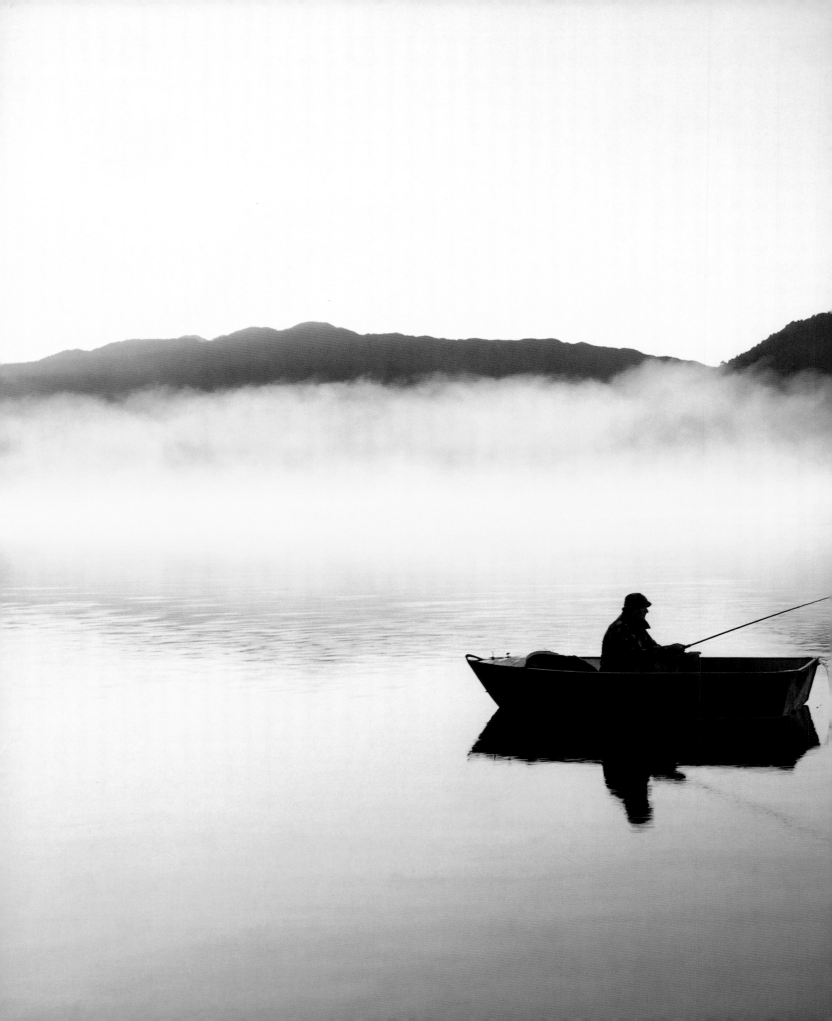

Life admist nature

110-111 *Golden light shines through morning mist on the West Coast's Lake Kanarie as this lone fisherman tries his hand for a breakfast feed. Many such lakes are dotted along the West Coast of the South Island. Fly fishing for trout in mountain streams also attracts a dedicated following of enthusiasts in New Zealand. The brown and rainbow trout were introduced to New Zealand*

in the 19th century. Many luxurious lodges exist in the country to cater for the visitor keen to test his skills with the rod. Some resorts insist that any fish caught is gently released back into the water.

111 *Big game fishing off Painia in the Bay of Islands attracts enthusiasts from all over the world.*

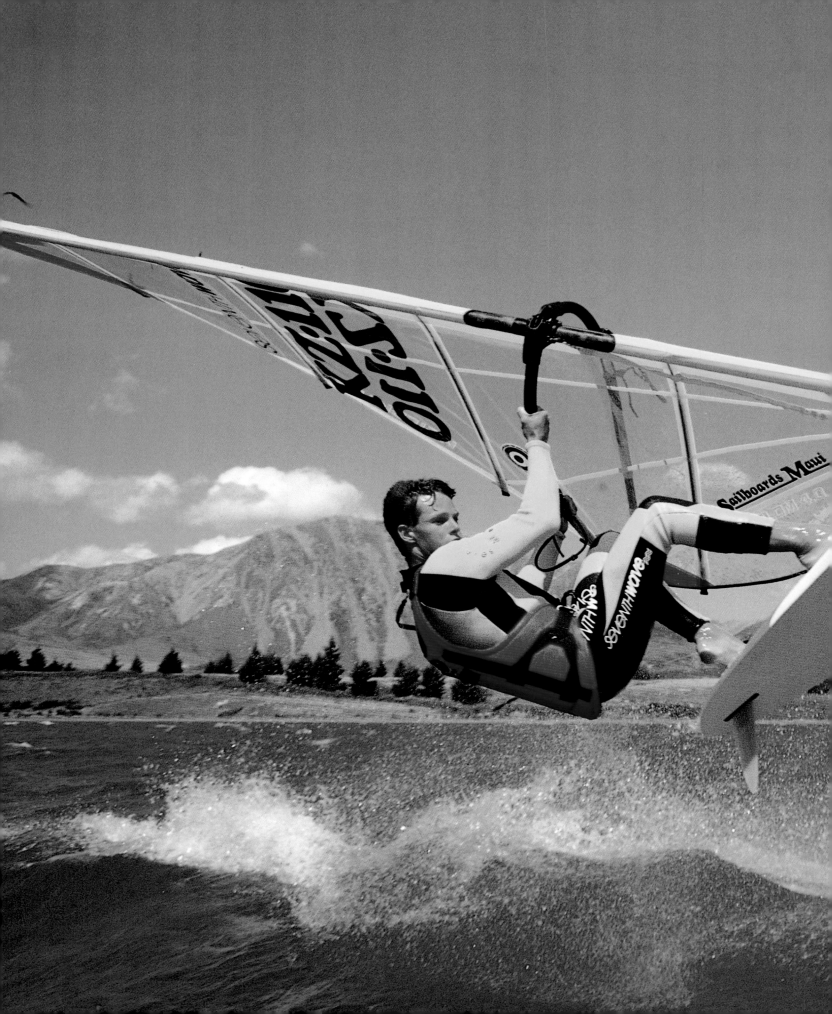

Off the edge
of a wave

112-113 *Windsurfing on Canterbury's
Lake Coleridge will test even the experts
as a strong westerly wind off the Southern
Alps rips across the water. New Zealand,
being a small group of islands with a
myriad of lakes and wild coastlines,
is an ideal place for windsurfing.*

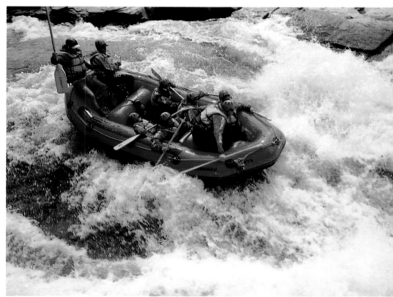

113 *Commercial rafting companies
take passengers on many of the thrilling
mountain rivers spilling down from the
peaks of the Southern Alps. For those
keener on a slightly tamer experience,
rafting and canoeing trips on the
meandering Wanganui river in the
North Island may appeal. New
Zealanders have built up a considerable
reputation in recent years for their
ability to excel in triathalon, multi-sport
competitions, involving mountain
running, cycling, canoeing and
swimming.*

114 The Whitbread Round-the-World race is perhaps the toughest test of both yacht and sailor. This aerial view of Auckland harbor shows the fleet departing on the New Zealand - South American leg of the race. The big ocean-going yachts are being farewelled by a flotilla of enthusiastic New Zealanders who have played host to the international crews for ten days while they rest, enjoy "Kiwi" hospitality and have their craft repaired.

115 Given the particular nature of its position, New Zealand could only be the homeland of navigators, starting with the Maori who occupied it around the 10th century A.D., then passing into the hands of the colonists that came from far-away Great Britain, up to the regatta champions, a new kind of oceanic adventure that has its most prestigious and qualified supporters here, from the designers of these fantastic boats to the teams that compete for prizes like the Americas Cup and the Whitbread Cup.

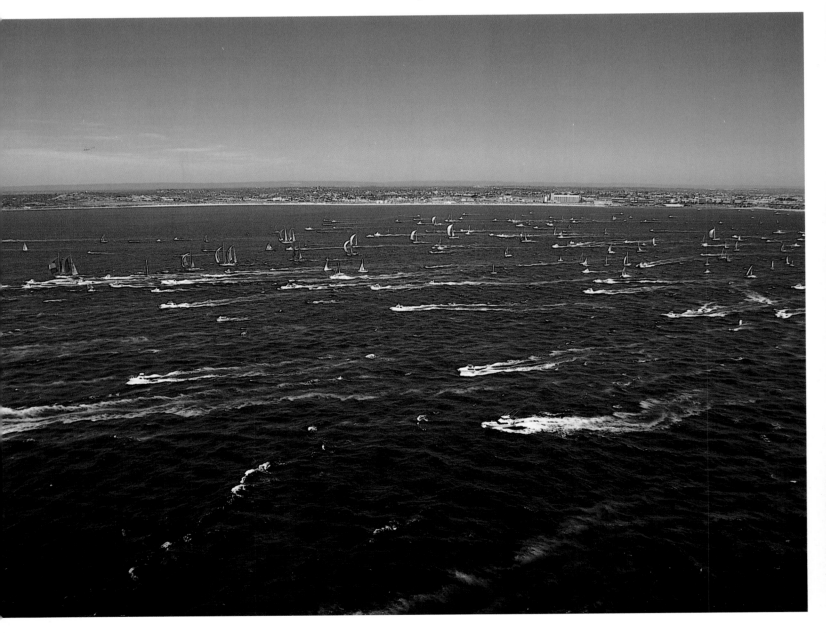

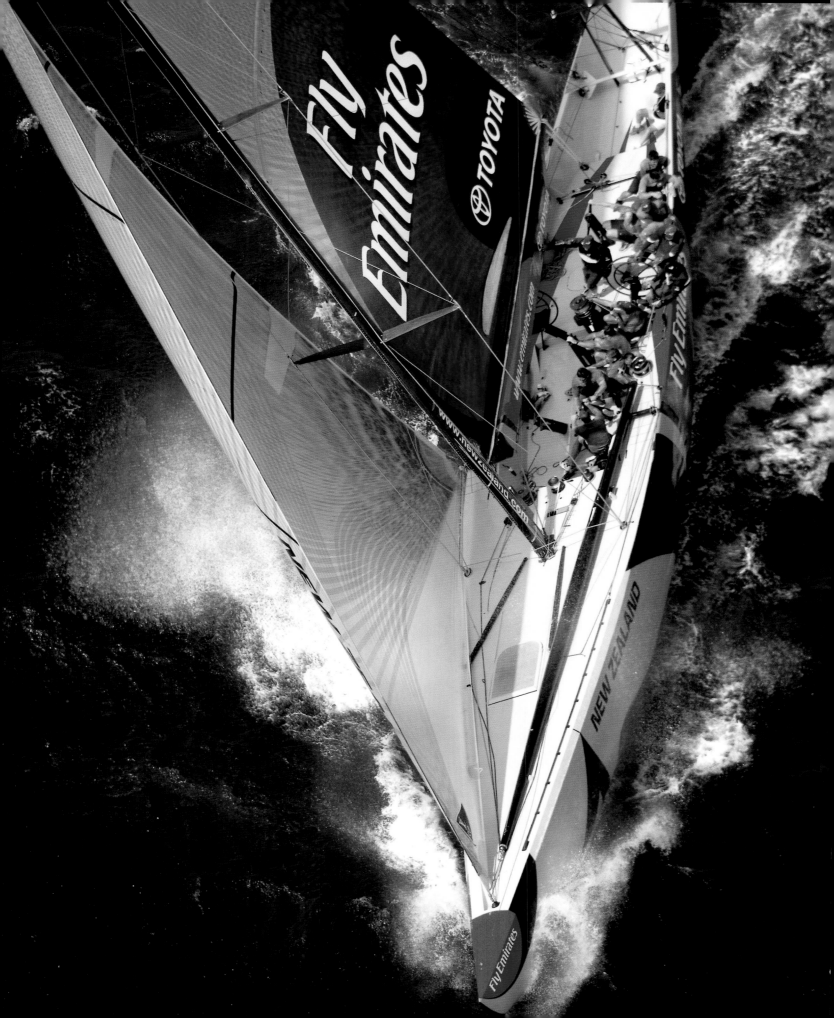

"Kiwi is magic"

116 top *Junior rugby football is played with a fervor and passion throughout the New Zealand school system. An increasing number of girls play both rugby and soccer. Everyone who plays the game aspires to join the ranks of the famous All Black National Rugby Team.*

116 bottom *This young woman is concentrating hard as she puts her horse through its paces at a country agricultural show. Horsemanship has long been an important sport in New Zealand inspired in recent years by the Olympic gold medal winner Mark Todd.*

117 *Country fairs such as this one in Queenstown often have competing axemen chop their way through logs anchored to a baseplate.*

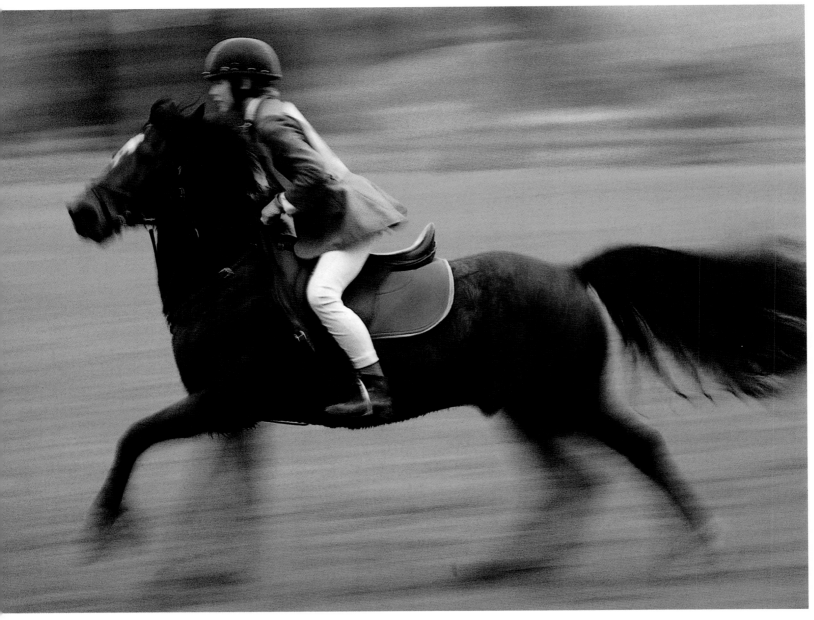

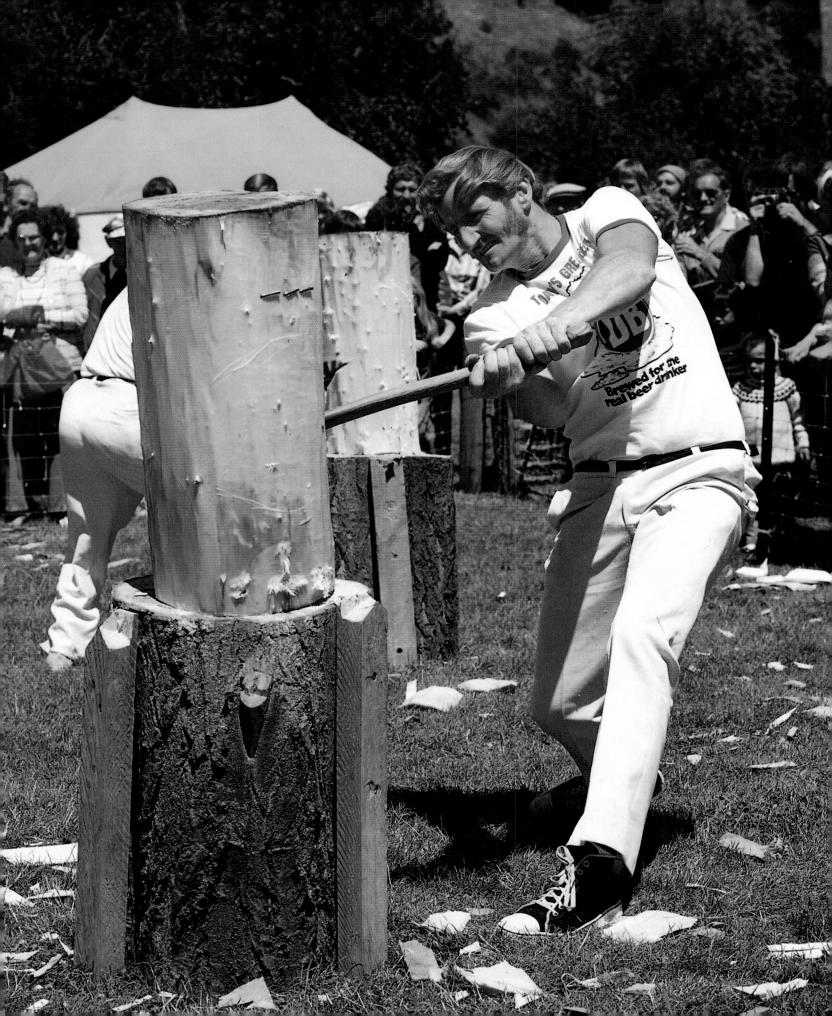

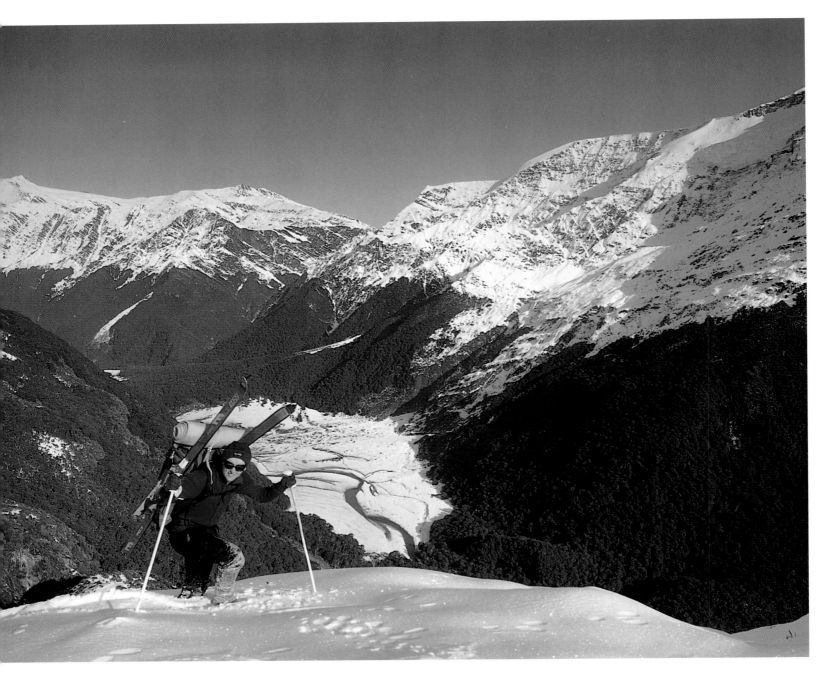

118 *This ski mountaineer has had a long hard climb from the valley floor of the Matukituki river to French Ridge hut. Mount Aspiring National Park in winter holds some very demanding skiing and climbing routes which require skill and experience to handle safely.*

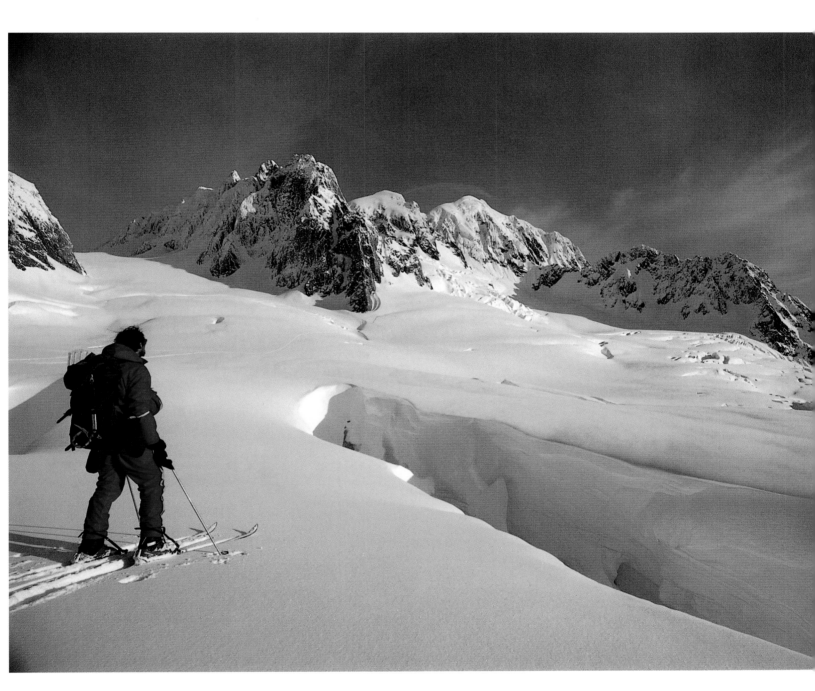

119 *Ski touring in Westland National Park under New Zealand's second highest peak Mount Tasman holds some great delights. Good snow conditions usually exist throughout the winter months from July to October.*
The national parks in New Zealand have an excellent network of high mountain huts which can be used by self-sufficient parties for a very modest cost.

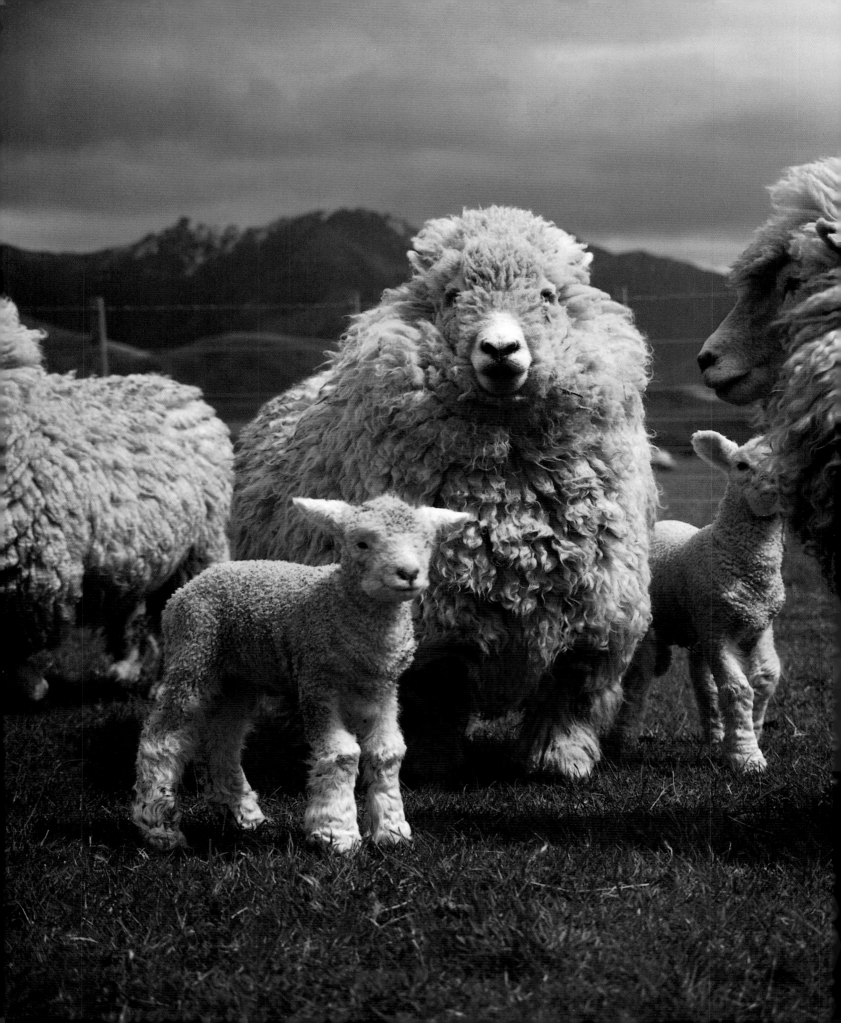

Farming: a way of life

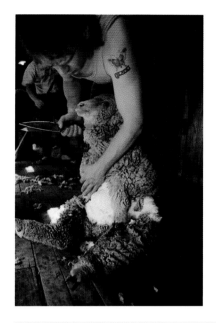

120-121 *Spring lambs arrive in late August/September, although in this photograph the ewes have not been shorn before lambing. Early lambs, timed to meet demand for the Christmas market in the Northern Hemisphere, can sometimes be severely affected by snowfall.*

121 top *New Zealand shearers are in demand around the world for their skilful speedy work. Many shearers work on a continual circuit around the world travelling from New Zealand farms to South Africa, Italy, Australia and the Falkland Islands. Women are also employed in shearing gangs some of whom clock up impressive daily tallies solely with hand shears.*

121 bottom *This typical Southland sheep farming landscape gives a feeling for much of the farming country in the lower South Island.*

122-123 *This dairy herd is moving out into a fresh paddock under the Seaward Kaikoura mountains after the morning milking. Dawn light illuminates the peaks and overcast sky.*

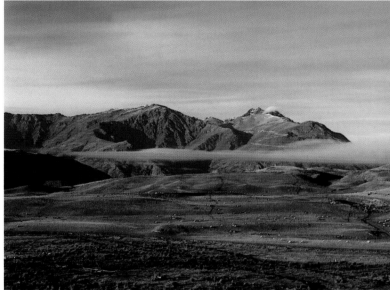

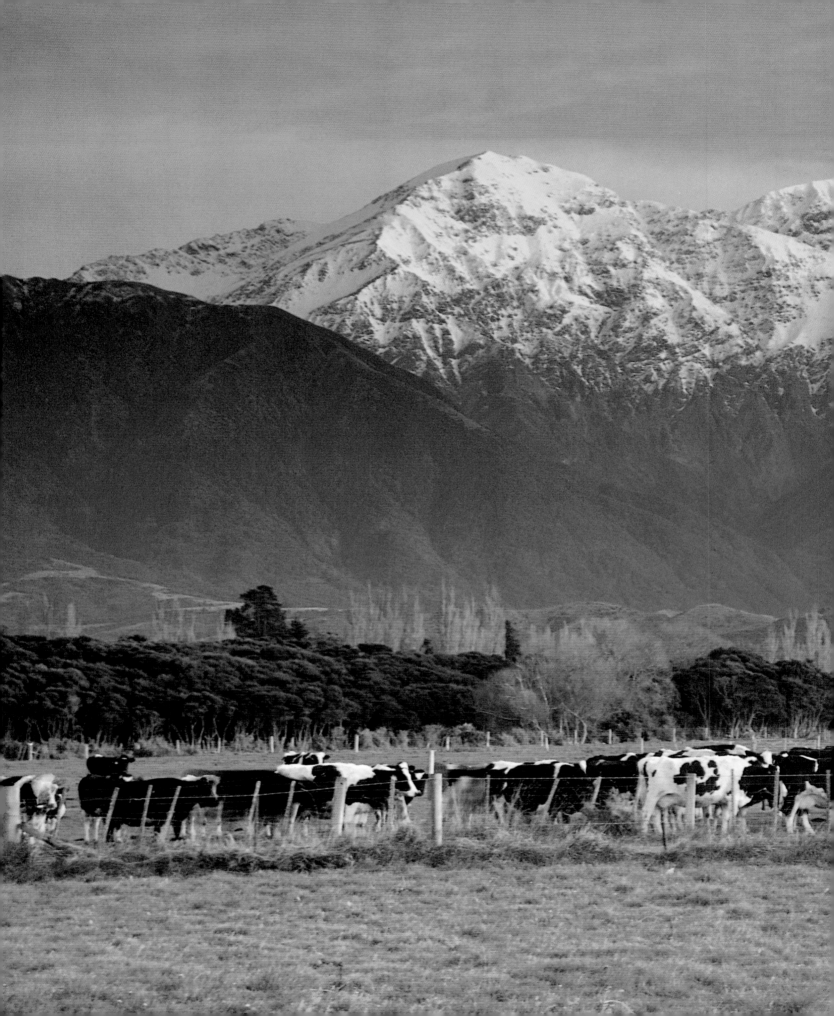

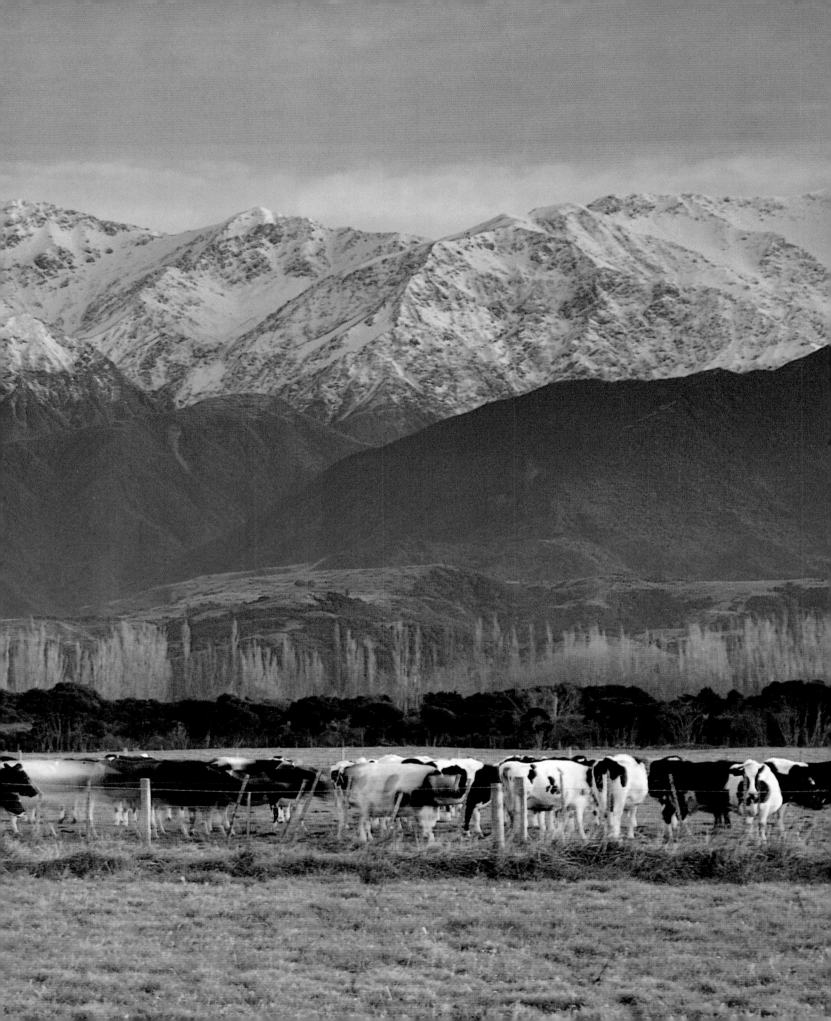

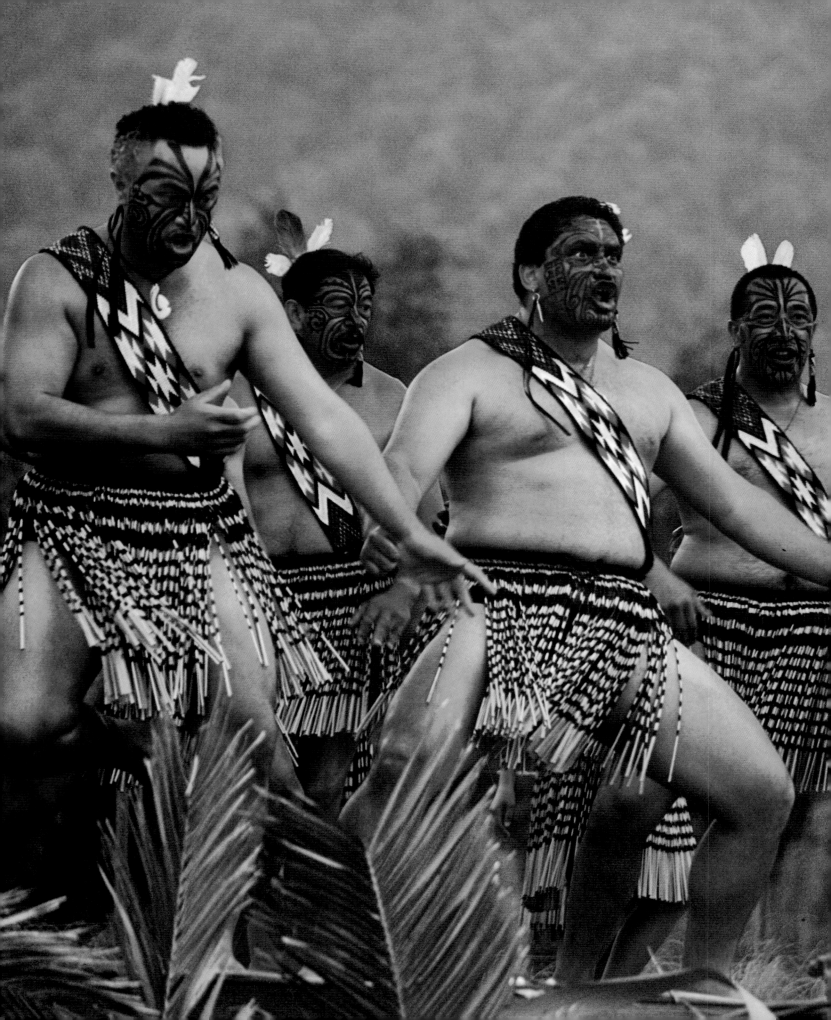

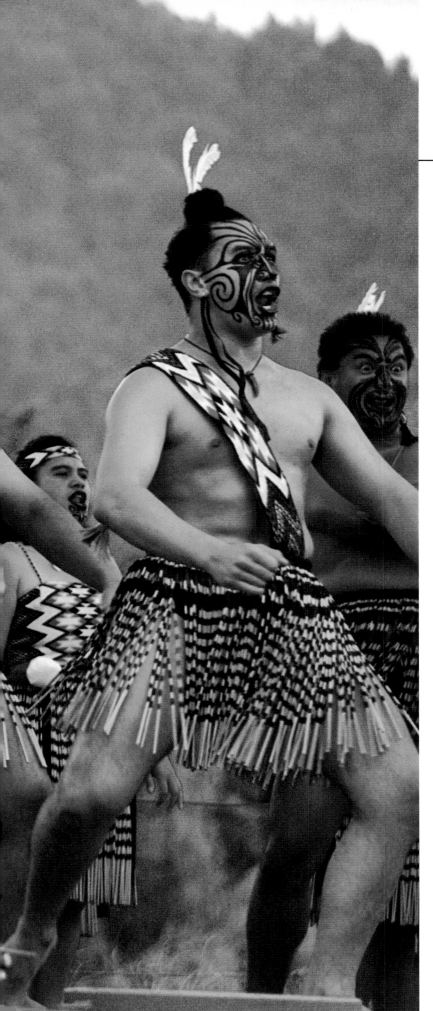

The Vikings of the Sunrise

124-125 and 125 top *The Maori Haka can be as fierce today as it was when the* Pakeha *(Europeans) first faced the war-like Maori in the 1800s. Skilled Polynesian navigators, the Maori landed on the northern coast of New Zealand in their ocean-going* waka *(canoes) some 800 years before the arrival of the first Europeans. Modern Maori still maintain* wakas *taking part in various ceremonies and interisland voyages.*

125 bottom *Maori women get ready to perform their traditional Poi dance in Christchurch to welcome foreign dignatories.*

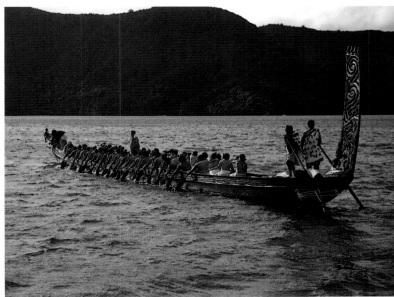

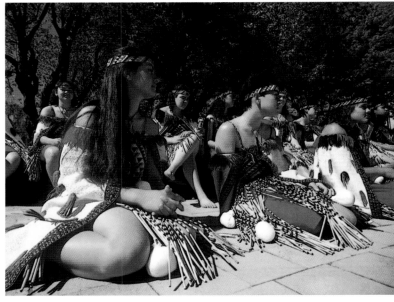

126-127 *Traditional Maori entrance ways on their* maraes *(courtyard, meeting grounds) are carved in native Totara and Kauri woods. The Maori people still welcome guests onto their* maraes *with a* hui *ceremony whereby the visitor is called onto the* marae *with a* karanga - *a long wailing call that beckons the living and celebrates the dead. The* karanga *is performed solely by women. The Maori language and most other aspects of their culture are very much alive in New Zealand today.*

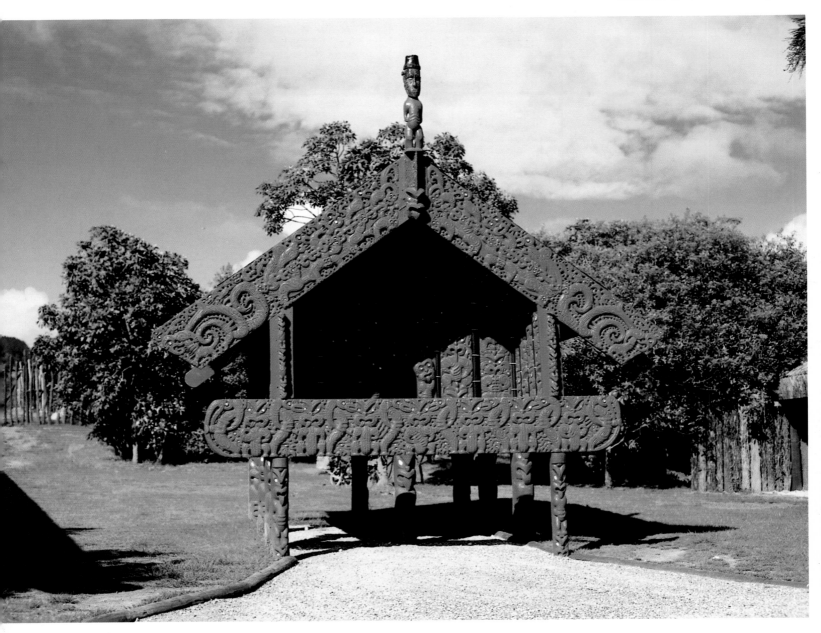

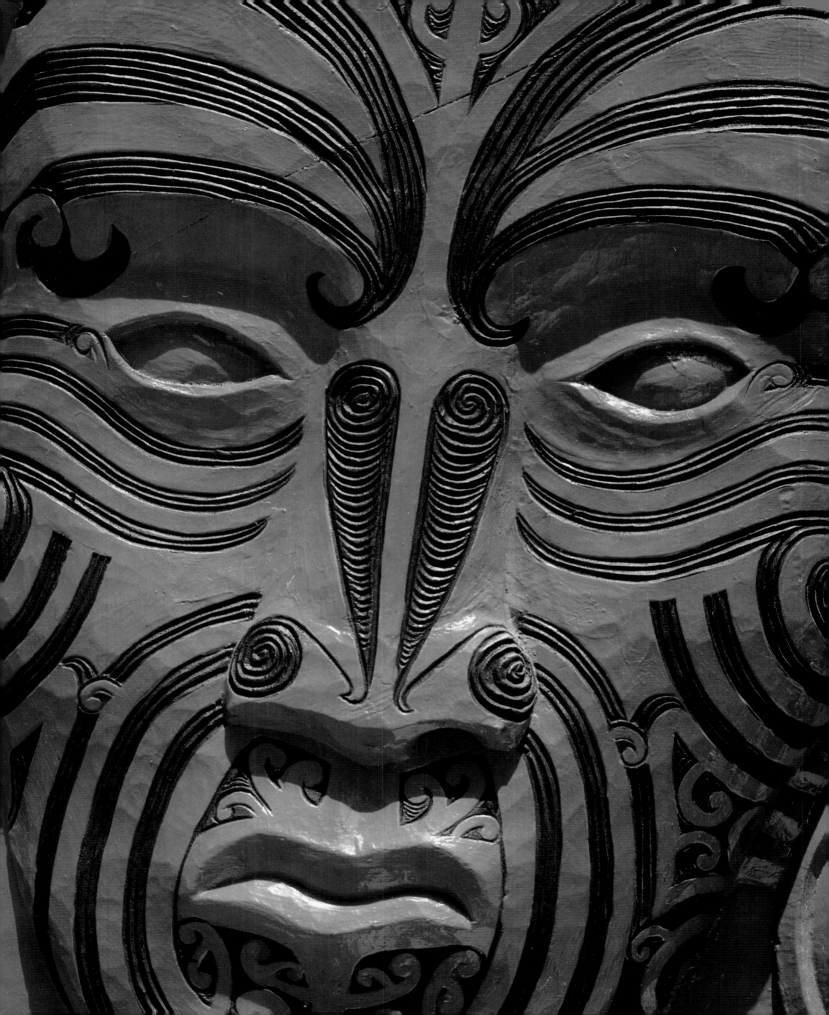

128 *Cigar-shaped clouds forming over the Remarkable mountains above Queenstown are the harbingers of strong wind and heavy rain sweeping in from the Tasman Sea.*

RONALDO

SECOND EDITION

Abbeville Press Publishers

New York · London

A portion of this book's proceeds are donated to the **Hugo Bustamante AYSO Playership Fund**, a national scholarship program to help ensure that no child misses the chance to play AYSO Soccer. Donations to the fund cover the cost of registration and a uniform for a child in need.

Text by Illugi Jökulsson
For the original edition
Design and layout: Árni Torfason and Ólafur Gunnar Gudlaugsson

For the English-language edition
Editor: Joan Strasbaugh
Production manager: Louise Kurtz
Design: Ada Rodriguez
Copy editor: Amy K. Hughes

PHOTOGRAPHY CREDITS

Getty Images: front cover (Lars Baron), p. 2 (Mike Hewitt), p. 22 (Rooney: Michael Regan), p. 23 (Bale: Denis Doyle), p. 23 (Zlatan: Harry Engels), p. 25 (Ronaldo: Denis Doyle), p. 28 (Claudio Villa), p. 29 (left: Jeff J. Mitchell), p. 29 (right: Denis Doyle), p. 30 (Laurence Griffiths), p. 31 (Michael Steele), p. 35 (above: Jasper Juinen), p. 33 (below: Denis Doyle), p. 34 (Allsport Hulton), p. 35 (Denis Doyle), p. 36 (left: Jamie McDonald), p. 36 (right: Ben Radford), p. 37 (Shaun Botterill), p. 42 (celebration: Denis Doyle), p. 46 (Stuart Franklin/FIFA), p. 48 (David Ramos), p. 50 (Ronaldo: Europa Press), p. 51 (Ronaldo: Juan Naharro Gimenez), p. 52 (upper: David Ramos), p. 52 (lower: Jasper Juinen), p. 53 (upper: ChinaFotoPress), p. 53 (Denis Doyle), p. 54 (Ian Walton), p. 60 (Jasper Juinen).

Shutterstock: front cover and p. 10 (Ferguson: Mitch Gunn), p. 10 (Mourinho: Maxisport), p. 10 (Ronaldo: Maxisport), p. 11 (Ancelotti: katatonia82), p. 13 (Maxisport), p. 14 (Ronaldo: Photo Works), p. 14 (Januzaj: mooinblack), p. 16 (Ronaldo: Maxisport), p. 16 (Ronaldinho: Maxisport), p. 17 (Natursports), p. 18 (Olga_Anourina), p. 20, p. 21 (Mitch Gunn), p. 20 (Ronaldo: Natursports), p. 21 (Suárez: mooinblack), p. 22 (Messi: mooinblack), p. 22 (Natalia Mylova), p. 25 (George Michael: Mark III Photonics), p. 26 (Ronaldo: Mitch Gunn), p. 38 (Tomasz Bidermann), p. 40 (Bale: Photo Works), p. 40 (Ronaldo: Natursports), p. 40 (Zidane: Eoghan McNally), p. 40 (Zlatan: Maxisport), p. 40 (Kaká: Maxisport), p. 41, pp. 44–45.

Árni Torfason: p. 8, 9, 36, 56, 57, 58, 60.

Please note: This book has not been authorized by Ronaldo or persons associated with him.

First published in the United States of America in 2015 by Abbeville Press, 137 Varick Street, New York, NY 10013

First published in Iceland in 2014 by Sögur útgáfa, Fákafen 9, 108 Reykjavík, Iceland

Second edition
10 9 8 7 6 5 4 3 2 1

A previous edition of this book was cataloged as follows:
Library of Congress Cataloging-in-Publication Data
Illugi Jökulsson.
 [Cristiano Ronaldo. English]
 Ronaldo / by Illugi Jökulsson. — First edition.
 pages cm. — (World soccer legends)
 Translated from Icelandic.
 Summary: "The story of the "ultimate footballer," Cristiano Ronaldo. Covers the star's youth in Madeira, his nicknames, his record with Manchester United, and includes a list of the numerous awards he has received"— Provided by publisher.
 1. Ronaldo, Cristiano, 1985—Juvenile literature. 2. Soccer players—Portugal—Biography—Juvenile literature. I. Illugi Jökulsson. Cristiano Ronaldo. Translation of: II. Title.
 GV942.7.R626I45 2014
 796.334092—dc23
 [B]
 2013045842

For bulk and premium sales and for text adoption procedures, write to Customer Service Manager, Abbeville Press, 137 Varick Street, New York, NY 10013, or call 1-800-ARTBOOK.

Visit Abbeville Press online at www.abbeville.com.

CONTENTS

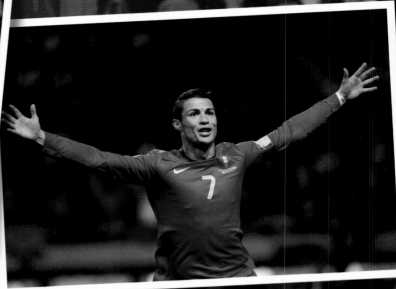

PORTUGAL'S BEACON OF HOPE

Portugal has long had a powerful soccer team but has never managed to win first prize at a big tournament. The Portuguese therefore did not expect to win the 2014 World Cup—the most challenging tournament between the world's leading national soccer teams—but they were proud of their team's effort. And who knows what the future will bring for the Portuguese team? Their wildest dreams may still come true. As a matter of fact, Portugal is lucky enough to boast one of the world's strongest soccer players.

CRISTIANO RONALDO!

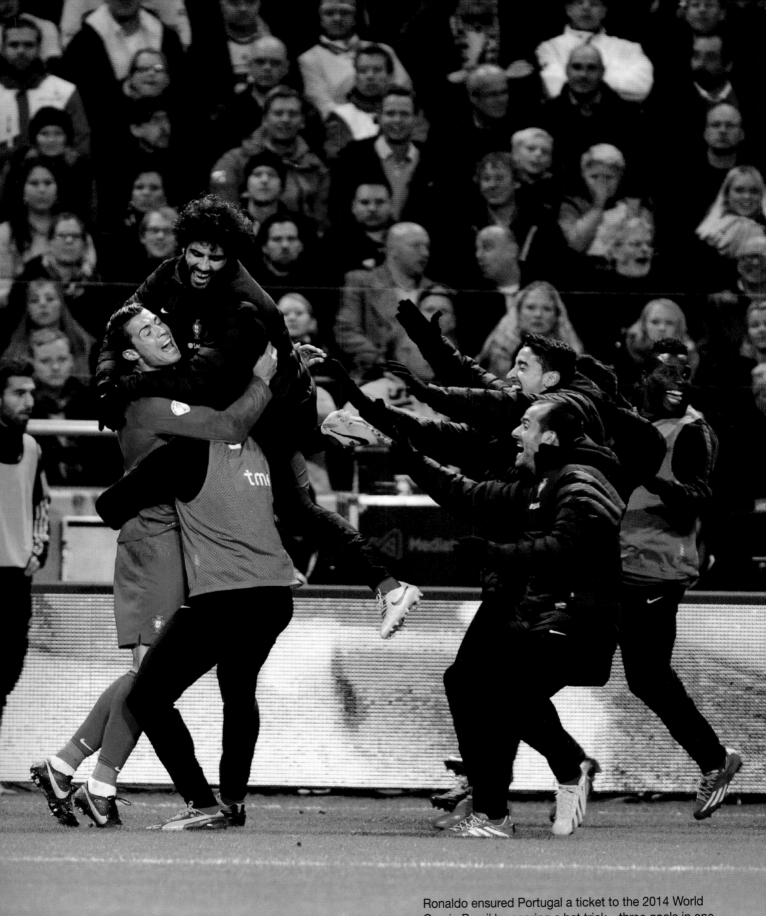

Ronaldo ensured Portugal a ticket to the 2014 World Cup in Brazil by scoring a hat trick—three goals in one game—in playoffs against Sweden on November 19, 2013, in Friends Arena in Stockholm.

Alex Ferguson, former Manchester United manager

"I think he's the best player in the world. He can play with both feet, he has fantastic skill, strength, and bravery, and he's a great header of the ball. I saw how he dedicated himself in training sessions to becoming the best in the world."

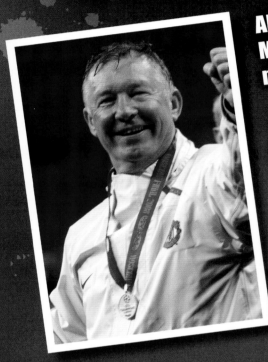

José Mourinho, Chelsea coach

"Cristiano Ronaldo is unique. Each year he achieves such great accomplishments that you think that he can't do better. But then he always improves. He's simply on another level than other footballers."

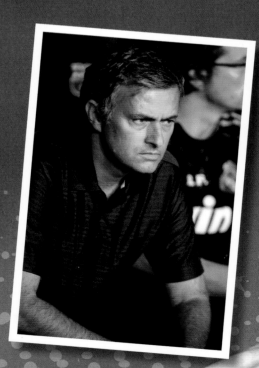

PLAYER

Carlo Ancelotti, Real Madrid coach

"His talent and ability for scoring goals were no surprise to me. But I was a bit surprised by his strength of character and his willingness to sacrifice himself for success both on the field and outside it. . . . Now that he has acquired the Ballon d'Or for the second time, he is even more eager to prove his worth!"

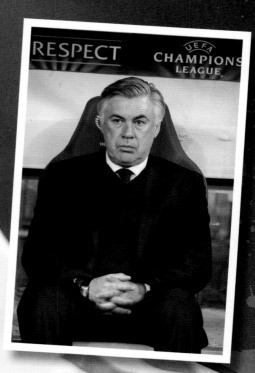

WHERE DOES HE COME FROM?

MADEIRA

Funchal

Portugal

Cristiano Ronaldo comes from Funchal, the largest town on the island of Madeira, which belongs to Portugal.

Portugal

The country covers an area of 35,500 square miles in total and has a population of 10.4 million. The capital is called Lisbon and has 2.8 million inhabitants.

The Madeiras

The largest island, Madeira, is 286 square miles and has a population of 260,000, of which 111,000 live in the capital, Funchal. Twenty-seven miles away is another island, Porto Santo, which is 16 square miles in size and has a population of 4,300. There are several smaller, uninhabited islands in the archipelago. The islands are roughly 300 miles off the coast of Africa, and more than 620 miles from the mainland of Portugal. The flight between Madeira and Lisbon takes approximately one-and-a-half hours. The Madeiras are 250 miles north of the Canary Islands, which belong to Spain.

History

European ships sailing along the African coast probably found the Madeiras a long time ago, and around AD 1420 sailors and merchants from Portugal started to settle on them. The Portuguese cleared the forests that covered the islands in order to plant sugarcane. The sugar plantations were later moved to Brazil and replaced with vineyards. There is a variety of wine produced in the archipelago called Madeira wine. In addition to agriculture, the islanders make their living from fishing, tourism, and financial services.

In 1976, the Madeiras were granted political autonomy.

Soccer

Soccer is the most popular sport in Portugal. The three strongest clubs by far

are Benfica and Sporting from Lisbon, and Porto from the city of Oporto. Porto has dominated the Portuguese League since the beginning of the 21st century. In recent years, the club Braga has been growing in strength. There are several soccer clubs in Madeira, and two of them, Maritimo and Nacional, play in the Portuguese top division. They are among the strongest clubs in the league and have competed in the European tournament, but haven't won any trophies or titles. Matches between these two teams are heated affairs.

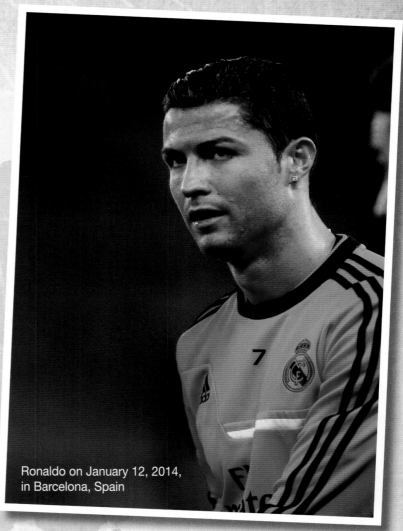

Ronaldo on January 12, 2014, in Barcelona, Spain

Who is he?

Cristiano Ronaldo is the youngest of four siblings. He has one older brother, Hugo, and two older sisters called Elma and Liliana Catia. They are considerably older than him, as they were born between 1974 and 1976.

Ronaldo's parents were called José Dinis Aveiro and Maria Dolores dos Santos, and were regular working-class people. José was a gardener and Dolores a cook. The family had very little money to spare.

What is his name?

One of his sisters got to choose his first name, but his middle name was inspired by Ronald Reagan, who was president of the United States when Ronaldo was born. Reagan used to be a modestly successful film star and was a favorite of Ronaldo's father.

According to Portuguese naming traditions, people usually use the surnames of both mother and father, so the boy's full name is . . .

Cristiano Ronaldo dos Santos Aveiro.

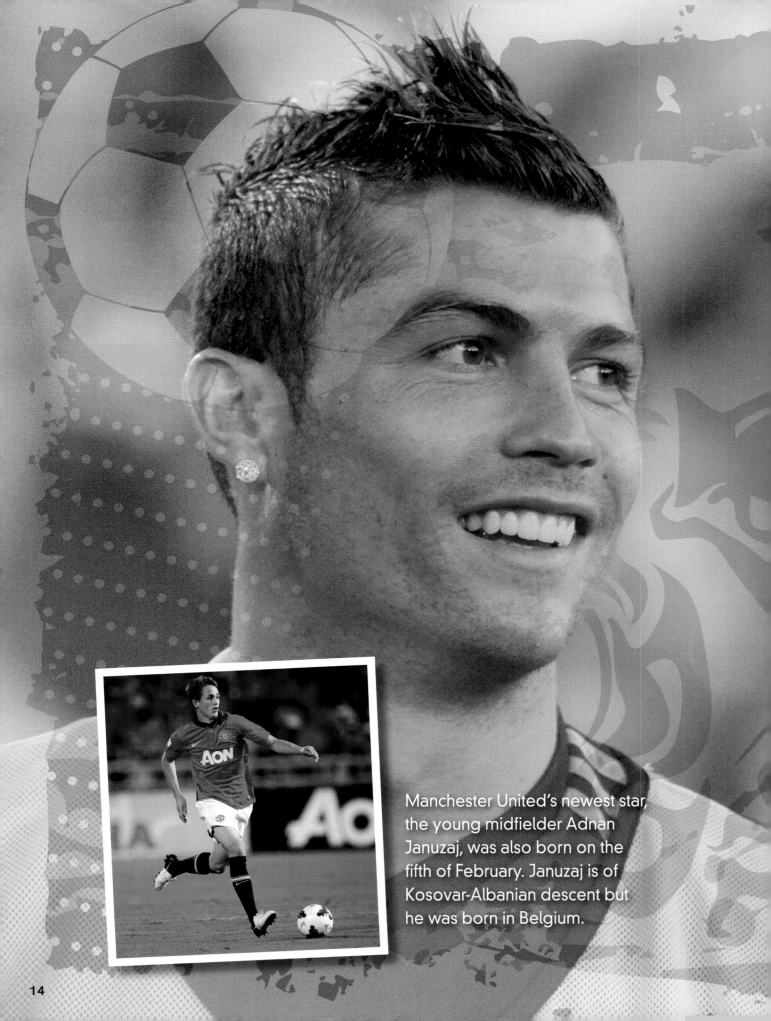

Manchester United's newest star, the young midfielder Adnan Januzaj, was also born on the fifth of February. Januzaj is of Kosovar-Albanian descent but he was born in Belgium.

CR'S BIRTHDAY

Cristiano Ronaldo was born on February 5, 1985. His zodiac sign is Aquarius, which reigns in the sky from January 21 to February 19. Of course, astrology has no scientific value, but people born in the zodiac sign of Aquarius are said to be fit, frank, diligent, energetic, and imaginative. That would certainly describe Cristiano Ronaldo! Body parts ruled by Aquarius are the thighs, ankles, feet, and chest—that also seems about right! The name Aquarius, which means "water-bearer" or "cup-bearer," comes from Greek mythology. Aquarius was a boy called Ganymede who was known for being the greatest and most handsome in the world. Cristiano would probably say that sounded just about right, too!

He shares his birthday with other famous soccer heroes. Two of those are retired: Gheorge Hagi, an incredible midfielder from Romania who played with both Real Madrid (1990–1992) and FC Barcelona (1994–1996), and Giovanni van Bronckhorst, who was a left back for Barcelona (2003–2007) and played more than 100 international games for the Netherlands.

Two of the best strikers active today also share a birthday with Ronaldo. The Argentine Carlos Tévez was born on February 5, 1984, and the Brazilian Neymar was born on February 5, 1992. Barcelona's Neymar will probably compete with Cristiano Ronaldo for the media's attention during the next few years!

Finally, a hugely promising young midfielder with Manchester United, the Belgian Adnan Januzaj (of Kosovar-Albanian ethnicity), was born on February 5, 1995.

The young Cristiano.

A Good Day for Football!

February 5
S. G. Eriksson 1948
Hagi 1965
Bronckhorst 1975
Tévez 1984
C. Ronaldo 1985
Neymar 1992
Januzaj 1995

15

THREE RONALDOS!

The name Ronaldo is not very common, so it's a little strange that three men named Ronaldo have been elected World Player of the Year a total of seven times in eighteen years.

THE FIRST RONALDO

Ronaldo Luis Nazário de Lima, Brazil
Born on September 18, 1976

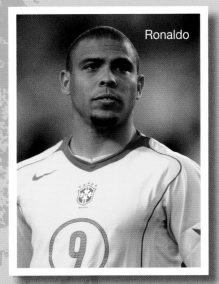

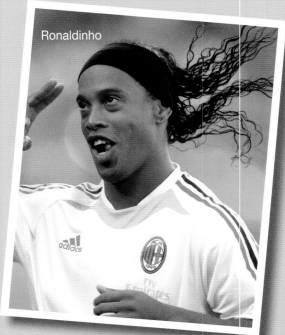

The greatest goal machine in the world from 1995 to 2005, he scored countless goals for PSV Eindhoven, Barcelona, Inter Milan, and Real Madrid. He suffered frequent injuries but was completely unstoppable when he was in top form. Ronaldo was fantastic with the Brazilian national team, was elected FIFA World Cup Best Player in 1998, and was awarded the Golden Shoe in the 2002 World Cup. He holds the record for most goals scored in a World Cup final, a total of 15.

From 1993 to 2011, Ronaldo played 518 matches with his clubs and scored 387 goals. He played 98 internationals and scored 62 goals.

He was awarded the FIFA World Player of the Year in 1996, 1997, and 2002, as well as the Ballon d'Or in 1997 and 2002! The two awards were combined in 2010.

LITTLE RONALDO!

Ronaldo de Assis Moreira
"Ronaldinho," Brazil
Born on March 21, 1980

He emerged while Ronaldo Nazário was still in his prime and so he was dubbed "Ronaldinho," or "Little Ronaldo," to distinguish between the two. Ronaldinho played with Barcelona from 2003 to 2008. At his best he was incredibly skilled, tricky, and entertaining to watch on the field. He was an amazing scorer and some of his free kicks were simply breathtaking. Ronaldinho contributed greatly to his national team, and both Ronaldo Nazário

and Ronaldinho were on the 2002 World Cup team. Eventually Ronaldinho seemed to lose interest in playing for the big European clubs, and he moved back to Brazil in 2011.

Ronaldinho had played a total of 684 league games and had scored 273 goals by May 2014. He had also played 97 internationals and scored 33 goals. He was awarded the FIFA World Player of the Year in 2004 and 2005 and the Ballon d'Or in 2005!

THE BEST RONALDO?

Three years after Ronaldinho was elected FIFA World Player of the Year, it was CRISTIANO RONALDO's turn. He was awarded the honor in 2008.

The defining talents of Ronaldo Nazário were speed and explosive power. Ronaldinho was known for his feints, sly passes, and beautiful free kicks. It's fair to say that Cristiano Ronaldo combines the best talents of the two earlier Ronaldos!

When will the next Ronaldo appear?

FIFA BALLON D'OR (World Player of the Year until 2013)

1991	Lothar Mattäus	2003	Zinedine Zidane
1992	Marco van Basten	2004	Ronaldinho
1993	Roberto Baggio	2005	Ronaldinho
1994	Romário	2006	Fabio Cannavaro
1995	George Weah	2007	Kaká
1996	Ronaldo	2008	Ronaldo
1997	Ronaldo	2009	Lionel Messi
1998	Zinedine Zidane	2010	Lionel Messi
1999	Rivaldo	2011	Lionel Messi
2000	Zinedine Zidane	2012	Lionel Messi
2001	Luís Figo	2013	Ronaldo
2002	Ronaldo		

What does the name mean?

"Ronaldo" is the same name as "Ronald" in English. It is Nordic in origin and means "he who rules with counsel" or "wise ruler."

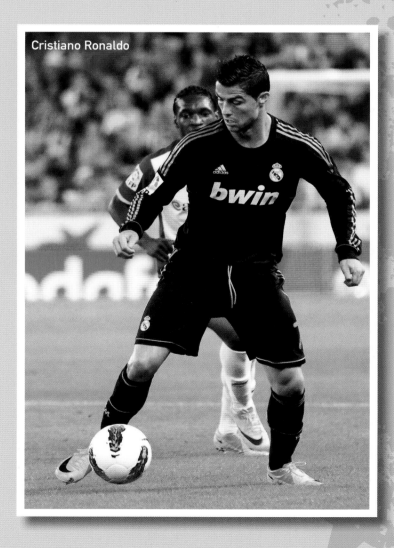

Cristiano Ronaldo

Funchal in Madeira.
This is where Cristiano Ronaldo grew up.

5

THE BEGINNING IN PORTUGAL

Cristiano Ronaldo's father, José Dinis Aveiro, was a soccer fan. He took care of the uniforms for the soccer club Andorinha, which is a small club in Santo António—the neighborhood in Funchal where Ronaldo grew up. José gave his son a soccer ball for his fifth birthday, and Ronaldo loved it so much that he even took it to bed with him! Ronaldo's mother, Dolores, also supported him wholeheartedly when she and her husband realized that their boy was unusually talented at soccer.

He played in the youth teams for Andorinha but joined a larger club in Funchal, Nacional, when he was 10. By then, anyone could see that Cristiano Ronaldo would go far. He was extremely talented but also hardworking and ambitious. Nobody was more conscientious at training. He would get very upset if things didn't go well; sometimes he would break down in tears, and his teammates would laugh at him. He didn't care—he was just so determined to do well and to WIN!

When he was just 12 years old, Sporting, one of the biggest Portuguese clubs, bought him from Nacional for a handsome sum. It was unheard of for a mighty club in Lisbon to pay so much for a 12-year-old, but the management of the club was convinced that he would become one of soccer's greats. It was a big step for a small kid who had never left Madeira to move to Lisbon by himself. At first, Ronaldo was often lonely and missed his family. But he dealt with it by training harder, determined to become the world's best player!

On October 7, 2002, Ronaldo debuted with Sporting's first team in the Portuguese Premier League. The opposing club was Moreirense. Ronaldo was 17, and he started with a bang. The youngster scored two goals in the match, which Sporting won, 3–0.

The first goal gave a taste of what was to be expected from Ronaldo. After passing back and forth with his teammate in midfield, Ronaldo took off with the ball, leaving all of Moreirense's midfielders and defenders in the dust. He made a fine scissor move as he whizzed past the remaining defenders and smashed the ball under the goalkeeper and into the net. Cristiano Ronaldo had arrived on the big stage!

MANCHESTER, ENGLAND!

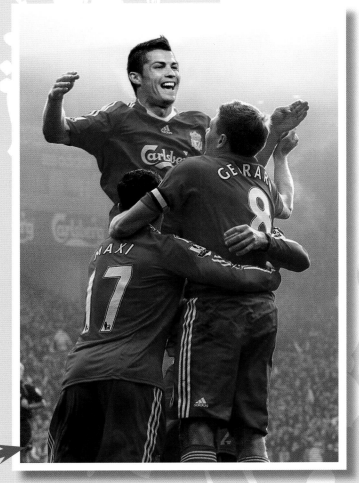

Gerard Houllier, decided that Ronaldo was too young. He felt that Ronaldo needed to mature and play a bit longer at home in Portugal. So he turned down the offer. That was a huge sporting and business blunder if there ever was one!

Sir Alex swoops in

The English soccer superpower Manchester United visited Lisbon in the summer of 2003 to play a practice match against Sporting, which Cristiano Ronaldo played for at the time. He was just 18. Even though United was one of the great clubs of European soccer, Sporting won the match, 3–1. Ronaldo was the key to the team's success. He outplayed United's players time and again. There are several versions of what happened next.

This photo of Cristiano Ronaldo and Steven Gerrard celebrating a goal for Liverpool . . . and this one of Ronaldo celebrating a goal for Arsenal are both fakes! But they actually could have been real. In the autumn of 2002, Ronaldo was invited to train with Arsenal. Arsenal's manager, Arsene Wenger, is known for having a great eye for young talent, but somehow he didn't spot Cristiano Ronaldo! In the spring of 2003, Ronaldo's agents offered him to Liverpool, and the Merseyside club certainly was interested. It was obvious that the lad had potential! But eventually Liverpool's manager,

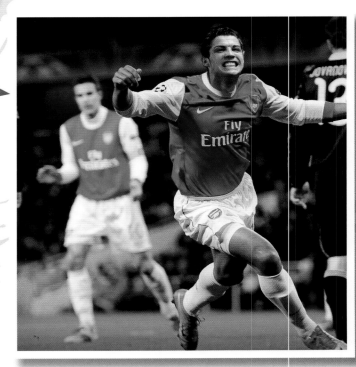

One story goes that on the way to the airport after the match, the United players Rio Ferdinand and Ryan Giggs sat down on the bus next to the manager, Alex Ferguson. They were fascinated by the young Portuguese player and almost ordered their manager to buy him for United. Sir Alex agreed and shouted to the bus driver to turn around. They drove back to Sporting headquarters and Ferguson signed Ronaldo there and then.

It may not have happened exactly like this, as in all probability United had already decided to buy Ronaldo before going to Portugal. But it is true that he impressed everyone with his skill, and that was the last game he played for Sporting. Soon enough he was on a plane headed for Manchester.

Return to Portugal

In September 2007, four years after Ronaldo left Sporting, the two clubs met again in Lisbon, in a UEFA Champions League match. It was on the very same field where Ronaldo had played with Sporting against United in that practice match. Sporting had a strong team and they were determined to win on their home ground. But they failed to score, and when the match was almost over, Ronaldo scored an unexpected header.

He seemed slightly uncomfortable scoring that vital goal against his old club. After modestly celebrating the goal with his teammates in United, he bowed to the Sporting fans. He had been their idol. And when the match ended with a 1–0 victory for United, the Sporting supporters gave their lost son a standing ovation. He had entertained them so much in the past that they generously forgave him for crushing their hopes of victory.

HOW TALL IS HE?

Cristiano Ronaldo grew tall at an early age. He's 6'1" and weighs 186 lbs.

HEIGHT UNDER THE BAR: 8 FEET

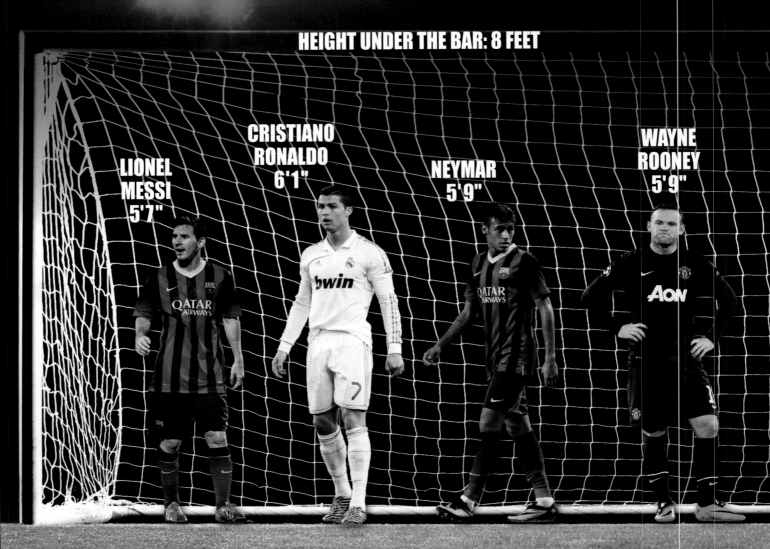

LIONEL MESSI 5'7"

CRISTIANO RONALDO 6'1"

NEYMAR 5'9"

WAYNE ROONEY 5'9"

Soccer is one of few sports in the world in which size does not matter greatly. Below you can see Ronaldo's height compared to a few other famous contemporary forwards.

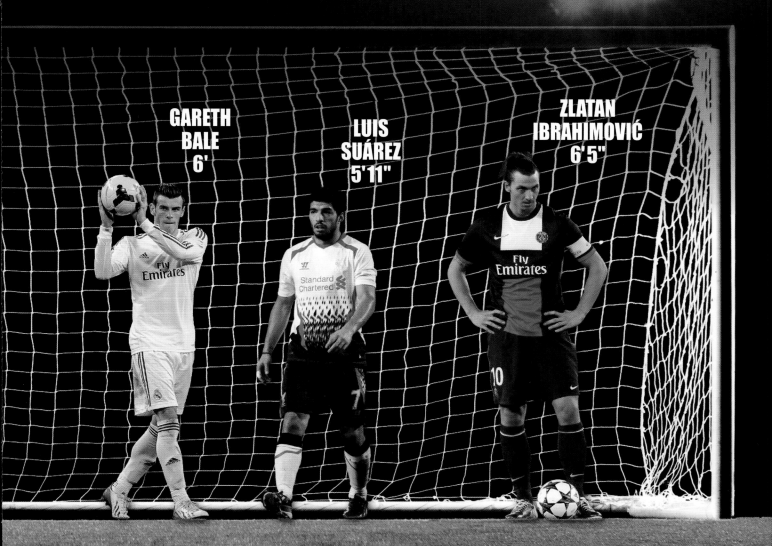

GARETH
BALE
6'

LUIS
SUÁREZ
5'11"

ZLATAN
IBRAHIMOVIĆ
6'5"

FAVORITES

Salt fish—or *bacalao* as it's called—is very popular in both Spain and Portugal. The fish is salted cod caught in northern waters, especially around Iceland. The Portuguese have hundreds of bacalao recipes, and one of them is "Bacalhau à Brás." It's really easy to make, and it's available all over Portugal, almost like fast food.

Ronaldo enjoyed this dish often when he was growing up in Madeira, and he says that Bacalhau à Brás is still his favorite food!

FAVORITE FOOD:
BACALAO!

Cook Ronaldo's Favorite Meal!

Bacalhau à Brás

- —1.5 lb. bacalao
- olive oil
- 3 onions, thinly sliced
- 2 cloves of garlic, finely chopped
- lb. potatoes, shredded
- 5 eggs, beaten
- salt and pepper to taste

Sauté the onion and garlic in the olive oil in a large pan. Cut the cod into long strips, and shred the potatoes so they resemble matchsticks. Add the fish to the pan and, while it fries, deep-fry the potato sticks in another pan. When the potatoes are ready add them to the pan with the fish, and gently stir all the ingredients together. Then beat the eggs in a bowl with a fork and pour them onto the pan. Stir gently until the eggs are cooked. Serve and eat!

FAVORITE DRINK: Santal fruit drink.

FAVORITE MUSIC: Romantic music by Sade, George Michael, Elton John, and Phil Collins. Any kind of dance music. "When I need to get my eyes open in the morning, I listen to catchy Brazilian music!" he claims.

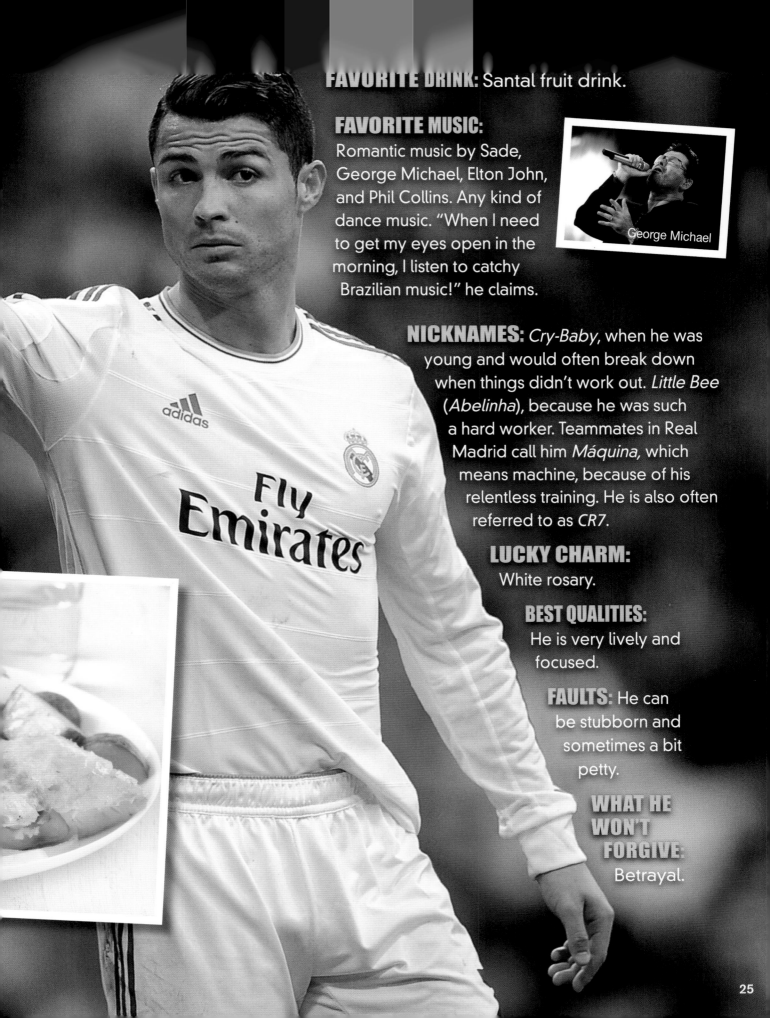

George Michael

NICKNAMES: *Cry-Baby*, when he was young and would often break down when things didn't work out. *Little Bee* (*Abelinha*), because he was such a hard worker. Teammates in Real Madrid call him *Máquina,* which means machine, because of his relentless training. He is also often referred to as *CR7*.

LUCKY CHARM: White rosary.

BEST QUALITIES: He is very lively and focused.

FAULTS: He can be stubborn and sometimes a bit petty.

WHAT HE WON'T FORGIVE: Betrayal.

25

UNITED and Ronaldo

Cristiano Ronaldo scored his first goal for United on November 1, 2003. He took a free kick from the far left flank, and the ball soared across the field, dropping suddenly into the back of the net. In the spring of 2004, he scored the first goal for United in the FA Cup Final, when United beat Millwall, 3–0.

Aside from these goals, Ronaldo didn't score much during his first seasons with United. He was young and had obvious potential, but he could be slightly unreliable. Sometimes he seemed to drift off, and he was often accused of diving and was too prone to complaining to the referee.

But, he wasn't meant to be a top scorer in those first seasons, anyway. Manager Sir Alex Ferguson felt he was best positioned on the flank. But Ronaldo improved each year, becoming stronger and more confident. His goal-scoring abilities proved to be phenomenal, from anywhere on the field. In the 2007–2008 season, he was no longer just promising, but simply one of the best players in the world.

Season	League matches	League goals	Total matches	Total goals
2003–2004	29	4	40	6
2004–2005	33	5	50	9
2005–2006	33	9	47	12
2006–2007	34	17	53	23
2007–2008	34	31	49	42
2008–2009	33	18	53	26

Premier League 2003–2004

1 **Arsenal**
2 Chelsea
3 Manchester United

UEFA Champions League: Round of 16, lost to Porto under the management of José Mourinho. Porto went on to win the title that year. **Ronaldo goals: 0**

Premier League 2004–2005

1 Chelsea
2 Arsenal
3 Manchester United

UEFA Champions League: Round of 16, lost to AC Milan. Liverpool won the title. **Ronaldo goals: 0**

Premier League 2005–2006

1 Chelsea
2 Manchester United
3 Liverpool

UEFA Champions League: Disaster. Number four in their preliminary group. Barcelona won the title. **Ronaldo goals: 1**

Premier League 2006–2007

1 Manchester United
2 Chelsea
3 Liverpool

UEFA Champions League: Lost in the semi-final to AC Milan, who went on to defeat Liverpool in the final. **Ronaldo goals: 3**

Premier League 2007–2008

1 Manchester United
2 Chelsea
3 Arsenal

UEFA Champions League: United defeated Chelsea in the final in Moscow. The match concluded with a 1–1 draw. Ronaldo scored the United goal with a header. Frank Lampard scored for Chelsea. In the penalty shootout, Petr Chech saved a penalty kick from Ronaldo, but United still won in the end. **Ronaldo goals: 8**

Premier League 2008–2009

1 Manchester United
2 Liverpool
3 Chelsea

UEFA Champions League: United made it to the final the second year running, but lost 2–0 to Barcelona. Samuel Eto'o and Lionel Messi scored the goals. **Ronaldo goals: 4**

TRIUMPHS AND TRIBULATIONS

With Manchester United, Ronaldo achieved all the greatest victories there are on the field. But he also had to endure disappointments. In the smaller photo, he is celebrating the 2007–2008 UEFA Champions League title with teammate Wayne Rooney. In the photo on the far right we see that Ronaldo is man enough to handle the huge Champions League cup! The match against Chelsea was held in Moscow. In the larger photo, Ronaldo is walking brokenhearted off the field after losing the Champions League final the following year. That match was played in Rome, and Barcelona beat United 2–0, on May 29, 2009. In the background is the victorious coach of the Catalan team, Pep Guardiola.

MAJOR AWARDS

WITH MANCHESTER UNITED 2003–2009

Premier League Title 2006–7, 2007–8, 2008–9

FA Cup 2003–4

Football League Cup 2005–6, 2008–9

FA Community Shield 2007

UEFA Champions League 2007–8

FIFA Club World Cup 2008

Premier League Golden Boot as top scorer 2007–8

UEFA Champions League top scorer 2007–8

World Soccer Player of the Year 2008

FIFA Puskás Award for the most beautiful goal 2009

WITH REAL MADRID SINCE 2009

La Liga Title 2011–12

Copa del Rey 2010–11, 2013–14

Spanish Super Cup 2012

UEFA Champions League 2013–14

UEFA Super Cup 2014

La Liga top scorer 2010–11, 2013–14

UEFA Euro top scorer 2012

FIFA Player of the Year 2013

UEFA Champions League top scorer 2012–13, 2013–14

UEFA Best Player in Europe Award 2013–14

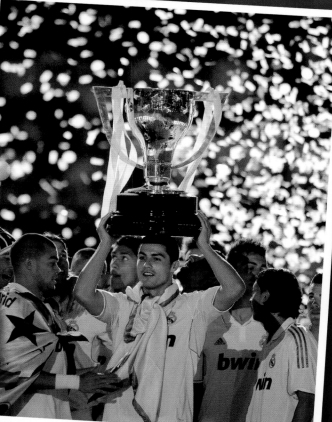

PLAYING FOR UNITED

2003–2009

The First Season

Cristiano Ronaldo played 40 matches during his first season with United, 2003–2004, and usually came off the bench.

Goals 2003–2004
(all competitions)

1. Rudd van Nistelrooy 30
2. Paul Scholes 14
3T. Diego Forlán, Ryan Giggs 8
5. Louis Saha 7
6. Cristiano Ronaldo 6

ManU's starting eleven usually looked like this during Ronald's first season:

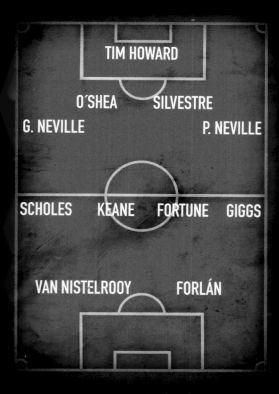

TIM HOWARD

O´SHEA SILVESTRE

G. NEVILLE P. NEVILLE

SCHOLES KEANE FORTUNE GIGGS

VAN NISTELROOY FORLÁN

The Final Season

One year after Ronaldo joined United, Sir Alex bought an 18-year-old striker from Everton, Wayne Rooney. And the team changed little by little. In 2008–2009, Carlos Tévez also played a lot in the front line. He and Cristiano Ronaldo share the same birthday (see p. 15). A friend of Ronaldo's from Portugal, Nani, joined United in 2007–2008 and played alongside him.

Goals 2008–2009

(all competitions)

1. Cristiano Ronaldo 26
2. Wayne Rooney 20
3. Carlos Tévez 15
4. Dimitar Berbatov 14
5. Nemanja Vidic 7

ManU's starting eleven usually looked like this during Ronaldo's last season:

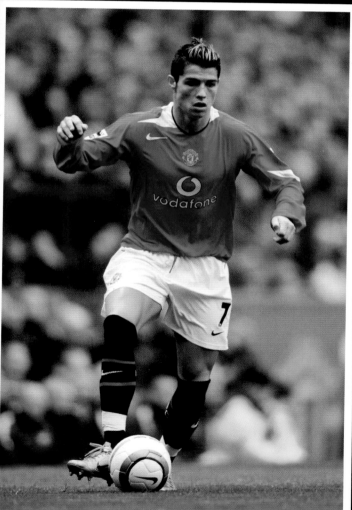

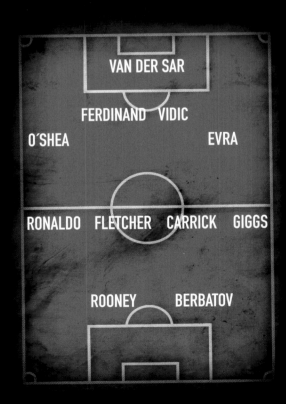

VAN DER SAR

FERDINAND VIDIC

O'SHEA EVRA

RONALDO FLETCHER CARRICK GIGGS

ROONEY BERBATOV

FAMILY MAN

Cristiano Ronaldo's father, José Dinis Aveiro, was very proud of his son and of his success as a soccer player. He would visit him in Manchester on a regular basis and watch him play. When everything was fine, they had a really good relationship.

But things weren't always fine; José was an alcoholic and drank too much. It was very difficult for those around him, and the drinking also ruined his health.

When Ronaldo was all grown up, he made several attempts to help his father and get him therapy, but to no avail. José was too afflicted by his alcoholism.

On September 7, 2005, Ronaldo was in Moscow with the Portuguese national team. The upcoming match was Russia–Portugal in the 2006 World Cup qualifiers. Ronaldo was just 20 years old but already one of Portugal's brightest stars.

Shortly before the match, coach Felipe Scolari and captain Luis Figo approached Ronaldo. They told him as gently as they could that his father had died. He had succumbed to alcohol-related liver failure.

Ronaldo was devastated. Scolari and Figo told him that of course he would not have to play against Russia, but Ronaldo insisted. He wanted to play in honor of his father and try to score a goal for him.

He didn't score a goal in that particular match, but the next time he scored a goal for Portugal he dedicated it to his father.

A risk not worth taking

It was not only Ronaldo's father who had to battle addiction. His older brother, Hugo, has struggled with both alcohol and drug addiction. Hugo managed to kick the habit with Ronaldo's help. Ronaldo is a sensible man; he knows that if your parents or close family members have struggled with addiction, you may well be vulnerable too. He doesn't want to risk falling prey to alcoholism, and therefore he decided at an early age never to drink alcohol.

He takes this vow very seriously and once sued an English paper for claiming that he had been drinking. It turned out to be untrue. Cristiano Ronaldo doesn't drink.

Romance and parenthood

Cristiano Ronaldo is a handsome young man, and he has been in several relationships with beautiful women. Since moving to Madrid, he has been in a relationship with the Russian model Irina Shayk, who is, however, not the mother of his son.

His son? Oh yes! He has a son! To everyone's surprise, Ronaldo announced in July 2010 that he had fathered a child. He broke the news on his Facebook page.

There, Ronaldo claimed to feel "great joy and emotion" over the birth of his son. Nobody knows who the boy's mother is, because, according to Ronaldo, she doesn't want to be in the spotlight. He also announced that he would have full custody of the boy, who was given the name Cristiano. What else?!

Ronaldo's mother, Dolores, and his sisters have helped him in raising little Cristiano.

Dolores Aveiro with little Cristiano.

Cristiano Ronaldo and Irina Shayk

33

EUSÉBIO CHARMS EVERYONE

Eusébio was born in Mozambique—a former colony of Portugal—in the southern part of Africa. He grew up in severe poverty. Eusébio and his friends were even forced to construct makeshift footballs by stuffing newspaper strips into socks. From very early on, Eusébio's talents were obvious; he was super-quick and an eager goal scorer. He moved to Portugal as a teenager and began playing with the top team Benfica. He was soon a tremendous success.

Eusébio became a great role model for youngsters in Portugal, including Cristiano Ronaldo, and when Eusébio died in January 2014, Ronaldo spoke of his influence: "We know that Eusébio was one of the greatest players of all time, and getting to know him was extremely valuable to me. . . . His advice always revolved around being hopeful and positive."

Eusébio was the first Portuguese to win the Ballon d'Or. He was also awarded the European Golden Shoe for being the top scorer in Europe twice. In addition, Eusébio was the first African to enter the pantheon of the world's greatest soccer players.

In Portugal, Eusébio was dubbed the Black Panther, the Black Pearl, or simply, the King!

EUSÉBIO
1942–2014
National games 1965–1975: 64
Goals: 41

Eusébio and Cristiano Ronaldo met often and were always on great terms.

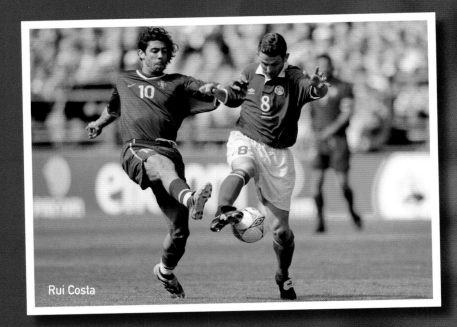
Rui Costa

Fernando Couto and Vitor Baia

THE GOLDEN GENERATION

After 1966 the Portuguese team failed to enter the World Cup for two decades. The team performed poorly at the 1986 World Cup in Mexico, and another 16 years would pass before Portugal would reenter the competition. However, a powerful group of players that in Portugal is known as the "Golden Generation," journeyed to Japan and South Korea for the 2002 World Cup. Many of the Portuguese teammates were also members of the strongest squads in Europe, and together they played a sprightly and compelling offensive game. The greatest of these players was Luís Figo, who for years was counted among Europe's best competitors and won the Ballon d'Or in 2000.

In the UEFA European Championship 2000, Portugal landed in fourth place. They defeated England, Romania, and Germany in the group stages but lost to the French world champions in the semifinals. The team that participated in the 2002 World Cup was considered likely to succeed, but instead failed miserably and did not make it beyond the group stages.

The Golden Generation was nevertheless still at the top of its game during the UEFA Euro 2004, which was hosted by Portugal. The home country hoped for victory, especially since a powerful new member had joined the team: 19-year-old Cristiano Ronaldo.

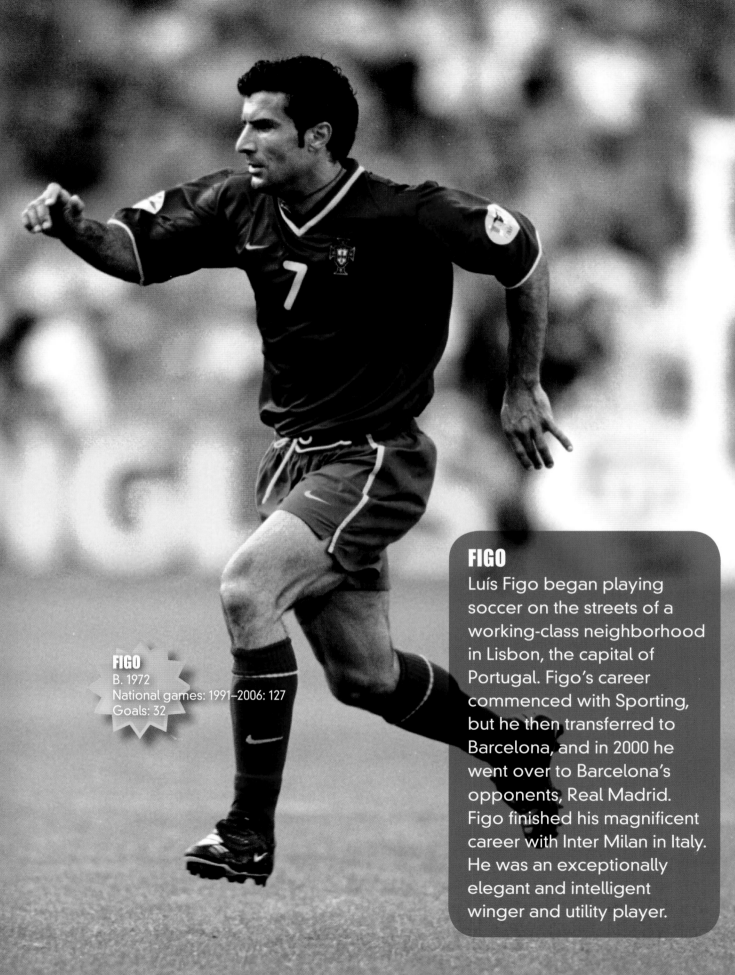

FIGO

FIGO
B. 1972
National games: 1991–2006: 127
Goals: 32

Luís Figo began playing soccer on the streets of a working-class neighborhood in Lisbon, the capital of Portugal. Figo's career commenced with Sporting, but he then transferred to Barcelona, and in 2000 he went over to Barcelona's opponents, Real Madrid. Figo finished his magnificent career with Inter Milan in Italy. He was an exceptionally elegant and intelligent winger and utility player.

Cristiano Ronaldo, captain (at top right), before the match against Poland in February 2012.

CRISTIANO RONALDO TEAM CAPTAIN OF PORTUGAL!

Cristiano Ronaldo played his first match for Portugal on August 20, 2003. He was 18 years old and had recently transferred to Manchester United. The match was a friendly against Kazakhstan. The young Ronaldo started on the bench but came on at halftime.

At the end of August 2013, he had played 105 internationals scoring 40 goals.

The home country passionately hoped for victory in the UEFA European Championship of 2004. Most players of the Golden Generation, led by Luís Figo, were in top form. Success could therefore be safely assumed.

The coach, Luiz Felipe Scolari, had Ronaldo up his sleeve and intended to use the lightning-quick young winger as his secret weapon. As it turned out, Ronaldo played a great deal, and was soon on the starting eleven. It was, however, a great disappointment for Portugal when they lost in the final to Greece. It was an unexpected and unfair result. Greece played a gritty defensive game but managed to net one goal. Try as they might, Ronaldo and the other Portuguese attackers didn't manage to score an equalizer.

Portugal played well in the 2006 World Cup qualifiers, and Ronaldo was nothing short of spectacular, scoring seven goals. When the finals began in Germany on June 9, 2006, Portugal did well to begin with.

They beat England in the quarterfinals in a penalty shootout, after a 0–0 draw in extra time. Ronaldo secured the win for Portugal. But then Portugal lost to France in the semifinals, and again to the Germans in the match for third place. The World Cup was therefore a disappointment for both Portugal and Ronaldo.

The 2008 European Championship didn't go well for Portugal, either. Ronaldo had scored eight goals in the qualifiers, and Portugal made it to the semifinals, where they were eliminated by Germany. Ronaldo was starting to feel the heat from fans.

The disappointment continued in the 2010 World Cup. The new coach, Carlos Queiroz, appointed Ronaldo as captain. At first, this didn't seem to do either the team or Ronaldo any favors. He didn't score a single goal in the qualifying campaign, and Portugal almost didn't make it to South Africa. There, Portugal underperformed, though they did thrash the weak North Korean team, 7–0. (Ronaldo scored his one and only goal in this match.) After two 2–2 draws, Portugal was eliminated from the competition by Spain in the Round of 16.

After a bad start, Portugal made it to the finals of Euro 2012 in Poland and Ukraine. There Ronaldo showed his mettle. He led his men to a good win over Denmark and then scored both goals as Portugal defeated the Dutch, 2–1. In the quarterfinals, the inspirational captain then scored the winning goal against the Czech Republic. Portugal had reached the semifinals, but then they were defeated on penalties by the eventual winners, Spain.

THE GOLDEN GENERATION, 1990–2005, INCLUDED THESE HEROES.

Goalkeeper: Vítor Baía
Defenders: Jorge Costa, Rui Jorge, Beto, Fernando Couto
Midfielders: Rui Costa, Paulo Sousa, Paulo Bento, Costinha, Luís Figo
Forwards: Sá Pinto, João Pinto, Nuno Gomes, Pauleta

Unsportsmanlike?

Ronaldo played superbly in the 2006 FIFA World Cup, even though he didn't score many goals. However, there was a lot of controversy around one incident in a match against England. Wayne Rooney, Ronaldo's United teammate, stamped on the foot of one of the Portuguese defenders. Ronaldo loudly complained to the referee, who obligingly sent Rooney off. In replays of the incident, Ronaldo could be seen winking at his Portuguese teammates.

The referee later clarified that his decision had not been based on Ronaldo's complaining but on the severity of Rooney's foul. That did not appease the English supporters, who blamed Ronaldo for England's elimination from the World Cup—and of course hated him for it!

At this time, Ronaldo was often criticized for diving and various theatrics. But Rooney came to his teammate's defense claiming that he'd done nothing wrong, and eventually the English fans forgave him.

TO REAL MADRID!

Early on, people started to discuss a possible transfer for Cristiano Ronaldo from Manchester United to Real Madrid of Spain. It seemed almost inevitable at some point, as Real is one of the very strongest clubs in the world. Ronaldo had always longed to play for the team.

In the summer of 2009, Ronaldo felt it was time to leave, and Sir Alex Ferguson, manager of Manchester United, was willing to let him go. He knew that for his protégé the Real dream was simply too strong to resist.

Ronaldo was grateful and said, "He has been like a father to me in the sport and one of the most important factors and most influential in my career."

He was at the time the most expensive player in history; Gareth Bale beat the record in 2013 when he joined Real Madrid, but Ronaldo's newest contract may put him on top again.

Record-breaking Transfers

1 Gareth Bale, Wales
Tottenham to Real Madrid
2013
est. 100 million euros

2 Cristiano Ronaldo, Portugal
Manchester United to Real
Madrid 2009
94 million euros

3 Luis Suárez, Uruguay
Liverpool to Barcelona 2014
81 million euros

4 Ángel Di María, Argentina
Real Madrid to Manchester
United 2014
75 million euros

5 Zinedine Zidane, France
Juventus to Real Madrid
2001
75 million euros

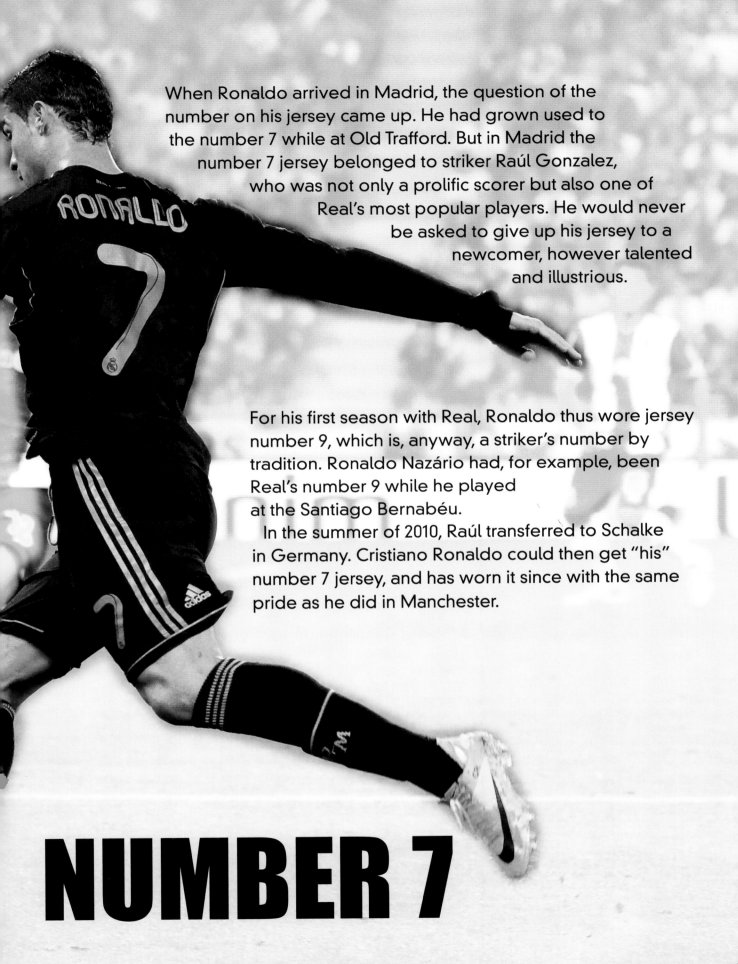

When Ronaldo arrived in Madrid, the question of the number on his jersey came up. He had grown used to the number 7 while at Old Trafford. But in Madrid the number 7 jersey belonged to striker Raúl Gonzalez, who was not only a prolific scorer but also one of Real's most popular players. He would never be asked to give up his jersey to a newcomer, however talented and illustrious.

For his first season with Real, Ronaldo thus wore jersey number 9, which is, anyway, a striker's number by tradition. Ronaldo Nazário had, for example, been Real's number 9 while he played at the Santiago Bernabéu.

In the summer of 2010, Raúl transferred to Schalke in Germany. Cristiano Ronaldo could then get "his" number 7 jersey, and has worn it since with the same pride as he did in Manchester.

NUMBER 7

SPANISH CHAMPION!

When Cristiano Ronaldo joined Real, he started scoring more than he ever had with United. He played a great part in Real's success. During Ronaldo's first two seasons with Real, the club gathered so many points that at any other time it would have secured victory in La Liga, Spain's top league. But the invincible Barcelona totaled even higher both seasons, and Real had to settle for second place. In the 2011–2012 season, though, no club could touch Real, and Ronaldo scored more goals than ever before. For example, he scored 7 hat tricks!

Real's starting eleven in 2011–2012 usually looked like this:

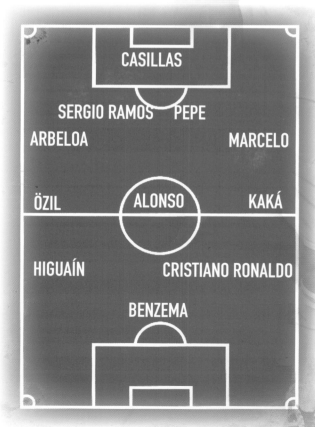

CASILLAS

SERGIO RAMOS PEPE

ARBELOA MARCELO

ÖZIL ALONSO KAKÁ

HIGUAÍN CRISTIANO RONALDO

BENZEMA

The midfielder Khedira and the attackers Di María and Callejón also played a great deal. The coach was the colorful Mourinho.

Constant rivalry with Barcelona

Real Madrid is the most successful soccer club in the world. After the 2012–2013 season, Real had won La Liga 32 times, the Copa del Rey 18 times, and the UEFA European Champions League nine times.

The club's archrival, FC Barcelona, had won La Liga 22 times, the Copa 26 times, and the UEFA European Champions League four times.

The clubs have very different recruitment policies; Barcelona places great stress on homegrown talent, raising its own players from an early age. These boys become the key players in the first team, such as Xavi, Lionel Messi, and Andrés Iniesta. Real Madrid, on the other hand, prefers to buy superstars from other clubs and build the team around them—superstars like CRISTIANO RONALDO.

Ronaldo's stats with Real Madrid aganist Barcolona

November 2009–March 2014

	Real wins	Barça wins	Ties	RONALDO
La Liga	2	6	2	5
Copa del Rey	3	1	2	5
Super Cup	1	2	1	3
UEFA Champions L.	0	1	1	0

Matches between Real Madrid and Barcelona are called "El Clásico" and are usually very exciting. To begin with, Ronaldo didn't do too well against Barcelona. But on April 21, 2012, that changed. Ronaldo and his Real Madrid teammates turned up at Camp Nou in Barcelona, where Real hadn't managed to win a match in five years. But this time Ronaldo scored a winning goal for Real in the 73rd minute, after a great run and an assist from Mesut Özil. It was Ronaldo's finest hour. Not only did he secure a victory over the archrivals on their home ground, but he also ensured that Real would be crowned champions of Spain for the first time since 2008!

RONALDO AND REAL

When Cristiano Ronaldo joined Real Madrid, Manuel Pellegrini was head coach. Despite raking in points in La Liga, Real came second after Barcelona, and Pellegrini was fired. In his place came José Mourinho, who had won titles with Porto in Portugal, Chelsea in England, and Inter in Italy. He was therefore considered one of the best coaches in the world. He moved Ronaldo from the wings to the front and gave him a free hand (or foot), with fabulous results;

Ronaldo flourished and scored goals at a rate almost unheard of in Madrid before. He was top scorer in Spain during the 2010–2011 season.

Real became Spanish champions in 2011–2012, but the team was defeated by Barcelona the following season, and they failed to win the Champions League. This led to Mourinho being fired, and the Italian Carlo Ancelotti was hired as his replacement. With Ancelotti at the helm, Ronaldo kept scoring and scoring!

Season	League games	League goals	Total games	Total goals
2009–2010	29	26	35	**33**
2010–2011	34	40	54	**53**
2011–2012	38	46	55	**60**
2012–2013	34	34	55	**55**
2013–2014*	30	31	47	**51**

* Through September 2014

José Mourinho, the famous and controversial manager of Real Madrid. He was fired in 2013 after failing to win a trophy the previous season. He was replaced by Carlo Ancelotti.

Real's performance in La Liga after Cristiano Ronaldo joined:

LA LIGA 2009–2010

1 Barcelona 99
2 Real 96
3 Valencia 71

UEFA Champions League: Round of 16, lost to the French club Lyon. Inter won the title. Ronaldo goals in the CL: 7

LA LIGA 2010–2011

1	Barcelona	96
2	Real	92
3	Valencia	71

UEFA Champions League: Real made it to the semifinals but lost to Barcelona, who went on to claim the title.
Ronaldo goals in the CL: 6

LA LIGA 2011–2012

1	Real	100
2	Barcelona	91
3	Valencia	61

UEFA Champions League: Real made it to the semifinals but lost to Bayern Munich. Chelsea claimed the title.
Ronaldo goals in the CL: 10

LA LIGA 2012–2013

1	Barcelona	100
2	Real	85
3	Atl. Madrid	76

UEFA Champions League: Real made it to the semifinals but lost to Borussia Dortmund. Bayern Munich won the title.
Ronaldo goals in the CL: 12 (most by any player)

LA LIGA 2013–2014*

1–2	Barcelona	50
	Atlético Madrid	50
3	Real	47

UEFA Champions League 2013–14: Real Madrid won the tournament in a match against Atlético Madrid. The victory gave Real its tenth UEFA Champions League title.
Ronaldo's goals in the group stage: 9

* As of May 2014

45

BEST PLAYER IN THE
WORLD

Cristiano Ronaldo was nominated best men's soccer player in the world for the seventh time in a row in 2013. Lionel Messi, a player for Barcelona, had won the sought-after Ballon d'Or (Golden Ball) the previous four years. Given that Ronaldo had landed in second place four times, and had actually received the Ballon once, in 2008 when he was with Manchester United, many thought his time had come again. Other nominees for 2013 were Messi and Franck Ribéry, of Bayern Munich—but Ronaldo took the prize. "No words can describe this moment. . . . I am deeply touched," the 28-year-old champion said as he stood on the stage and accepted the award. Among the audience members was Ronaldo's mother, who could not restrain her tears any more than her son could.

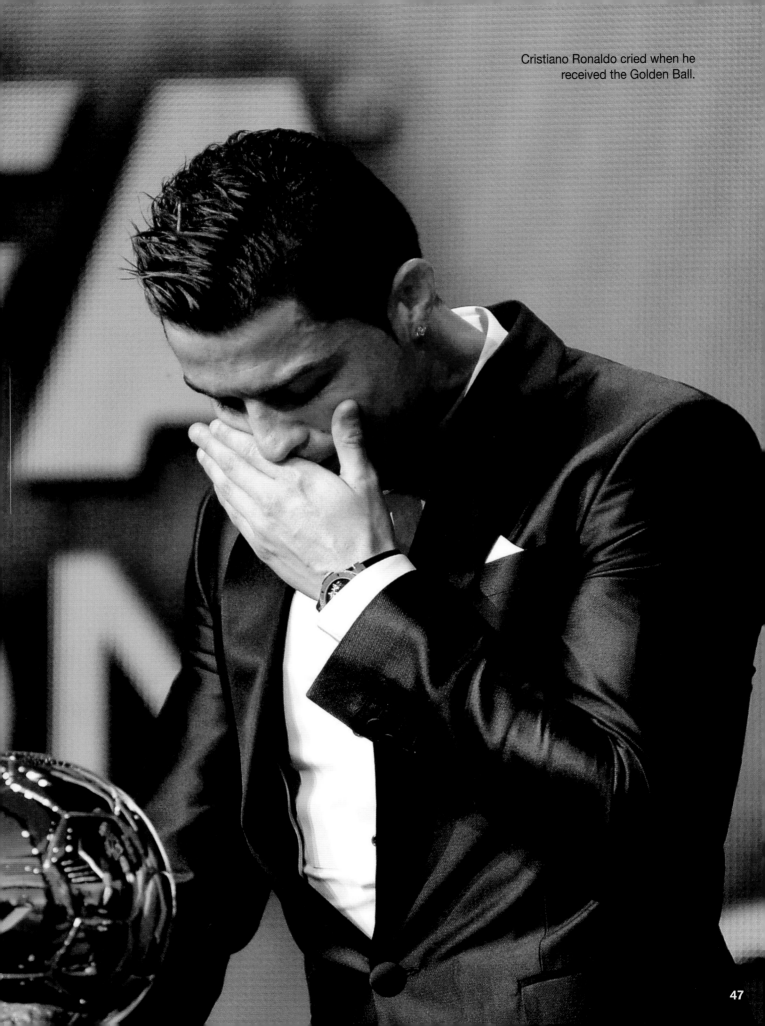

Cristiano Ronaldo cried when he received the Golden Ball.

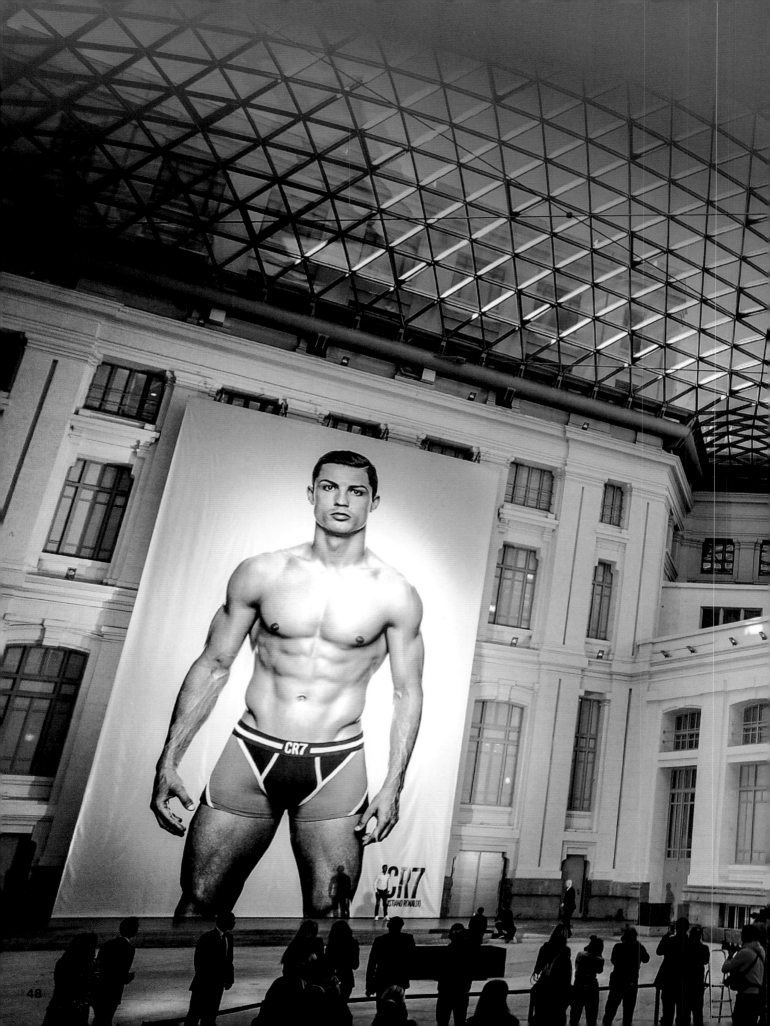

HANDSOME!

A popular and elegant player like Cristiano Ronaldo is, of course, sought for all kinds of advertising. For that he gets a lot of money. Here he displays his new CR7 underwear on a 62-foot-high sign at Cibeles Square in Madrid.

SERIOUS CAR LOVER!

Cristiano Ronaldo loves fast luxury cars, and he can afford them. He currently owns 19 cars, so he must need a very large garage! Here are a few cars in his collection.

BMW M6

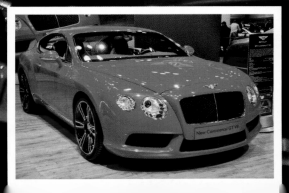

Bentley
Continental
GTC

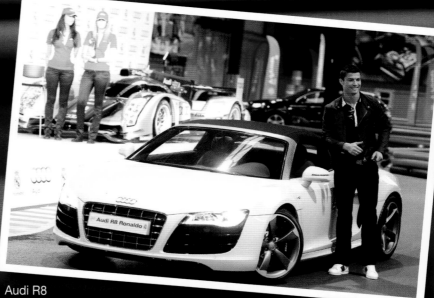
Audi R8

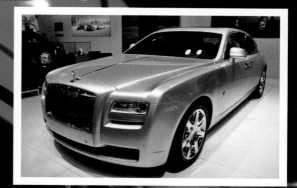
Ferrari 599 GTB Fiorano

Rolls-Royce Phantom

10 FACTS

Ronaldo's grandmother was from the Cape Verde Islands but moved to Madeira to work as a maid.

In the 2011–2012 season, Ronaldo scored a goal against every team in the Spanish league. That was something no soccer player had achieved before!

Ronaldo's home in Manchester was burgled in 2003 and jewelry worth £30,000 ($50,000) was stolen.

Ronaldo is very interested in fashion and owns his own clothing stores in Lisbon and Madeira, called CR7.

Ronaldo is known for working hard in training, and when he was a teenager he practiced dribbling the ball with weights attached to his ankles. He believed this would make him lighter on his feet in actual matches.

When Ronaldo was 15 he was diagnosed with a racing heart. It could have ended his career; he was already signed with Sporting Lisbon. He was admitted to the hospital, where he underwent laser surgery that went very well. He was back in practice a few days later.

Ronaldo has twice scored four goals in a single match, both for Real in the 2010–2011 season. His first "double brace" was against Racing Santander in a 6–1 victory, and the second was in a 6–2 victory against Sevilla.

On January 12, 2008, Ronaldo scored his first hat trick for United, when he made three goals in a 6–0 victory against Newcastle. On May 5, 2010, he scored his first hat trick for Real in a match against Mallorca.

Ronaldo got his first red card for United on January 14, 2006, for kicking Andy Cole of Manchester City.

Ronaldo's contract with Real states that another club can buy him, whether Real wants to sell or not. But only if that other club is willing to part with 1 billion euros!

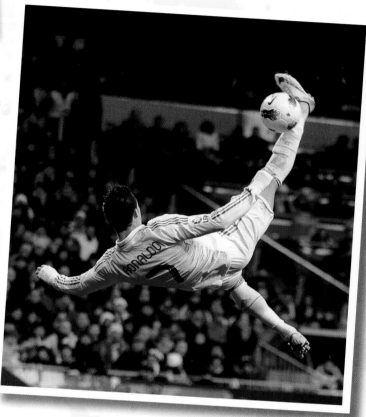

Portugal fell into a challenging group in the UEFA Euro 2012, held in Poland and Ukraine. Many believed the team had little chance against powerful teams from Germany, the Netherlands, or even Denmark. In the first game, Portugal lost to Germany, 0–1. In the following game, against Denmark, Portugal gained a 2–0 lead, but the Danes managed to even the score. Another loss seemed near, until Portugal's Silvestre Varela finally scored the winning goal in the 87th minute. According to some, Ronaldo's performance in these games was unconvincing.

Ronaldo, however, shook off all derogatory talk in the third game, against the Netherlands. The Netherlands had played in the finals against Spain in the 2010 World Cup, but now they fell short in the face of the incredible skills of Ronaldo, who scored both goals in a 2–1 victory.

And Ronaldo maintained his stride in the first game of the quarterfinals, against the Czech Republic. Despite being constantly surrounded by a host of Czech defenders, Ronaldo succeeded in finally scoring the only goal of the game, which secured Portugal a place in the semifinals.

In the semifinals, the Portuguese team was in a 0–0 tie with the Spanish defending world champions in a tremendously spirited game, but took defeat in the penalty shootout. Regardless, the Portuguese team performed impressively, and the games prepared them for the 2014 World Cup.

THE TEAM CAPTAIN TAKES THE LEAD AT THE 2012 EUROPEAN CHAMPIONSHIP!

Ronaldo's goals in finals of international tournaments!

Tournament	Games	Goals
2004 UEFA Euro	6	2
2006 FIFA World Cup	6	1
2008 UEFA Euro	4	1
2010 FIFA World Cup	4	1
2012 UEFA Euro	5	3
2014 World Cup	3	1

Ronaldo scores a goal against the Netherlands in the UEFA Euro 2012.

THE WAY TO BRAZIL

During the 2014 World Cup in Brazil, the Portuguese team landed in a group with Germany, Ghana, and the United States. Portugal lost 0–4 to Germany (the eventual 2014 World Cup champions), the biggest defeat the Portuguese team has ever experienced in a World Cup.

The second game came to a 2–2 tie with the U.S. team. Finally, the Portuguese managed to beat the team from Ghana, 2–1. Unfortunately, this was not sufficient to allow Portugal to proceed, because the U.S. team had more points.

The 2014 Portuguese National Team's Key Players*

	Position	Age	Club	Games	Goals
Rui Patrício	goalkeeper	26	Sporting	30	
Bruno Alves	defender	32	Fenerbahçe	72	9
Pepe	defender	31	Real Madrid	58	3
Fábio Contrão	defender	26	Real Madrid	45	3
João Pereira	defender	31	Valencia	36	
Nani	midfielder	27	Man. United	75	14
Raul Meireles	midfielder	31	Fenerbaçhe	74	19
João Mountinho	midfielder	27	Monaco	68	2
Miguel Veloso	midfielder	27	Dynamo Kiev	49	2

*Age, games, and goals for Portugal, as of May 2014.

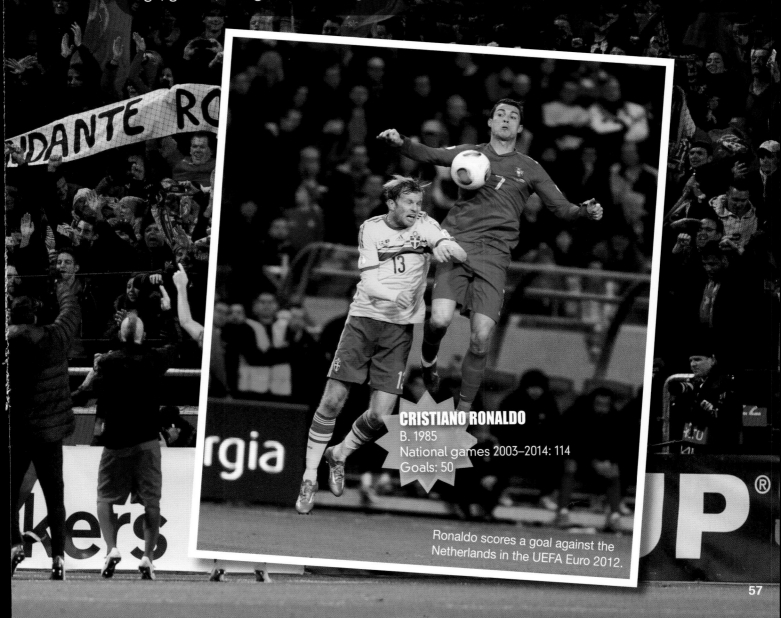

CRISTIANO RONALDO
B. 1985
National games 2003–2014: 114
Goals: 50

Ronaldo scores a goal against the Netherlands in the UEFA Euro 2012.

WHAT'S NEXT?

Leading Portugal to a World Cup championship is most likely the deepest wish of the boy from Funchal. This may be an unrealistic wish, but no one can predict how far Cristiano Ronaldo can take his companions on the national team, with his ambition, daring nature, and genius for play. He did, after all, fulfill his other dream, winning the European Champions League with Real Madrid in 2014.

Ronaldo's contract with Real was scheduled to terminate in 2015. There was talk that Ronaldo might return to Manchester United or even join the ranks of Manchester City or Chelsea. As of the beginning of 2014, it seemed that the only teams that could possibly afford the services of the man from Madeira were in those English cities or the newly rich French teams of Paris Saint-Germain or A.S. Monaco. But in September 2013, Ronaldo signed a new five-year contract with Real Madrid, and so he remains at the team's Santiago Bernabéu stadium, where his fans can count on him to give his very best in every game—and continue to smash the ball into the net!

Ronaldo has chosen to play the rest of his career with Real, and he also continues to be part of the Portuguese national team. He will, doubtlessly, put all his effort into realizing his dreams of winning the World Cup and future Champions League titles.

> "I have no interest in what people say about me. I am always in top form and I am always improving myself. That's why no one can doubt my accomplishments in sports."

Learn More!

Books

- *Ronaldo: The Obsession for Perfection*, by Luca Caioli.
 An insightful, well-written, and entertaining biography.
- *Cristiano Ronaldo: An Unauthorized Biography* (e-book), Belmont & Belcourt Books, 2012.
 Comprehensive and full of useful statistics.

Websites

- The **Wikipedia** entry on Cristiano Ronaldo offers an abundance of information about the player, his family, his teams, and his teammates.
- espnfc.com (Soccernet)
- goal.com
- 101greatgoals.com
- realmadrid.com
- cristianoronaldofan.com (A fan page)

Glossary

Striker: A forward player positioned closest to the opposing goal, who has the primary role of receiving the ball from teammates and delivering it to the goal.

Winger: A player who keeps to the margins of the field and receives the ball from midfielders or defenders and then sends it forward to the awaiting strikers.

Offensive midfielder: This player is positioned behind the team's forwards and seeks to take the ball through the opposing defense. They either pass to the strikers or attempt a goal themselves. This position is sometimes called "number 10" in reference to the Brazilian genius Pelé, who more or less created this role and wore shirt number 10.

Defensive midfielder: Usually plays in front of his team's defense. The player's central role is to break the offense of the opposing team and deliver the ball to his team's forwards. The contribution of these players is not always obvious, but they nevertheless play an important part in the game.

Central midfielder: The role of the central midfielder is divided between offense and defense. The player mainly seeks to secure the center of the field for his team. Box-to-box midfielders are versatile players who possess such strength and foresight that they constantly sprint between the penalty areas.

Fullbacks (either left back or right back): Players who defend the sides of the field, near their own goal, but also dash up the field, overlapping with wingers in order to lob the ball into the opponent's goal. The fullbacks are sometimes titled wing backs if they are expected to play a bigger role in the offense.

Center backs: These players are the primary defenders of their teams, and are two or three in number depending on formation. The purpose of the center backs is first and foremost to prevent the opponents from scoring, and then to send the ball toward the center.

Sweeper: The original purpose of the sweeper was to stay behind the defending teammates and "sweep up" the ball if they happened to lose it, but also to take the ball forward. The position of the sweeper has now been replaced by defensive midfielders.

Goalkeeper: Prevents the opponent's goals and is the only player who is allowed to use his hands!

Pick Your Team!

Coach:

Who do you want playing with Cristiano Ronaldo?
Pick a team for him. Don't forget the coach!

Goalkeeper:

Right back:

Left back:

Defender:

Defender:

Midfielder:

Midfielder:

Midfielder:

Striker:

Striker:

Ronaldo

Striker:

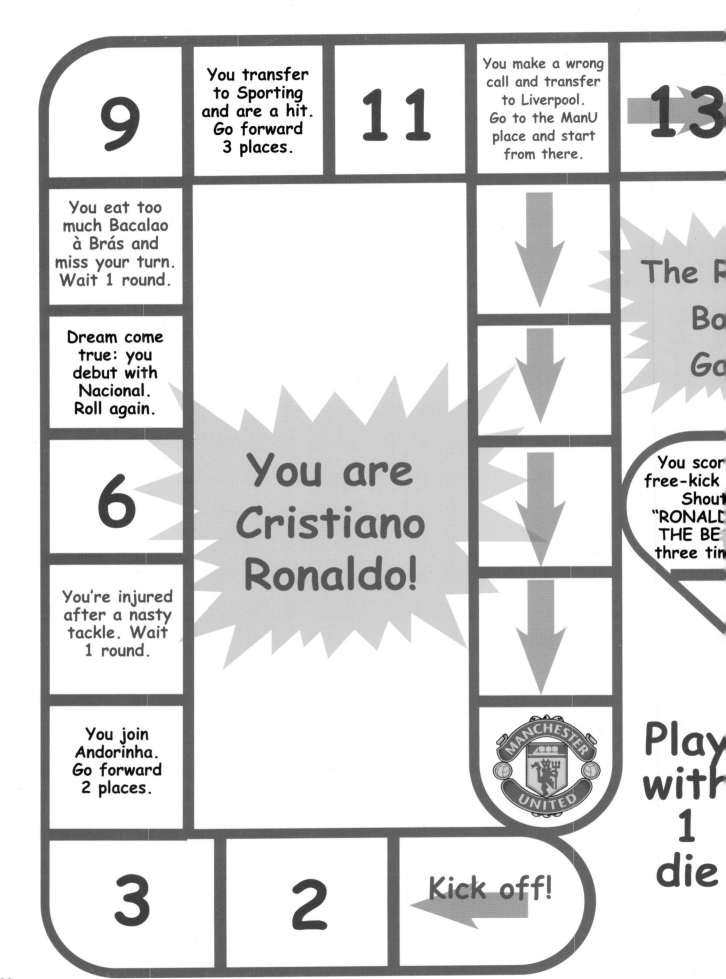

9

You transfer to Sporting and are a hit. Go forward 3 places.

11

You make a wrong call and transfer to Liverpool. Go to the ManU place and start from there.

13

You eat too much Bacalao à Brás and miss your turn. Wait 1 round.

Dream come true: you debut with Nacional. Roll again.

6

The R...
Bo...
Go...

You scor...
free-kick...
Shout...
"RONALD...
THE BE...
three tim...

You're injured after a nasty tackle. Wait 1 round.

You are Cristiano Ronaldo!

You join Andorinha. Go forward 2 places.

Play...
with...
1
die...

3

2

Kick off!